IMAGES OF JUSTICE

Opposite:
The Mafa story

Mafa was alleged to have garrotted her
husband but in a jury trial was acquitted.
The case occurred before Mr Justice
J.H. Sissons' arrival in Yellowknife, but it
provided him with one of his most
dramatic carvings.

Attributed to Alice Evaglok, c. 1917–70s
or George Evaglok, c. 1914–80s
Kugluktuk (Coppermine), NWT
Stone, sinew
16.8 × 6.3 × 8 cm

IMAGES OF
JUSTICE

A Legal History of
the Northwest Territories
and Nunavut
as Traced through the Yellowknife
Courthouse Collection of
Inuit Sculpture

Dorothy Harley Eber

McGill-Queen's University Press
Montreal & Kingston · London · Ithaca

⊘ Dorothy Harley Eber 1997

ISBN 978-0-7735-3415-5

Legal deposit fourth quarter 1997
Bibliothèque nationale du Québec

Printed in Canada on acid-free paper
First paperback edition 2008

McGill-Queen's University Press acknowledges the support of the Canada Council for the Arts for our publishing program. We also acknowledge the financial support of the Government of Canada through the Book Publishing Industry Development Program (BPIDP) for our publishing activities.

Following the death of Mr Justice J.H. Sissons, his family presented much of his sculpture collection to the people of the North. The collection was augmented by Mr Justice William Morrow and is now known as the Yellowknife Courthouse Collection of Inuit Sculpture. Works from the collection are reproduced here with permission of the Supreme Court of the Northwest Territories.

Sections of this book have appeared in different form in *Natural History*, January 1990; *Arctic Circle*, Summer 1992; and *Cape Dorset*, the 1980 exhibition catalogue of the Winnipeg Art Gallery.

The writing of this book was assisted by a contract from the Department of Justice, Human Rights Section, and a grant from the Canada Council.

Canadian Cataloguing in Publication Data

Eber, Dorothy
 Images of justice : a legal history of the Northwest Territories and Nunavut as traced through the Yellowknife courthouse collection of Inuit sculpture (McGill-Queen's native and northern series ; 15)
 Includes bibliographical references and index.

ISBN 978-0-7735-3415-5

1. Inuit – Legal status, laws, etc. – Northwest Territories – History. 2. Justice, Administration of – Northwest Territories – History. 3. Law – Canada – History. 4. Inuit sculpture – Northwest Territories. 5. Inuit in art. 6. Trials – Northwest Territories – Art. 7. Yellowknife Courthouse Collection of Inuit Sculpture. I. Title. II. Title: Justice. III. Series.
 KEN5929.E23 1997 347.71′0089′971207912 C97-900677-5

Typeset in Minion 11/14 by Caractéra inc., Quebec City

Cover photographs and photographs on pages 56 (top), 57, 124, 136, and 152 by Richard Harrington; all other photographs by Iona Wright, GNWT

To Annie and Ann,
my first friends in the North,
with admiration

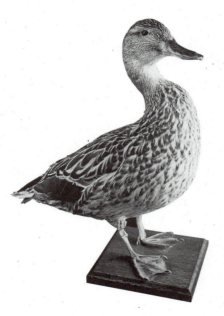

"The Billion Dollar Duck." Exhibit in *R. v. Sikyea*
Partially stuffed, this duck went to the Supreme Court of Canada.

CONTENTS

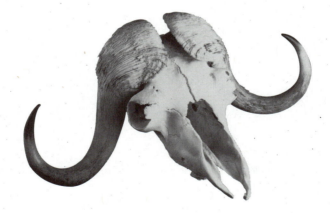

Musk-ox head. Exhibit in *R. v. Kogogolak*
The shot was heard in Ottawa.

ACKNOWLEDGMENTS

I am indebted to all who accorded me interviews, allowing me glimpses of the Supreme Court of the Northwest Territories in a fascinating period in history, insights into current concerns, and, sometimes, intimations of future developments. My aim was to talk to all who would talk to me – Inuit and white, judges, prosecutors, and defendants – and I thank all who did so for their patience and willingness to answer my questions. Many of their names appear in this book; others provided valuable background information.

Research for this book was done on several trips across the Northwest Territories. I am grateful to the Canada Council and the Department of Justice, Human Rights Section, for the generous support that enabled me to undertake these journeys. I must also thank the NWT Supreme Court for allowing me to accompany the court plane on circuit to Cape Dorset. I would also like to say thank you to Edith Mair of the Judges' Chambers, Yellowknife Courthouse, for the help I received from her on numerous occasions. I would like to acknowledge, too, the generous encouragement received at the outset of this project from Neil Sissons, the late Frances Hoye, Laurence G. Hoye, and Genevieve Morrow.

In writing this book I was lucky to have as valuable reference material Mr Justice J.H. Sissons' own memoir *Judge of the Far North* and the book *Northern Justice: The Memoirs of Mr. Justice William G. Morrow*, edited by W.H. Morrow. Andrea W. Rowe's well-researched thesis on the Sissons and Morrow courts was also very helpful. I am particularly grateful, too, to Dr Robin McGrath and Norman Hallendy for allowing me to read and quote from their manuscripts, both published and unpublished. In addition, a number of institutions and government departments and their personnel provided invaluable help. I must thank Doug Whyte of the National Archives of Canada, Glenn Wright of the RCMP historical section, Ingo Hessel and Joanne Logan of the Inuit Art Section, Department of Indian and Northern Affairs, and Joanne M. Bird, curator of collections, Culture and Heritage Division, Government of the Northwest Territories.

As on previous projects I am indebted to Merloyd Lawrence for her careful reading of an early draft of my manuscript and her many helpful suggestions. Dr John McLaren and Dr George Wenzel as well as two unknown readers gave the manuscript scholarly attention from which I benefited greatly. My thanks also to Claude-Armand Sheppard.

For the map for this book I must thank Harold Strub, author of *Bare Poles: Building Design for High Latitudes*. Lesley Andrassy and Melvin Weigel in Montreal, Jimmy Miyok and Johnne Oniak in Kugluktuk, and Jeanne Williamson in Arviat contributed most valuable help at different times, Susan Gardener Black in Iqaluit ran interference for me on numerous occasions, and I am grateful to Lisa Ell Ipeelie in Iqaluit, Tommy Anguttitauruq in Taloyoak, and Agnes Allen in Kugluktuk for expert interpretation. For much appreciated hospitality in the North, my thanks to Helen and Tom Webster, Sandy and Michael Kusugak, Marie Bouchard and Jim McLeod, Tessa Macintosh, and Susan Gardener Black.

My thanks to Philip Cercone, Joan McGilvray, and Susanne McAdam and all at McGill-Queen's University Press with whom, as on previous occasions, I have greatly enjoyed working. I thank Judith Turnbull, too, for her meticulous editing. Finally, I would like to acknowledge the help of my late husband, George F. Eber, who also supported this book.

Dorothy Harley Eber
Montreal, 1997

Preface to the 2008 edition

When the Nunavut Court of Justice opened the doors of its handsome new court house in Iqaluit on 7 September 2006 the little sculptures – none more than six inches high – that represent the stories of the legal cases told in this book were there on display, on loan from the Yellowknife Court House. "They were very popular," reported Mr Justice Ted Richard, senior justice of the Northwest Territories Supreme Court and trustee of the Yellowknife Court House Collection of Inuit Art. "School classes and various people came over to look at them," confirmed Madame Justice Beverley Browne, senior justice for Nunavut. I know from my interviews for the original printing of this book that some of the Inuit visiting the exhibit would have heard family versions of the stories behind the little carvings. With only one exception, all the sculptures represent cases that came before John Howard Sissons, first resident justice of the Northwest Territories, or his successor, William G. Morrow, during court circuits they made to what was then part of the Northwest Territories but which on 1 April 1999 became the territory of Nunavut.

Since its division, Canada's North now has a new judicial landscape. Nunavut sprang into life with its own court system, its own judges, and its own laws. "A new court was created there," said Mr Justice Richard, "called the Nunavut Court of Justice. It has the same jurisdiction we have in the NWT but with one difference: in the NWT we have a territorial and a supreme court which correspond to the provincial court and the superior court in the provinces. In the run-up to Nunavut the Inuit expressed themselves as really wanting to do something different from our usual court structure and so the Nunavut Court of Justice was created with only one level of trial court – quite unique. It takes all cases."

Richard recalls a meeting he attended in Iqaluit "when it was being decided what the justice system was going to look like in Nunavut." Present were the judges of the NWT; representatives of the Federal Department of Justice, the NWT Department of Justice, and Inuit Tapirisat of Canada;

Pauktuutit, the women's group; and others. "A large number of people. Everything flowed from that meeting –and subsequent meeting," says Richard.

In Nunavut, according to Justice Browne, "Because we created one level of court, we have three judges who can basically do everything. They can do a mischief trial, or they can do a jury trial; they can do a divorce or they can do a child protection case. When we go into the communities we do all kinds of things, from child support applications to trials – whatever's outstanding we do; so the court has been very effective and efficient in terms of access to justice."

The designers of the Nunavut justice system also sought to increase the involvement of Inuit in the delivery of justice. "It was decided as a primary objective to strengthen the Justice of the Peace system in the communities," Richard reported. "For the first five years Neil Sharkey headed up the training program and its administration and basically tried to give as much assistance as possible – because the JPs are still lay Inuit people." (Sharkey acted for the defence in *Regina v. Niviaqsi Laisa*, a 1991 case examined in this book.) Community justice initiatives also continue to play a part. "There are justice committees in most communities and they are active so they take the less serious cases off our dockets," said Justice Brown. "They do a good job. There's progress being made, I think." Justice Browne also makes it a practice in the communities to have elders sit with her to help with sentencing. "Always," she affirms. "Not in Iqaluit because it is a busy, busy court and on a regular basis it would be very difficult to do it, but in every other community. I was in Cape Dorset last week and we had four elders." The court has at its service its famously talented interpreters, essential since, according to Justice Richard, in contrast to most native languages in Canada, the Inuit language is well preserved. "It's just thriving. It is very much a working language for the government of Nunavut. They get an A on the report card." Legal interpreters graduate from Nunavut's demanding training courses . "I taught a class last Monday and eight new interpreters will graduate this week," Justice Browne told me.

Initially Nunavut adopted the laws of the Northwest Territories. "All the statutes of the NWT were adopted by Nunavut and they immediately started enacting their own statutes or amending the existing statutes," explained Justice Richard. "For example, in every jurisdiction you have an election act and the election act sets out the number of constituencies and what their names are and what their geographic boundaries are. Obviously, right away, over in Nunavut, they had to change the election act so they could set out the ridings in that jurisdiction."

The little carvings displayed in Iqaluit's new court house trace the legal history of Justices Sissons and Morrow's ground-breaking courts. Are the early law cases the little carvings represent still relevant today? According to Justice Browne, "The cases that came up before Sissons and Morrow are in many ways first contact cases. We are certainly not in the position of first contact any more, though we have cases with cultural elements that come before the courts regularly. But I think the creativity of the early judges in the North is certainly relevant today. The cases they tried and the carvings that represent the cases show them trying to be reflective of living in another culture and creatively recognizing the differences in our cultures. So they are a good history lesson of which we should always be mindful as we do our day-to-day work."

Justice Richard agrees, "We still have novel issues on the constitutional law side. The NWT is not a province. In the legal world there are still issues that come up in the field of constitutional law – about what the effect is of not being a province but a territory, or, in the old terms, a colony of Ottawa." He pointed out that *Regina v. Tootalik*, a 1969-70 case that came before Mr Justice Morrow and features in this book, is as relevant as it ever was. "That's the sovereignty case. It's current in that politically right now the Americans still do not recognize our sovereignty." *R. v. Tootalik* started out as a games law case and ended up as a ruling on Canada's national boundary. "*R. v. Tootalik* hasn't been overturned. So it is there to be used by the Canadian government in asserting sovereignty."

Mr Justice Richard noted that since division the court in the NWT under-takes fewer circuits than it did "because we don't have to go to Nunavut, obviously. Right now one half of the work is here in Yellowknife. The economy here has been in overdrive ever since they discovered diamonds."

Both Sissons and Morrow found that even in their day the cases before them were increasingly coming to look like cases in the south. Richard noted that according to Statistics Canada the crime rate in the North is higher than the national average. "If you look, for example, at sexual assault, year after year after year our rate is consistently five or six times the national average and it is the same in Nunavut. Most of the crime is in the small communi-ties. Some people could explain this by saying crime is more easily detected or more reported than in downtown Toronto. I'm not sure; but unfortu-nately we have many social problems in the North and the rate of violent crime is one of them. There's alcoholism, and we now have a cocaine prob-lem in Yellowknife. There's housing… when you have three or four families living in a home that's built for one family, you're just bound to have social problems."

Justice Browne prefers not to discuss statistics. She noted, "There are lots of hopeful signs in Nunavut. The court house is a microcosm. We have mostly young Inuit people working in the courthouse. They are awesome. They get compliments from every judge that comes from away and from the local judges as well. These talented, with-it young people are the future of Nunavut."

Representative of this talent is Nunavut's crop of new Inuit lawyers, grad-uates of a novel law course organized in Iqaluit with British Columbia's University of Victoria. According to Justice Richard, "The program, put together with a lot of federal money on a one-time only basis, assembled a class of students and moved them through a four-year law program. I think this culminated in the spring of 2005, after which each graduate began twelve months of articling." There were 105 applications for the course; six-teen were accepted and eleven graduated. "I expect ten will be practicing lawyers when they get all the necessary things out of the way," said Justice

Browne. Three have already been called to the Nunavut bar, among them Susan Enuaraq, whose work as a paralegal I observed during my visits to the old Iqaluit court house in the mid 1990s. Surprising many, Frances Piugatuk, a high-profile court worker at the time I interviewed him, did not apply, opting instead for a new career path. "He'll do an awesome job whatever he's into," said Justice Browne. University of Victoria personnel came up to Iqaluit for graduation ceremonies and used the opportunity to confer honourary degrees on Justice Browne – "a nice touch," noted Richard – and on Inuit elder Lucien Ukaliannuk, whose support for the program and lectures in Inuktitut on the indigenous customs and laws that supported the fabric of the old Inuit society, according to Justice Browne, were "absolutely integral."

The new lawyers will increase the pool of native-born legal talent by more than one thousand percent. Paul Okalik, a University of Ottawa law student at the time this book was written, was called to the bar in 1999; within the week he was premier of Nunavut. With their excellent training the new lawyers will have many opportunities: "I would hope so," said Justice Richard, "but I hope they'll stay in the law."

Interest in the little carvings that tell the stories behind the cases that Sissons and Morrow heard on their court circuits seems to increase as the era retreats into history. In 2005 they were exhibited at the Power Plant Contemporary Art Gallery in Toronto and journeyed to the the Confederation Centre in Charlottetown, Prince Edward Island. Mr. Justice Richard anticipates more exhibition requests. But, as trustee of the collection, he noted, "The tougher question will be if someone formally asks why are those carvings not permanently situated in Nunavut?" That will be a difficult decision. Should the carvings – increasingly called simply the Sissons-Morrow Collection – stay in Yellowknife where Mr Justice Sissons and Mr Justice Morrow fought their epic battles with Ottawa to take meaningful justice to the peoples of the North? Or should they move to Nunavut where the judges heard the landmark cases the carvings represent? Mr Justice Richard acknowledges, "I'll cross that bridge when I come to it."

From telephone interviews with Mr Justice Ted Richard in Yellowknife on 6 March 2007 and with Madame Justice Beverley Browne in Iqaluit on 14 March 2007

Dorothy Harley Eber,
Montreal, April 2007

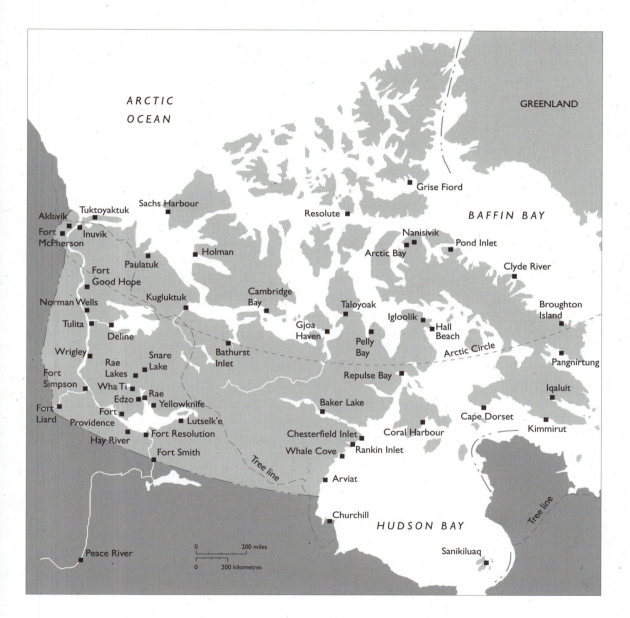

ARCTIC
OCEAN

GREENLAND

Grise Fiord

BAFFIN BAY

Sachs Harbour

Resolute

Aklavik
Tuktoyaktuk

Nanisivik

Pond Inlet

Fort
McPherson
Inuvik

Arctic Bay

Holman

Clyde River

Paulatuk
Fort
Good Hope

Norman Wells

Kugluktuk

Cambridge
Bay

Broughton
Island

Tulita

Taloyoak

Igloolik

Deline

Gjoa
Haven

Hall
Beach

Wrigley

Snare
Lake

Bathurst
Inlet

Pelly
Bay

Arctic Circle

Pangnirtung

Rae
Lakes

Iqaluit

Fort
Simpson

Repulse Bay

Wha Ti
Edzo

Rae
Yellowknife

Fort
Liard

Fort
Providence

Baker Lake

Cape Dorset

Lutselk'e

Kimmirut

Hay River

Fort Resolution

Chesterfield Inlet

Coral Harbour

Fort Smith

Whale Cove
Rankin Inlet

Tree line

Arviat

Peace River

Churchill

HUDSON BAY

Sanikiluaq

Tree line

0 200 miles

0 200 kilometres

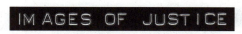

IMAGES OF JUSTICE

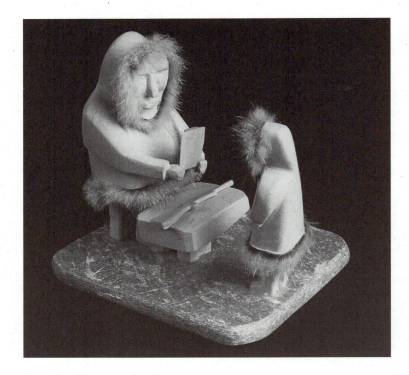

R. v. Kaotak
Allan Kaotak, c. 1925–?
Cambridge Bay, NWT
Probably stone (the exact nature of the medium requires further analysis), fur
17 × 14.5 × 17.5 cm
This carving was presented to Mr Justice Sissons by the defendant after his first trial in the NWT.

The rocks of the great caribou drive – the *taloyoak*, from which this Boothia Peninsula community gets its name (it used to be called Spence Bay) – stretch out on the tundra close enough to the hamlet so that if you know where to look you can clearly see the pits where the hunters used to wait for the herd.

"When the caribou passed through the rocks, the men in the pits would kill the last ones and then other men take the ones up front," Lena King-meatook tells me. "Some would escape and there's a lake up ahead where hunters on kayaks would hunt them with spears and bows and arrows."

Lena herself never saw Inuit hunt this way, but there are men still living in Taloyoak who did. "That's how they did it for generations and generations."

In Taloyoak, bound by the waters and ice of the Arctic Ocean, the old Inuit world still seems close. But from near the front of Lena's house, where strings of arctic char are drying in the sun, I can also clearly see Disney World, the newest area of town, so called because the houses there have brightly alternating red and blue roofs. It is this contrast of old and new, the closeness of the present to the past, that astonishes all visitors to the modern North.

In Taloyoak people tell stories of the British explorers – of Parry and Ross and of encounters with Franklin's crews – but I have stopped here because living here are protagonists of the high dramas that marked the transition years.[1] I am paying my first call on Lena because her late husband, Abraham Kingmeatook, a notable Inuit artist (one of his dog-teams appeared on a stamp), is among those whose carvings illustrate some of those dramas in the remarkable Yellowknife Courthouse Collection of Inuit Sculpture, which provides a focus for this book.

This collection of small-scale sculpture depicts scenes from noteworthy court cases that came before the Northwest Territories Supreme Court (until 1972 known as the NWT Territorial Court) and its first two resident

justices in the years between 1955 and 1970, the first fifteen years of its establishment. Started by Mr Justice John Howard Sissons and augmented by his successor, Mr Justice William George Morrow, the collection represents legal history – and social history, too. (Only one case represented in the collection, *R. v. Sikyea*, occurred outside the area that, as a result of the division of the Northwest Territories, will become Nunavut on 1 April 1999, and *Sikyea* has relevance for all aboriginal people in Canada.)

Even today the Northwest Territories, one-third of Canada and the size of India, has a population of only some sixty-six thousand people, one-third of whom are Inuit, the rest Indian, Métis, and white. The cases the carvings illustrate came before the court at a pivotal period of social change for Inuit – the moment when the ancient camp system was eroding and age-old practices and traditional mores were being called into question. As a result of the southern technological society's northward push – its engine was the Distant Early Warning (DEW) Line of radar stations – in the years after the Second World War, Inuit began living "the new way," moving from the snow houses and the camps to settlements with schools and nursing stations. By 1970 the move to these settlements, which chiefly sprang up around the old fur-trading posts, was virtually complete across the North. The carvings on display on the ground floor of the Yellowknife Courthouse tell stories that illuminate the life Inuit led in these difficult days and attest to the challenges the court faced as Inuit adopted new lifestyles and the court had to rule on traditional practices as well as pass judgment on crimes arising out of new circumstances.

The Sissons and Morrow courts heard hundreds of cases. When I first read the transcripts of the fourteen cases represented by the little sculptures in the courthouse display cases, they seemed to me legal snapshots from an incredible journey – a journey that has brought Inuit from camp days to the present times. It is the hope of enlarging the snapshots that brings me to Taloyoak.

To help with our interview I show Lena some photographs, some of them pictures of carvings made by her husband. One depicts a huge polar bear, a small hunter, and two little animals I had thought were polar bear cubs but Lena says are dogs. This illustrates *R. v. Tootalik*, an important game law case in which it was contended that Jimmy Totalik, Lena's near neighbour, had illegally shot a mother polar bear and her two cubs. Lena remembers the carving well. "I helped by polishing the whalebone – the bear and the dogs." (Today Totalik family members spell their name with one "o.")

Carving was and is an important occupation for Inuit. In the 1950s and 1960s, as campers left the land, art programs were introduced across the North, initially as make-work projects. The high quality of the work surprised many and has brought the Inuit wide recognition and significant income.

Lena and I are lucky in our interpreter. Helping me put my questions is Tommy Nalongiak Anguttitauruq, her close relative and a legal interpreter. When he was four years old, the RCMP came to his family's camp in the Perry River area. "They were registering everyone and handing out numbers – we called them dog tags – and writing things down. I wondered what they were doing, and I wanted to write things down, too. When I was older I told my father I wanted to be an interpreter. He said, 'What good would that do?' I said, 'I could interpret for you.' And he said, 'What this family needs is more hunters.'"

But life changed. By the time Tommy was thirteen, he was regularly called out of school to interpret for the courts. Recently he has taken many of the NWT legal interpreting courses, which have honed his natural ability.

Tommy points out to me Jimmy Totalik's bungalow just across the road from Lena's house, but probably the great bear hunter is not at home, he says, as Jimmy is always out at camp. Lena tells us her husband "felt very sorry for Jimmy Totalik having to go to court. Kingmeatook could never forget what happened to him." Referring to the carving, she says, "He was

going to make more dogs but there was not enough material. He was going to put a harness on those two little dogs but he was in a hurry to take the carving to the store to buy the groceries."

Nevertheless, the carving Kingmeatook made that day bears witness to a landmark judgment. *R. v. Tootalik* started as a minor game case and ended in a ruling on Canada's national boundary.

During their day in court some of the cases depicted in the courthouse collection attracted wide attention, making headlines far from the North, but in many less-publicized undramatic cases, the court on its regular circuits to the small Arctic settlements had a deep impact on Inuit lives.

Unexpectedly, Lena tells us that she had her own experience with the court. She was a young girl when in about 1962 she first saw Taloyoak, then just a few buildings around the Hudson's Bay Company's fur-trading post. This was after the RCMP plane had stopped on the ice in a remote area near Pelly Bay and officers came to her family's igloo to pick her up. The police were beginning an investigation that would lead to charges against her father, his conviction, and later his banishment from the community.

Lena's father was twice put on trial, and Lena recalls appearing before Mr Justice Sissons: "The judge was quite old and walked with a cane. When they were holding court, there was quiet. The judge and the lawyers were dressed in their special clothes. There were quite a few RCMP walking around and they were armed. Just before the end the judge had me sit right in front of him and he asked me questions. I had to put my hand on the Bible. I understood that a victim who needs to go to court has to tell the truth and not make up stories because if you tell a lie you cannot tell the exact same story next year."

Lena is among hundreds of Inuit whose lives were altered by the court and its circuits. "She says she got good help from the court," says Tommy. "The memory and suffering are with her still but she is grateful to the court for the better life that she has had since then."

"The laws are here to protect us," adds Tommy. "We cannot do without the courts."

Such positive comment was not inevitable when I travelled across the North asking questions about the justice system in the years between 1989 and 1995. But no one contested Tommy's contention: "We cannot do without the courts."

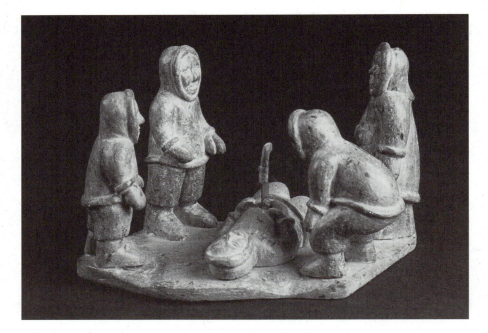

R. v. Angulalik
Agnes Topiak, c. 1905–79
Kugluktuk (Coppermine), NWT
Stone, metal, wood, sinew
14.5 × 11.5 × 9.5 cm

The NWT Supreme Court and Its History

In a fury of capital letters the Sissons era of justice in the Canadian Northwest Territories began: JUDGE SISSONS ARRIVING HERE SATURDAY FIFTEENTH WISHES TO TAKE OATH OF OFFICE ... read the telegram dispatched 14 October 1955 from Yellowknife to R.G. Robertson, commissioner of the NWT and deputy minister of northern affairs and national resources. On 17 October Robertson wired from Ottawa to Police Magistrate L.H. Phinney: PURSUANT TO SECTION TWENTY-TWO OF THE NORTHWEST TERRITORIES ACT I HAVE TODAY AUTHORIZED YOU TO TAKE THE OATH OF OFFICE OF MR JUSTICE JOHN H. SISSONS.

On 18 October Magistrate Phinney administered the oath and John Howard ("Jack") Sissons began his remarkable Arctic career. His years in the North would make him widely (though not universally) admired and, to the general public, far and away the best-known Canadian jurist of his day – articles in *Time, Life, Look,* and *Reader's Digest* would see to that. In the process he would become an uncomfortable thorn in the flesh of Ottawa's bureaucracy, and six years later Robertson would write: "Sissons seems to have developed the idea that he is the Great White Father of the Eskimos in modern guise and that it is for him to decide how the law should apply to them regardless of what the Parliament of Canada or the Counsel of the Northwest Territories may decide."[1]

Jack Sissons was sixty-three at the time of his appointment as first resident judge of the NWT Supreme Court, old, some thought, for an initial confrontation with the Arctic. He walked with a limp, the result of childhood polio, not an asset on arctic terrain, but his struggle to overcome this handicap, those who worked with him believe, had made him stubborn, tough, sometimes gruff, and prepared to do battle. "Judge Sissons ruffled feathers," says Mr Justice Mark de Weerdt who went to Yellowknife as a young lawyer in 1958 and later became senior justice of the NWT. He left the North in 1996 to take up an appointment to the bench of the Supreme

Court of British Columbia. "We were lucky to have him at that time. We are all human and some judges are likely to be better equipped. He was eminently qualified, dedicated, and courageous."

Sissons was born in 1892 in Orillia, Ontario, where his father for thirty-four years was chief attendant at the Orillia Mental Asylum. Everett Tingley, now of Calgary, who worked with Canadian representatives at the international tribunal for war crimes at Nuremberg, was court reporter through most of the years of the Sissons and Morrow courts. He recalls, "Sissons liked to say, 'You can't tell me that – I grew up in an asylum,' and he did, too."

Sissons taught in a one-room Ontario school before becoming a Depression-era lawyer in the Alberta frontier town of Grande Prairie in the Peace River country. Here he met and married Frances Johnson, a visiting Dublin girl with a taste for adventure who worked for his practice. The friendships he made with the Indians along the Peace River gave him, as he wrote in his memoirs, *Judge of the Far North*, "a first-person knowledge of these people which would be helpful in the future in a way I could not yet imagine."[2] During the Second World War, for a short period he went to Ottawa as a member of Parliament. He became "one of Mackenzie King's boys," helped initiate a judicial inquiry into the conditions of the Indians of Lesser Slave Lake, and had his first run-ins with Ottawa bureaucrats at Indian Affairs. He was defeated in his second election but in 1946 King made him a judge in the district court of southern Alberta, and he was in Lethbridge as chief judge of the southern circuit when the call came to go North. When he took up the appointment, he brought with him a sympathy for the northern people, people caught in the crosscurrents of change, and the belief that to serve justice in the North the laws and the court would have to adapt.

The summons had come unexpectedly, relayed on the telephone by Mr Justice E.B. Wilson on behalf of Minister of Justice Stuart Garson. "There is an appointment to be made to a new territorial court in Yellowknife; it is a Supreme Court appointment. Are you interested?"[3] Sissons accepted after

one brief conversation with his wife. The minister of justice himself called a few hours later, and Sissons formally agreed to his appointment as the first judge of the reconstituted Territorial Court of the Northwest Territories (there had in fact been a previous NWT Territorial Court – since 1972 called the Supreme Court – but it expired on 31 August 1905, when most of what is now Alberta and all of Saskatchewan withdrew from the Territories to become provinces). "I was surprised when this call came for me to be this judge. But I was ready. I had always been ready,"[4] Sissons later declared.

His decision was gutsy and hailed as such, although there were Alberta colleagues only too delighted to speed him on his way. "He was a battler," says de Weerdt, "and he saw the two-tiered trial court in Alberta as something that should be abolished, which it eventually was, but at the time judges in many cases were averse, so he was seen as a bit of a threat because he had political connections. When the NWT court was re-established and they were looking for a judge, I am sure there were many Alberta Supreme Court judges who cheered lustily and championed his appointment."

In Ottawa the news of the appointment may not have been so well received. There had been some feeling (Sissons put down his suspicions rather frankly in his book) that no experienced judge or lawyer would accept an appointment to the Far North and that therefore the job might elevate a civil servant to the bench.[5] Sissons believed that the "high civil servant" whom officialdom intended for the job would have continued to live in Ottawa, travelling north to hold court from time to time "like a foreign potentate."[6] A list of seven civil service lawyers (with little actual practical experience of the law, Sissons considered) had been submitted. However, members of the law societies of the day were opposed to this route to the judiciary. "It wasn't altogether for your sake, Jack," Mr Justice Wilson had remarked when discussing the fact that the appointment had come Sissons' way. "We wanted to keep those civil servant boys from usurping the job."[7]

From the outset the stage was set for a combative relationship with Ottawa. "It often seemed in the next eleven years that the court was lined up

on one way of doing things and the administration on the other," Sissons recalled. Throughout his years in the North, Mr Justice Sissons gave as good as he got, sometimes – as in *Re Noah's Estate* and *R. v. Koonungnak* – in fuming judicial writ. Court reporter Everett Tingley recalls that Sissons did his own typing. "You'd hear him typing down the hall and you'd know from the sound of the typing what kind of a mood he was in."

The law Sissons had to uphold flowed from the received English law in force on 15 July 1870, unless amended, and from federal enactments and NWT ordinances. And he had to apply it in an immense area characterized by vastly different cultural conditions. Down the Mackenzie River there were fast-growing frontier societies, ushering in new ways of doing things, but in the North, in the true Arctic, traditional camp life, its customs and beliefs, would prevail for the most part for some years longer.

"Mr Justice Sissons made no secret of his contempt for the senior Ottawa mandarins," says de Weerdt. "Whether this extended to Commissioner Robertson, who I don't believe he met until 1961, I do not know." When Sissons took office, the NWT was run by a commissioner who took instruction from the Cabinet or from the minister of northern affairs and national resources, though Sissons was to complain that "it was often the other way round."[8] There was a council of nine members, five appointed and four elected from the Territories. The commissioner and the senior policy-making Northern Affairs mandarins all lived in Ottawa. And until 1970 the administration of justice in the NWT came under the federal Department of Justice. (The NWT crown attorney's office continues to be part of the justice department, operating out of offices in three locations in the Territories.)

"Sissons felt he had to work against an administration at two or three thousand miles distance," says de Weerdt. "They couldn't understand what he felt had to be done and that perhaps was only natural. Because their concerns were basically national, their concerns were of a totally different order. And they had the idea that he could sit in Yellowknife and everyone just come

down to Yellowknife. They had no idea what we had to contend with in terms of distances and the problems relating to moving people around."

Today the mandarins have forgiven – and forgotten. "I don't remember any difficulties or problems with Judge Sissons. It's a long time ago and it may be that my memory is faulty. I'm not saying there weren't any but I don't remember them," says Gordon Robertson, who eventually became clerk of the Privy Council and the pre-eminent mandarin of his day. "He struck out strongly for what he perceived to be the interests of the Inuit people. Heart and mind. He's perceived as a very interesting figure. Sissons and Morrow were thought of as strong people, interested in the Eskimo and the Indians of the time, and they were both quite colourful figures and I think this occasioned a certain amount of pride."

In Yellowknife, where the sidewalks were paved with wood, Sissons' appointment was welcomed and applauded. The legislation to establish the new court had been in place since April 1955, but there had been no appointment and cases, civil and criminal, were piling up. The *News of the North* for 21 October 1955 announced Sissons' presence with the headline NORTH-WEST TERRITORIES TAKES ANOTHER STEP FORWARD[9] and commented editorially, "It is also well that the man named is not a stranger to the shortcuts and improvisations which may be required in a pioneer community such as this."

"I think we all showed up for the ceremony," recalls Elizabeth Hagel Bolton, who became the first woman to practise law in the NWT. (She now lives in Calgary.) When Sissons arrived, the NWT bar numbered exactly two people. "There was John Parker and my husband, Don Hagel. That's all. A year or so later, when Parker left, Mark de Weerdt arrived to take over his practice." She recalls a sense that a new era had begun: "I think everyone was very hopeful because now we had our own superior court. Previously there had been a quite different jurisdiction and a stipendiary magistrate. There had been a lot of things going wrong with the court. I was not a

lawyer at the time but even I began to realize this. There had been a practice on the civil side, for instance, where if someone owed somebody money, they would just take out a garnishee summons to file with Giant Mine or Con Mine, wherever the person worked. They wouldn't bother to get a judgment or even take a suit first, they would just take out this summons, which was a very peculiar proceeding, to say the least. I think there was probably quite a bit of injustice. We thought Mr Justice Sissons would pull things together properly, which of course he did.

"Now we had a higher court, and after he arrived, he made it a rule that the court would move to the people. And so then the court started to travel, which it had not done before."

EARLY JUSTICE

For all practical purposes the law first reached the Far North shortly after the turn of the century. In 1903 the government of Canada decided to establish two police depots in its enormous Arctic territories, acquired in 1870 and 1880 through treaties with Britain – one at Cape Fullerton on the west coast of Hudson Bay and one on Herschel Island in the Beaufort Sea. The Canadian government wanted to police the American and Scottish whalers active in these areas and to levy taxes, but the move was not popular. Newspaper headlines in Scotland announced, FISCALITIS IN THE ARCTIC and CANADA V. THE DUNDEE WHALERS. Under the headline THE LONG ARM OF THE TAX GATHERER, a 1904 editorial in a Dundee paper commented, "Till within a very recent period this great territory has been exempt from all forms of government, and its vast expanse has been a no man's land, free citizens of which have been nomadic Esqimaux, whalers and explorers. Now the old order is giving way to new."

By the 1920s there were police detachments – and also Hudson's Bay Company (HBC) posts – widely spread throughout the vast Arctic lands of the NWT. Members of the force became famous for their long patrols.

Besides regulating their society through a system of taboos, the Inuit in remote camps had their own rough justice. "They were eking out an existence in a very harsh environment. They didn't have time for crime of a petty nature. If a person was going to disrupt the community, the livelihood, and the gathering of food, they were executed," says Bob Pilot of Pembroke, Ontario, NWT deputy commissioner from 1979 to 1984 and a former Royal Canadian Mounted Police (RCMP) officer sometimes recruited by Sissons as an adviser to the court. The story circulates, never pinned down as to location, of how an Inuit posse hunted down a dangerous member of its nomadic community, put him in a snow house, and carried out his execution by driving harpoons through the igloo.

Was Inuit justice ever of a more formal nature? Norman Hallendy, Arctic researcher and photographer, says, "The prevailing wisdom is that Inuit had no law, courts, or formal justice, and Inuit elders across the Arctic will back this up." However, field work he conducted in 1991 suggests, intriguingly, that on south Baffin Island, at least for a period of time in this century, a more rigorous form of justice did exist. In a paper prepared for the World Archaeological Congress III, 1994, Hallendy described a remarkable circle of large, upright stones on the coast of southwest Baffin, shown to him by a Cape Dorset elder on 1 August 1991. The elder had called this place and its megalithic structure "Akitsiraqvik," a very old word with an imbedded root meaning "to strike out, to punish." According to the elder, this was "where a powerful council met and exercised justice before the arrival of the Qallunaat – the white men." The circle was also a place where Inuit met for games and archery contests. Hallendy found it "curious that the structure and the manner in which people were seated there appears identical to the Viking 'thing.'"

Hallendy's paper also provides details of the last-remembered formal Inuit trial, which took place in August 1924. Hallendy had heard the account from a second Cape Dorset elder, Osuitok Ipeelee, one of the North's most famous artists. Osuitok explained that the trial did not take place in

Akitsiraqvik but on the south Baffin coast where the members of all the camps were on hand because of the expected arrival of the HBC supply ship. The Inuit council at that time, Hallendy wrote, may have consisted of as many as fifty camp bosses from all over the Foxe Peninsula, representing "a power elite" that he called the "*issumaliutiit* – roughly the intelligentsia." The council was to render judgment on a man who claimed that it was by accident that he had shot and killed his hunting companion, an explanation not accepted by the dead man's relatives.

Some members of the council had been taken to the place where the victim had fallen. They had examined the area where the accused had taken his position to shoot birds; they had considered the weather, the time of day, and the myriad of details familiar to hunters. Then they met to reach a decision.

Only the accused and his parents were permitted to appear before the council. The accused gave his testimony and answered questions. Having been required to stand throughout the proceeding, he became very tired and lost his balance, but recovered. Then, resigned to dying, he said, "If you decide to kill me, take me away from this place, and shoot me where I will bleed to death slowly. And if that punishment doesn't satisfy you then take my child and do the same."

The council remained silent for a long time. Then [a leading camp boss] exclaimed, "Whoever kills this man removes my will to live!"

His penetrating words struck at the thoughts of everyone on the council, and they decided to spare the accused's life. However there was a condition – should the accused ever be involved in another person's death in any way, at any time, his own death would follow swiftly.

Perhaps because of current public interest in aboriginal justice, Hallendy's paper reached the Supreme Court of Canada. It was circulated among the members and deposited in the Supreme Court Library for future reference.[10]

When RCMP officer Bob Pilot went into the North, at about the age of eighteen, the members of force were care givers as much as policemen: "Inuit and the RCMP got along well together. Superintendent Larsen was very insistent that we learn the language.[11] We learned the language, we gave the Eskimo dogs their shots, we gave out welfare." Pilot saw the North change. And the nature of policing, too. The construction in the mid-1950s of the DEW Line (the string of distant-early-warning radar surveillance stations located seventy miles apart across Arctic Canada) and the influx of southern labour and technology it brought with it had a decisive impact on Inuit lives. "When you have large numbers of white people coming in, you have to bring in a lot more police. They didn't have the opportunity to get to know the people. The Inuit felt all they wanted to do was put them in the hoosegow because they drank too much."

Bob Pilot was stationed in the High Arctic at Grise Fiord on Ellesmere Island when the circuit court arrived there for the first time. He watched the court plane circle overhead. "They were the first people to come in by plane. Sissons pioneered justice in the eastern Arctic. It had to come."

THE CIRCUIT COURT

Within weeks of his arrival in Yellowknife Mr Justice Sissons came to the decision that was to mark the course of the court in future years: to do justice in the North, he believed, the court must travel on circuit, even to the most distant reaches of the Territories. Circuit courts are an old tradition; Henry II of England sent judges out on circuit to the shires. (Common law arose when the judges visiting their various districts found laws that were common to each area. When something was distinct, it was deemed an exception – custom.) Prior to the Sissons era of justice in the North, there had been irregular circuit courts. Minor offences in the far-flung Arctic communities were handled by white residents, usually HBC personnel, or

until 1968, when because of obvious conflict of interest the practice was abandoned, occasionally by RCMP personnel, sitting as justices of the peace. A magistrate with considerable powers did travel on circuit sporadically in the western Arctic, and for a capital offence in the region a judge might be summoned from the south. In the eastern Arctic, a magistrate's court operated occasionally out of Ottawa until 1967, but in actual fact only rarely did a court reach this vast undeveloped region, the so-called stepchild of the North. Administering justice in the eastern Arctic was undeniably the big challenge.

With rapidity Sissons set about planning for circuit courts. By March 1956 he was writing to Jean Lesage, minister of northern affairs and national resources, with plans for a travelling court. "I would like it known throughout the Northwest Territories that the Queen's writ runs to all the Northern outposts and that there is a Territorial Court which is prepared to serve them." And he outlined his precepts, which he would reiterate often:

- Justice shall be taken to every man's door;
- This court shall go on circuit to every part of its realm at least once or twice a year;
- The proper place for a trial is the place where the offence was committed;
- No man shall be condemned except by the judgment of his peers and the law of the land.

The proposal received support, though not entirely for the reasons Sissons considered paramount. Jean Lesage wrote to Stuart Garson, minister of justice and attorney general for the NWT: "They would have, of course, the direct advantage of making justice readily accessible to people in remote areas. In addition, however, there would be a very real advantage in having this demonstration of Canadian sovereignty and administration on a high judicial level throughout these regions where administration is tenuous and where United States activities are bulking so large at the present time. For

both these reasons I think it would be most desirable to have a circuit arrangement established."[12]

Sissons had his circuit court but the battle had only begun. Throughout his years in the North he had to contend with turf wars. "There was a lingering sense that Ottawa 'owned' the Eastern Arctic and that anything Sissons might want to do there ought to be vetted by Justice or Northern Affairs, or both, first," wrote Andrea Rowe in a study of the court in the years 1955–72. "At one point while Sissons was organizing an Eastern Arctic circuit, he was instructed to attend in Ottawa [in order] to fly to Frobisher Bay with an Ottawa-based crown prosecutor and clerk. This idea, of course, drew a sharp negative reaction from Sissons and did not resurface."[13]

John Parker, appointed NWT commissioner in 1978 at a later stage of the Territories' development, recalls that in the days of early court circuits relations between Sissons and Ottawa from time to time were acrimonious: "Gordon Robertson had to convey the word of the Ottawa establishment. The federal government's objection, I think, was that Sissons might be exceeding his mandate by travelling hither and yon to do the cases. He was travelling extensively and I'm sure this was incurring costs that they hadn't anticipated. Secondly, he was tending to incorporate in the law some aboriginal justice approaches – views of the people. Simply put, this was objected to."

Even today the task of taking the court to some sixty small communities across the Territories, where a number of dialects and languages are spoken, is formidable. In an issue of the Yellowknife magazine *Up Here*, Louise Roy-Nicklen, who helped train the first Inuit enrolled in the NWT legal interpreters' program, wrote, "The very size of the NWT creates problems in administering justice. Small communities, scattered far apart, cannot maintain individual court services; justice must be brought in, like crates of fresh vegetables or medical aid, by air."[14]

In the 1950s, when runways were marked out by oil drums and air services were undeveloped, Sissons' decision to undertake regular court circuits all

across the North was progressive and courageous. "If we're looking for real pioneering, Judge Sissons went into the eastern Arctic on a systematic basis of circuits, two, three, four times a year," says Mark de Weerdt, who was often along as Crown prosecutor. "And we really did circuits in those days – we travelled from Yellowknife all the way down the Mackenzie, then across the Arctic to Frobisher Bay or elsewhere on Baffin Island, and then back on one swing." Travelling conditions were rough. The court party sometimes flew over Hudson Bay in a single-engine plane, although such flights were, with reason, discouraged.

Sissons appears to have taken some pains to be known as "crusty" and "cantankerous," but Mark de Weerdt pointed out in the *Yellowknifer* that those who travelled with him and worked in court with him knew him differently. "To us he was invariably courteous and kind … His combative side, while it sometimes showed in court, was displayed mainly in his correspondence with Ottawa officialdom and in the press. It made better copy."[15] Bob Engel, who founded the pioneering Northwest Territorial Airlines (later the NWT Air Canada Connector) and flew Sissons for years, says that the judge "felt his position required a certain decorum and he was not inclined to come down from the bench." Nevertheless, according to Engel, he also exhibited constant "flexibility, camaraderie and adaptability." Engel recalls a particular flight to Hay River: "It called for an early-morning departure and it was extremely cold. I was having trouble with the aircraft and I had to tell the judge there would be a delay while I corrected the problem. I was a young fellow who had invested his last dollars in his airline and I heard the clerk of the court say, 'I'll try to make arrangements for another aircraft.' Mr Justice Sissons said, 'We will not change horses in the middle of the stream. We will fly with Mr Engel when the problem is corrected.'"

Engel also recalls a rough flight: "We were flying circuit to the eastern Arctic and I was informed the weather was unfavourable at Baker Lake. I told the judge if the weather goes down we might have to spend the night

on the barrens. He said, 'We'll proceed.' The weather went down; it became traumatic – virtually boiling – so I lined up around the edge of a lake and carried out a precautionary landing on instruments. Ev Tingley said, 'My God, we've landed.' I said, 'Yes, we've landed, and were going to spend the night. Let's put the sleeping bags against the wall and make ourselves as comfortable as possible.' I always carried a good food package. Not emergency supplies but a good snack package … cheese and so on, and I passed this around. The judge produced two bottles of Canadian VO. That was his survival ration. He said, 'I believe this calls for a round.'

"The lake on which we landed is now called Sissons Lake. Mr Justice Morrow had a cairn put up there to commemorate the first and only time the circuit court went down in weather."

Sissons' physical courage was respected. "He had a modest physical handicap: he walked with a cane – he never complained," Bob Engel remembers. Lawyer David Searle, a frequent Crown counsel during Sissons' battle to protect aboriginal hunting rights, recalls that the judge did not take kindly to well-meant assistance. "He came north late in life and he had braces on his legs. You can imagine what it was like travelling in arctic conditions. I remember him stepping out of an aircraft in the fall of the year. We were on floats and he stepped down on the floats and of course they were very slippery. He wore leather boots with holes in them for the braces and these leather boots slipped. He was just about to go into the river when I grabbed him. I was a young lawyer then in my twenties but he did not thank me. He turned round, shook my arm off, and said, 'If I want your help I'll ask for it.'"

In those pioneering days a certain MASH quality went with the territory. William Morrow reportedly travelled with a case of rye and a pistol, and former HBC hand Bill Munro, now of Tees, Alberta, remembers how in his clerking days there was keen anticipation when Sissons was scheduled to fly into Baker Lake: "Yellowknife was a good source of overproof rum and Judge Sissons always brought a case of rum." The court slept where it had

to, sometimes on an HBC fur trader's floor. On one occasion Munro went over to the post late in the evening and found the entire court party asleep on the floor. "One of the bodies I stepped over was Judge Sissons. Sandy Lunan [the post manager] used to like to say, 'You can sleep on the floor and this is your space.' There was Judge Sissons, asleep on the floor."

When the court arrived at its destination, proceedings might be held in a Quonset hut, a fire hall, or a school. "We used to sit on children's chairs. Only the judge got a proper chair," remembers Rosalee Hobbs, a court reporter who travelled with the Morrow court.

In court Sissons was a stickler for form. He insisted on suitable ritual. The flag flew outside every make-do courtroom, and the coat of arms of Canada hung inside along with a NO SMOKING sign in four languages. Lawyers were gowned (although they sometimes wore parkas as well as their court clothes). "We always had to carry the court clothes with us and getting into them was quite something," says Elizabeth Hagel Bolton.

How was the court received? Bob Pilot, investigating officer in *R v. Amak, Avinga, and Nangmalik*, held in 1963 in the remote eastern Arctic community of Igloolik, says that at the time of that case Inuit from out on the land were in awe: "It was the first contact they had had with a police court and a judge. People were very reluctant to come into the schoolhouse. They watched through the windows. Those who had more contact with white people came into the court." But Sissons encouraged observers. He wanted to make Inuit aware that the court was their court, there to serve them. Inuit called Sissons "Ekoktoegee" (the one who listens). "He had a nice way of finding out what he had to," says Bob Pilot.

Red Pedersen of Coppermine, a former speaker of the Legislative Assembly, says, "I don't think the court caused much turmoil among the people at the time. In those days the Inuit were compliant – submissive to the white man's suggestions. And in the Inuit there is a strong sense of justice – if a person committed a crime, he deserved punishment. They never questioned the right to sentence." But Pedersen says there may have been mystification.

"If there was puzzlement, it was because a trial took place at all. With regard to the case *R. v. Shooyook and Aiyoot*, people around there [Spence Bay] felt that the right decision had already been taken. The people accused had not committed a murder – they had carried out a sentence [in the traditional manner]."

Ideally a bilingual Inuk interpreted for the accused, while lawyers retained by the Crown and the accused, but paid for by the minister of justice ($25 per day, $75 for a murder trial), argued the case for the prosecution and the defence. Early circuits, however, were hampered by the shortage of adequate interpreters and also of defence lawyers. This latter problem (many early cases were tried without the accused being represented) was partially rectified in 1960 when the Edmonton lawyer William Morrow was appointed to fly on circuit (he made half a dozen such circuits before his appointment as Sissons' successor) and act as defence counsel for anyone who might need his services. But the shortage of expert interpreters persisted, and the demands of the court put great pressure on those who were available. David Audlakiak of Iqaluit, a superb interpreter who worked for the court, admits to frequent "burnout."

In small communities the lack of interpreters sometimes meant that unqualified people were pressed into service. (On one early circuit stop a bilingual accused in one case interpreted for a unilingual accused in another.) Interpreters often interpreted for relatives and faced uncomfortable pressures. For important cases, however, the court could usually field amazingly skilled interpreters. Despite their value to the proceedings, these interpreters were customarily paid the minimum wage. After the preliminary inquiry in *R. v. Ayalik*, Crown counsel Mark de Weerdt wrote persuasively to D. H.W. Henry of the Criminal Law Section of the Department of Justice urging a review of interpreters' fees. "A good court interpreter is rare and his work calls for skills of a high order, not to mention certain qualities of good character and an unblemished reputation. His, in effect, is the voice of the court as well as that of the witnesses and counsel, to speakers of the

other language … I might add that the interpreters used at the preliminary hearing in this case have regular employment at rates of not less than $1.65 an hour. If they are to consent to act in the proceedings, it would seem that they should be paid at least what they would have otherwise earned."[16]

Judgment certainly called for the wisdom of Solomon. Widely different social conditions existed throughout the NWT. Down the Mackenzie, communities might be urban, developed, and sophisticated; in Arctic areas, traditional practices were still commonplace. Missionaries had been active in the Canadian Arctic since before the turn of the century, but Christianity and shamanism continued to mingle and co-exist. Good and bad shamans still exercised their powers. "I prosecuted several wicked witch doctors," a former Crown prosecutor remarked. Mr Justice Mark de Weerdt recalls acting as defence counsel for a man whose mother had "a handshake like a working man. This little person was without doubt a very powerful personality and I quite believe she was a witch doctor. Everyone was scared stiff of her. She was sitting in the preliminary inquiry and Orvil Troy [Crown prosecutor] complained to the presiding judge, Peter Parker, 'Your Worship, this woman is putting a hex on the witnesses. I ask that she be directed to leave.' I got up and said, 'Surely this man is entitled to have his *mother* here? Surely we are not going to exclude *her*?' We agreed we would use a screen and that she could sit behind the screen where the witnesses would not see her. A year later the Parliament of Canada very smoothly announced that screens could be used in court. Some time ago young lawyers were complaining that this was against the constitution. I said, 'I'll be interested to hear your arguments but I should tell you we have some precedents in the courts of the NWT.'"

Sissons rendered decisions in cases of assisted suicide, infanticide, and community-sanctioned execution. The court faced a daunting challenge in applying southern law, and Sissons was determined, as Mr Justice Morrow put it, "to prevent the words of the law books being allowed to oppress or cause undue hardship."[17] If this meant bending the law, he bent it. He took frequent recourse to English common law, held jury trials, availed himself

of discretion in sentencing, and rarely accepted guilty pleas. Experience had shown him that Inuit had difficulty with the concept of moral and legal guilt – Inuit had no corresponding word in their language for "guilty." In *Re Noah's Estate* and *Re Katie's Adoption*, he made changes to the law so as to recognize aboriginal rights. He attempted to achieve the same in wildlife cases, but his judgments were overturned. But Sissons' instincts proved right. "He's shining forth today as a fighter for native rights," remarks one observer of the court.

David Searle, who frequently acted for the Crown, believes that Sissons' polio handicap caused him to associate emotionally with the disadvantaged. Sissons had told him more than once that as a boy he couldn't run fast enough with his lame legs to catch up with childhood mimics and taunters. "He said, 'I'd just wait until they came by and then trip them with my cane.' He associated with anyone who was an underdog, and he saw the native people as underdogs and himself as their champion."

Old habits die hard. At the height of one of his most heated battles with bureaucrats, Sissons made metaphorical use of a particularly elegant bone cane he had commissioned from the Inuit of Pond Inlet. En route to meetings, presumably with adversaries in Ottawa, he told *Time* magazine, "I'll cut them off at the knees with this."[18] On reflection he acknowledged, "I often hit too hard but I was never to get away from fighting."[19]

Sissons retired in July 1966 at the age of seventy-four. His successor, of course, was forty-nine-year-old William G. Morrow of Edmonton, already well known to the North because of his half-dozen circuits as defence lawyer. Morrow, who helped start legal aid in Alberta, had initially undertaken the circuits because of his interest in the land and the people – his fees reportedly worked out at $10 a case. He hesitated before accepting the appointment; it is said he was approached twice. He feared the disruption of the move for his wife and four children and the isolation the position of judge would impose. "'Call me Bill,' he said when he took up the post, but that changed," a colleague remembers.

Morrow shared Sissons' commitment to native rights and his belief that the law must be flexible to be fair. He had been the gold medalist of his class and was more of a legal master of the law than Sissons. He had appeared as a lawyer before the Supreme Court of Canada on ten leave applications and twenty-one appeals, and he took a case "to the foot of the throne," the last case heard on appeal from Canada before the British Privy Council. On this latter occasion, as one of the more famous anecdotes told of him goes, he arrived in London during a sweltering heatwave and when counsel in court were offered the chance to doff their headgear, he initially declined, saying he hadn't come all the way from Alberta to be cheated out of the opportunity to wear a wig.

As judge, Morrow set a driving pace. "He had the energy to go, go, go. He'd never slow down," recalls Chief Judge Robert Halifax of the Territorial Court, who as a young lawyer had travelled with Morrow and considered him a mentor. "With Morrow there was always great pressure to get on to the next case. There were a few occasions when the lawyers got together and said, 'Look, sir, we just can't do this.' He'd back off for a couple of weeks, and then he'd be back to his old self."

Like Sissons, Morrow found he often had to battle to preserve the independence and status of his court. On this topic authors Jan Alexander Smith and Sherrilynn J. Kelly wrote, "The distinction between legislative, executive and judicial powers was less marked [in the North] than in other parts of the country. Justice Morrow was in very close contact with both the agencies of government and the people it served. Some government people in those days perceived the judge as just another civil servant 'who should be kept in his place.'"[20]

But Sissons had broken the trail, as Morrow was quick to acknowledge. The establishment of the circuit courts, Morrow wrote, "took a great deal of determination and courage. It came only after many fights with 'higher authority,' at great personal inconvenience and discomfort to the Judge, and not without considerable danger and risk. But the 'new Judge' eventually

triumphed, with the result that by the time of his retirement, the itinerant way of Justice and 'his brand' of Justice had become accepted and is now accepted by all."[21]

MODERN TIMES

As the century draws to a close and brings Nunavut close to reality, Sissons' "brand of justice" may see some revision.

Since the era of the Sissons and Morrow courts, the North has become a different place. Once administered by southern bureaucrats, the Northwest Territories now has a fully responsible government. In 1995 nineteen of twenty-four legislators were native born. It is a complex mix of people who come before the courts today. In Sissons' and Morrow's time, with very few exceptions, says Mr Justice Mark de Weerdt, "if you were Eskimo or Indian, you would be a certain kind of person, you would be living out on the land, probably you would have never gone to school. Now it's quite different. You've got a spectrum of people, some still pretty close to that profile, others who are pilots of airplanes, deputy ministers of government."

The structure of government evolved rapidly after 1967 when the federal government moved to give more autonomy to the NWT. In that year government for the Territories moved physically from Ottawa to Yellowknife. Says former minister of justice Michael Ballantyne, whose own parents came north with the move, "Essentially three planes of bureaucrats and all their paraphernalia arrived over a couple of days in Yellowknife – there's still one person who works for the government who came on the first plane."

By 1970 there was a territorial government of significant power in place and a territorial council that within a few years would become a fully elected government. The NWT now had control of the administration of justice, although the office of attorney general remained in Ottawa. There was a push, too, to develop self-government at the community level. Today the isolated Arctic settlements are communities with local infrastructure and

modern amenities – modern housing, modern schools, runways, and sched-
uled air service. Justice still flies in but now it flies the "skeds"; and it arrives
(as demonstrated in the *R. v. Niviaqsi Laisa* case) accompanied by skilled
interpreters and paralegals.

To meet the new realities the court system has evolved and grown. Inuit
as well as whites now serve as justices of the peace, initiating procedures that
send cases through the court system and handling minor offences. There are
now three Supreme Court justices and five territorial judges. And where
there were only two lawyers in the entire NWT when Mr Justice de Weerdt
went to Yellowknife, there are now, as the result of the rush of development
in the North, over one hundred, with several law firms located above the
Arctic Circle and lawyers in eight or ten communities (Desmond Brice-
Bennett in Pond Inlet, at the top of Baffin Island, with the most northerly
law firm in the country, is Canada's "top lawyer"). Legal aid has been insti-
tutionalized, and though some areas lag behind, on Baffin Island, the Iqaluit
centre for legal services, Maliiganik Tukisiiniakvik (the place where you
come to find out what laws mean), a 1970s initiative of the Inuit Tapirisat
of Canada (ITC), can boast a team of eminently qualified Inuit paralegals
who assist Inuit before the courts in their own language.

In 1988 the NWT government took a major step forward when it legislated
the creation of a legal interpreters' training program. The program has dra-
matically increased the pool of high-quality interpreters who serve both the
legislature and the courts and who assist in the commerce of contemporary
life.

But while modern times have brought modern ways, they have also
brought modern problems – drugs, alcoholism, and high unemployment.
On Baffin Island violent crime is a shocking six times the national average
according to a five-year study (*Crime, Law and Justice in the Baffin Region,
NWT, Canada*) conducted by criminologist Curt Griffiths of Simon Fraser
University.

Comparing early court circuits to those of the present day, Mr Justice de Weerdt says, "In the old days, it was physically difficult because just getting around was risky, and we didn't have twin-engine airplanes, for example; we went around in single-engine aircraft and there wasn't always a place to stay and so on and so forth. So it was adventuresome, it was occasionally dangerous, altogether delightful in many ways, even when there was a lot of hardship. Today all that physical side has become quite routine. On the other hand, today we have a much more complex cultural situation. We have a great deal more crime, we have a lot of violence, we have a lot of impact from alcohol. The people of the Arctic today are troubled by a great deal of social conflict that wasn't there before."

As the years of transition for the Inuit come to a close, residents of the mushroom-growth communities of the NWT worry about endemic violence and crime, so often alcohol and drug related, and what appears to be the emergence of a new underclass in their midst – young repeat offenders, constantly before the courts. This has led to some outspoken criticism of the justice system. Some say sentences are too lenient – "That's the perception across the North," says Sandy Kusugak of Rankin Inlet. This is disputed by Mr Justice de Weerdt: "Certain sectors of the public have been very vocal on that subject, and one may suspect they are reflecting what occurred twenty and thirty years ago. If you examine the record today, I think you will find that sentences in northern Canada are not so different in terms of sentence length from those elsewhere. And our judges no longer say, as some of my predecessors did, 'Because you are an Eskimo, I am going to do this and that. If you had been a white man, I would have done something else.' We no longer say that – ever."

But many question the effectiveness of the current penalties as deterrents. "They are so irrelevant," says Sandy Kusugak. "There ought to be some restitution, replacement, repair of property damage." She believes most offenders tend to be drop-outs – young males between fifteen and twenty-five who

do not speak much English or even Inuktitut well and who have not completed their schooling or taken job training. "That's a likely group. Of course, I do not know what they really think, but people tend to think they look on a jail sentence like a badge. It's a meritorious thing – a way to get away from home, to get some excitement." The Baffin Correctional Centre in Iqaluit is widely written off as a failure because it has no effective treatment programs. At a forum on the justice system held in Iqaluit in September 1995 to mark Maliiganik Tukisiiniakvik's twentieth anniversary, Pond Inlet elder Elisapee Ootoova said that she had once thought that the Baffin Correctional Centre – called "Ikajuqtauvik" (the place to get help) – would provide real help to inmates. Now she no longer does. "I hear they use drugs at the correctional centre."[22]

In an editorial in *Nunatsiaq News*, the eastern Arctic's widely read weekly, consulting editor Jim Bell wrote,

While it is probably true that sentences in the Baffin are not nearly as lenient as many people believe, it is most certainly true that those sentences are woefully ineffective in changing the behaviour of offenders.

No wonder. Seriously disturbed sex offenders and wife-batterers who spend their time in jail playing pool, sneaking hash into their cells and going for the odd snowmobile trip on the land aren't likely to change very much, no matter how much time they spend in jail.[23]

A southern observer may feel that compared to the situation in the south, northerners have unparalleled access to the courts, but in small Arctic communities, this is not necessarily the way it seems. One informant says, "There are people who say it [the court system] is here to help and there are those who say they could better deal with [offenders] themselves. When the court takes forever to get to town – it comes only so often – during the delay the offender is still living in the community and nothing has been done about it. When the court date comes around, it seems as though the

victim is victimized again by having had to wait so long. The offender has the choice of being tried by JP, judge, or jury, and some offenders know the courts so well they can delay and delay. It seems the offender picks and chooses."

NEW APPROACHES

While some people demand tougher sentences, more RCMP services, and the speedier removal of vicious offenders, others say that blaming, punishing, and sending people to prison is not the aboriginal way. Explaining government policy in 1991 Michael Ballantyne, then Speaker of the Legislative Assembly and minister of justice, says, "We're at a crossroads. Some northerners favour a separate justice system for native people, while others prefer evolution of the current system. What we're trying to do, rather than decide at this point whether we should have a separate system, is work towards a more community-based system."

Over several years the NWT Department of Justice has taken steps in this direction. The amendment to the NWT Jury Act, which allows unilingual people to serve on juries, has resulted in a great increase in jury trials as well as more community involvement (in some small communities the jury pools that are called when the court comes to town include virtually all residents over the age of eighteen). Unilingual juries necessitate completely bilingual trials and pose many challenges for interpreters and the court. Such trials can show the modern court at its impressive best. Furthermore, Territorial Court judges and JPS now frequently have elders sit with them, and consider their advice when sentencing.

Chief Judge Robert Halifax of the Territorial Court has followed the progress of unilingual jury trials carefully. He says, "One of the important advances we've made here – I've been here since 1972 – was really making an effort with the legal interpreting program. Unilingual jurors are now provided for in the Jury Act [there are eleven official languages in the NWT],

so if you had a case in the Delta you could well end up with a juror who speaks only English, somebody who speaks Inuvialuit, somebody who speaks Loucheux because of the mix in the region. It's a very, very difficult thing for interpreters."

When Halifax travelled as a young lawyer with Morrow, he often heard Morrow talk about "social decisions." "'It was a social decision made by a jury,' he'd say. I used to have a little trouble with social decisions – social decisions being made rather than legal decisions. If you won the case, you didn't mind the comments so much, I guess." Halifax sees a lot of social decisions from today's unilingual juries, perhaps particularly in cases of sexual abuse. Where a defendant faces charges of sexual abuse, it has been noted that in a high proportion of cases juries in the NWT acquit. "Unfortunately, there has been a lot of abuse," he says. "People [on juries] say, 'What's the big complaint? That's nothing to what I went through. Sure he's guilty but the punishment is too much.' They consider the punishment rather than whether he's guilty or innocent. Also, for aboriginal people dealing with problems, the objective appears to have been to heal the victim, the accused, and the community as quickly as possible because it was important not to have conflict when living a survival-type existence. Some of those old hangover values are still in existence today and have an effect on how we deal with these things."

The NWT Department of Justice hopes for significant further community involvement through its Community Justice Initiatives program, supported and developed in the 1990s through the terms of successive deputy ministers. "Everyone – some more reluctantly than others – has come to the conclusion that the way we do things isn't providing a long-term solution. Never before has there been such consensus on the part of police, the Crown, judiciary, and defence lawyers," says Donald Cooper, deputy justice minister in 1997. "Locking up people isn't the solution but neither is letting them walk away. Our emphasis now is to see if the communities can work

with individuals in trouble with the law, preventing them from coming into the criminal justice system in a formal manner, giving them some insight into how their behaviour is disrupting their community."

Don Avison, principal secretary to the NWT premier in 1997, was deputy minister of justice from June 1994 to March 1996. He says, "We have a disproportionately high rate of crime as compared with the national average, and the reality is the system needs to make some changes. A couple of years ago we dedicated a significant amount of resources and now have about eight people deployed through the NWT who have been given a lot of latitude to work with communities to develop alternatives to the mainstream or conventional justice systems. The majority are native people and speak languages indigenous to the areas where they are working. Because of the cultural diversity, what might work well in the Inuit community of Pond Inlet may not be what you see in Rae-Edso."

Avison hopes for a much greater degree of community responsibility for incidents where the police have had to intervene. "I think there is a broad range of matters where you don't require the involvement of the Crown. What we are seeing is the development of a significant relationship between the RCMP as the intervening agency that deals with crime and community members prepared to handle certain cases at the community level." Well-composed diversion committees for which the criminal code now provides, he believes, can focus continued attention on the problems of offenders, see that the victims are compensated, and promote community healing. He admits that ambivalence about the approach exists but says, "There are some communities so wracked by violence that the question should be put, can they afford not to invest the time and energy to ensure that they've got safe homes?"

Deputy Minister of Justice Cooper says that across the Territories there are now thirty-three community justice committees. He accepts that the current aboriginal justice concept may be more slanted to the Dene culture, but

he expects that Inuit who are planning for Nunavut will come up with their own community justice proposals. He, too, admits that sceptics can be found.

Iqaluit town councillor Kenn Harper says, "Murder, sexual assault, incest are no joke; drug trafficking is no joke. Many people are upset about the light sentences. I think they're very happy to see these guys taken out of the community and given stiffer sentences." But he agrees that current practices are not working. "Our jails are full; incarceration is seven times the national average." He concedes that "the mechanics for delivery" of justice might usefully be more "community sensitive."

Cooper says, "We've got to start with cases that are non-violent; if people see success with this category, they may be willing to consider more difficult waters."

Chief Judge Robert Halifax is closely involved with all community-based justice initiatives. With regard to the adult diversion programs, he says, "So far, the senior RCMP members are very committed to the diversion program. One of the difficulties, of course, is fetching that down to the detachment level, where you can have a case officer from a background of 'You catch a guy, you charge him.'"

Many of the cases that make their way to court are what are known in the North as "pop and chips" – minor break and enters. According to Halifax, "One of the big challenges for the RCMP at this stage is to get members really looking at whether it is necessary to lay charges. They're the front-end people." At one detachment recently, Halifax recalls, a corporal and two constables, working to accommodate the new community justice practices, got an offender who had broken a window to pay for it, repair it, and apologize to the victim, making everybody happy.

As a judge, Halifax is bound to follow the law, but whenever possible, he says, "I try to design sentences in such a way that they respond to cultural backgrounds and differences. For example, if someone has committed an offence in an area where there is fishing, instead of sending the offender to

jail, I might order him to provide so many pounds of fish and distribute this to the community."

Criminologist Curt Griffiths is cautious in his assessment. He says that while the idea of community-based justice has now become politically correct, it may not be the answer to all problems: "The downside to community justice is that every community has a power hierarchy. It doesn't matter if the community is up there [the North] or down here [southern Canada], every community has its leading families." In the North as elsewhere, the members of these families tend to gravitate to top positions. In some communities women have complained that powerful male leaders get away with abuse because people are afraid to report them. Pauktuutit, the organization that represents Inuit women in Canada, commented editorially in the fall/ winter 1995 issue of its newsletter, *Suvaguuq*: "Pauktuutit is concerned about the acceleration of the devolution of responsibility for justice issues."

Madeleine Qumuatuq is on the organizing committee of Iqaluit's Inuit Advocates, a group set up to help victims who "fall through the cracks." She says, "Women did have rights in the old days. They were equal. Everybody had a role for survival, but [the women] were taken by men for their own pleasure. Up till today some men think women should be in their power. That was an accepted attitude in olden days. Sometimes I'm told because I'm a woman I shouldn't speak out. But someone has to."

These are still early days for community-based justice, court observers agree. Halifax says, "It is not for me to say to communities, 'This is the kind of program you should have in your community.' I've seen so many programs over the years created by southerners that were not successful because they were not created by the community."

The Community Justice Initiatives program has its successes. One is its youth justice system, which has broken new ground in some communities. If deemed appropriate, the Crown counsel may refer a case to the Youth

Justice Committee, which aims to keep young offenders out of jail, to give them a second chance. The committee entails a high level of commitment, which not all communities are ready to provide.

Julia Ogina served for a time as chair of the Holman Island Youth Justice Committee. She says, "Basically we give [offenders] hours of community service work, work with the housing maintenance guys or crew. But they don't get paid. They have to fill up those hours. Or it may be work at the Co-op or with the hamlet or with the elders. It might be going into the elders' houses and cleaning, doing things for them. Or cleaning up the community. Whatever job we can shape or find. One other thing I also feel is most beneficial is to have [offenders] write an essay – about what they did and how they felt. I keep these in their files. The group feels that through these tasks the youth apologizes not only to us but to his parents and also to the victim in both verbal and written form."

Ogina doesn't think there were repeat offenders during the time she served on the committee.

A promising correction program is run by Elijah Erkloo of Pond Inlet. Under a contract he has with the NWT Department of Justice, he takes young offenders out hunting and teaches them survival skills. He usually has a party of three boys under eighteen, and they may stay with him for three months, a year, or – as once happened – eighteen months. They come from anywhere in the NWT. "We've even had them from the West," he says. Why are there so many young offenders? "They're not criminals as such – just confused kids. Their parents lived out on the land and then came into the settlement. The camp leader became the garbage collector. Everything is upside down for their parents." Ideally Erkloo would like to stay out on the land with his charges for an entire season, but he usually comes in after a month or so "to write a report, or something." He believes that the land experience builds independence. How successful is the program? Do the boys go on to become repeat offenders? "Some do, some don't," he says. "If I can save just one boy, I feel the program is a success."

What does Elijah Erkloo think of the concept of community justice? "I support it 100 per cent, but I might not call it that – in my mind it is social development." He believes Nunavut will rebuild Inuit pride. "Already we are saying, 'Let's do something for ourselves.'"

In preparation for Nunavut, the Inuit Tapirisat of Canada has committed itself to a review of the operation of the Canadian justice system in the North. A group of people directly involved in the northern justice system – both Inuit and non-Inuit – are to spend up to five years working out a plan for reforms.

While the idea of a separate justice system for aboriginal people still has some following, support may be dwindling. Harald Finkler, director of the Circumpolar Liaison Directorate at Indian and Northern Affairs and an early observer of the justice system, says, "After initial interest it was realized that the idea of a separate justice system had not much going for it in today's circumstances but there are some things Nunavut may want to take a look at. They may not want to be locked into mandatory sentences under our code – they may have a feeling that they need more room to consider what measures are most appropriate to the unique circumstances of northern communities." This may mean experimenting with methods that are tailored to restore harmony and reduce the likelihood of repeat offences.

Bob Pilot says, "Any northern justice system has to be part of the Canadian justice system – but why shouldn't Nunavut have the powers of the provinces? Why shouldn't they have their own police force; why shouldn't they pass their own by-laws, have their own ordinances? They may be different from those we have in Pembroke but they may be just as effective."

LOOKING AHEAD

On several visits to Iqaluit on Baffin Island I meet and talk to court workers attached to Maliiganik Tukisiiniakvik, among them Timothy Sangoya, Enook Petaulassie, Oolipika Ikidluak, Susan Enuaraq, and Frances Piugatuk.

Maliiganik Tukisiiniakvik would like to have court workers in all communities, but for the moment that is not possible. Even so, the talent pool in Iqaluit is impressive, and it is not surprising that territorial judge Beverley Browne has tried to find ways of providing some legal training on Baffin Island so that Inuit students may contemplate careers as fullfledged lawyers.

Frances Piugatuk admits to ambitions in that direction. Piugatuk, who regularly represents clients in court, started out as a court worker in Igloolik. "I had a weekend workshop," he says, "and a co-ordinator came along to the community and taught me the basic job. When I started, I assisted the lawyers, just basically interpreting, and from the lawyers learned how to do quite a good job." At his own expense he took the initial legal interpreting course given in the legal interpreters' training program in Iqaluit. "I did that on my own because I wanted to learn more about the law and I was not getting that as a court worker. In 1992 lawyers here in Iqaluit told me there was a job vacant and asked if I'd be interested and I accepted."

Frances Piugatuk is a namesake and relative of Qulitalik, whose assisted suicide was the issue in *R. v. Amak, Avinga, and Nangmalik*. The accused pleaded guilty, but Piugatuk believes justice miscarried in this case. "To us Inuit, Amak, Avinga, and Nangmalik had not committed an offence," he says with some passion. "They might not have been convicted at all if we knew then what we know now. Maybe they had no interpreter to tell them what was really happening. Maybe they could have been acquitted if they had been well represented."

Undoubtedly the next decade will see Inuit lawyers, perhaps Frances Piugatuk among them. But cases like *R. v. Amak, Avinga, and Nangmalik* are not likely to come before the bench. Changing lifestyles and old age pensions, family allowances, and welfare have removed the imperatives for practices that were the custom for millennia.

When I ask Frances Piugatuk if he thinks there should be a separate justice system for the Inuit, he says, "That's never going to become a reality. Because the crimes the Inuit people commit are the same as the crimes

white people commit. The Inuit system is usually rehabilitation if possible. We have a system of justice in place and what we have to do is make the present system work to our advantage. Hopefully there will be Inuit lawyers in the future and maybe we can have a hand in making the system a little bit more flexible."

There may well be changes ahead, but this would come as no surprise to Mr Justice Sissons, who died in 1969. He was, of course, the NWT justice system's most constant critic. "I was not satisfied and was never to be satisfied with the administration of justice in the NWT," he wrote in *Judge of the Far North*.[24] In light of history, it seems that the northern courts of the future will continue along past lines, always evolving in response to northern needs.

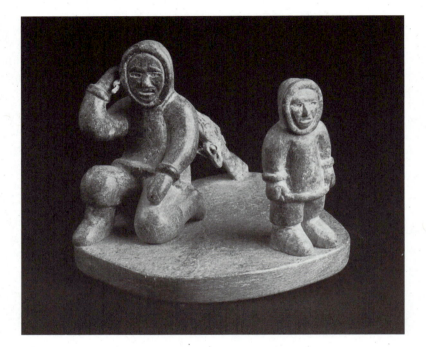

R. v. Kaotak
Agnes Topiak, c. 1905–79
Kugluktuk (Coppermine), NWT
Stone, hide
13 × 12.5 × 10 cm

1956

Regina v. Kaotak

Mr Justice J.H. Sissons began collecting Inuit carvings shortly after he tried his first case in the Northwest Territories. His first carving was sent to him by Kaotak, the accused in *R. v. Kaotak*, and seems to have been a surprise. In the sculpture the judge, a mighty figure dressed in an Inuit parka and holding a book of laws, is seated at a bench. Before him stands the small lonely figure of the accused.

Elizabeth Hagel Bolton says, "The first one – *Kaotak* – was simply presented to him and he liked it so much, and liked the idea so much, that he commissioned the others. He had them done for him. He was absolutely delighted and conceived the idea that he'd have all his cases memorialized that way. That's what he told me. He had them in his office in a display case, and if I happened to come up there, he'd have to show me a new one and tell me all about it."

There are actually two sculptures depicting *R. v. Kaotak*. The second, which shows how the gun was rigged up and held so that Kaotak's father could shoot himself, was acquired sometime later. It is the work of Agnes Topiak of Coppermine, who is credited with carving a number of Sissons' pieces.

The Yellowknife Courthouse Collection of Inuit Sculpture was one of the consequences of *R. v. Kaotak*. There were others.

The accused, Allan Kaotak, had been awaiting trial in the custody of the RCMP for six months when Sissons arrived in Yellowknife on 15 October 1955 to take up his duties. Kaotak had been charged with the murder of his father on the sea ice of Queen Maud Gulf on or about 25 April, a date "when neither he nor I could have dreamed that we would be in Yellowknife that year, facing each other across a judicial desk," Sissons wrote in his book *Judge of the Far North*.[1]

At issue in the case was whether Kaotak had murdered his father or had helped him commit suicide. In traditional Inuit camp life, old people who were ill or who felt they had lived their allotted span and would become a burden on their nomadic community sometimes chose to end their lives by suicide, perhaps demanding the help of their relatives. "Such cases were common in those days," notes Jean Belec, the officer who commanded the RCMP's Fort Smith subdivision from 1954 to 1957. "What we would call murder was just considered custom."

The RCMP had heard of the death of Kaotak's father, Kitigitok, from a missionary. The father and son, along with others, had been seal hunting far out on the ice. The two had left the main camp to return to a spot near the shore for meat they had cached. Kaotak subsequently reappeared at the seal hunting camp alone, saying his father was dead. When the RCMP came to interview him, Kaotak took the investigating officer to his father's body, which he had covered with a caribou skin. Beside the body was a gun with a cord attached. His father had killed himself by pulling the cord, Kaotak told the police.

There was a suggestion that Kaotak had been on bad terms with his father as a result of his estrangement from the wife Kitigitok had picked out for him, and Kaotak was arrested and charged with murder. "But the boy said no, his father had told him to do it," Red Pedersen of Coppermine recalls.

In this first case Sissons came face to face with what Inuit today call "the old way." Its tough imperatives and mores would often clash with accepted southern values. In Sissons' years in the North, both assisted suicide and infanticide would come before his court. The hard nomadic life had made infanticide (and also adoption) a regular practice. (The Lake Harbour hunter Kowjakuluk sometimes used to explain how the most fortunate moment of life for him had been at his birth, when his twin was "turned down." A mother could not carry two children in the amautik.) In his book *The Government of Canada and the Inuit, 1900–1967*, Richard Diubaldo described the steps taken in the 1920s to discourage infanticide: "Rather than

attempting to track down and prosecute the perpetrators of infanticide, the police began in 1921 to issue what they termed 'baby bounties' to Inuit of the Coronation Gulf District. The object, of course, was to discourage the practice of infanticide by inducing the Inuit to keep and bring up any children under the age of five. These humanitarian bribes – more correctly, inducements – included the issue of thread, needles, tobacco, pipes, ammunition, clasp knives, saucepans, kettles, calico, woolen stockings and socks." The baby bounties were heavy and difficult to distribute, however, necessitating special patrols, and they were discontinued in 1926, when "the police, obviously throwing up their hands, chose to ignore that infanticide was still prevalent – but it had gone underground."[2] A few years before, it had been "done openly," according to RCMP sergeant F.A. Barnes' report of 31 January 1926.

Sissons would try a number of infanticide cases, and he never left doubt that under the white man's law these were criminal acts, although in the Inuit culture "turning down" babies was countenanced. But discretionary sentencing powers allowed him to soften the bite of the law. He customarily delivered suspended sentences and said that transgressors now knew better.

Throughout his time in the North Sissons tried to learn all he could of Inuit culture. In preparation for *R. v. Kaotak* he began his own research, which continued after the trial, on suicide among the Inuit, contacting famous anthropologists and reading whatever studies on the subject he could find. "Although my studies were superficial they were helpful in understanding this case and others that came before the court in the next ten years, all from the same general area," he wrote.[3]

In former times suicide was fairly common among all Eskimos from Greenland to Alaska. The usual motives prompting it were suffering – mental or physical – and no longer being a useful and productive member of the group. The relatives usually did not wish the man to die and tried to dissuade him, but if he continued to ask for death they finally had to agree. If an assistant was required, it was usually the

wife, but the killing of aged and infirm parents by dutiful children was also evidently a common occurrence.

The means of self-destruction included stabbing with a knife or spear, shooting, strangulation, jumping off a cliff, drowning, exposure, and starvation.

Sissons found that suicide had "waned and almost disappeared" with the advent of the new era in the North. But he concluded, "The tendency is deep-rooted in the subconscious of the race, especially among older Eskimos who are more deeply imbued with legends and traditions from ancient times, which in the Arctic, were not long ago."

The question that would confront the jury, therefore, was, had Kitigitok committed suicide or had he been murdered?

Kaotak's trial took place on 15 December 1955 in the basement of the Elks' Lodge in Yellowknife. A courtroom was in the late stages of construction but was not yet ready, and apart from it, no courtroom existed in the NWT. Witnesses for the trial were flown in. (One was Angulalik, a native trader from Perry River whom Sissons would encounter again a little more than a year later as the accused in a murder trial. On that occasion he would also again meet the interpreter Sam Carter of Cambridge Bay who would die immediately after the verdict.)

But now Sissons' concerns were the circumstances of Kaotak's trial. It was taking place in Yellowknife, he considered, for the convenience of the court. The accused was on trial for his life far from his own territory while common law says an accused is entitled to trial where the offence is committed. And the jurors were white men, not a true jury of peers. As it turned out, however, it took the jury took only twenty minutes to find Kaotak not guilty on the evidence that suicide, often accomplished with the help of relatives, was a common practice in traditional Inuit life.

Soon afterwards Sissons set about making sure that R. v. Kaotak would be the last case to come before him in which "convenience" would determine the place of trial. On 3 April 1956, in a single-engine Otter, the court

embarked on its first circuit of the western Arctic, and on 26 July 1956 it began its first circuit of the eastern Arctic.

After his trial, Kaotak went back to his home territory and found work on the DEW line, but he had contracted TB while in jail and was finished as a full-time labourer. As so many did in those years, he took up carving to make money and was inspired to depict his own experience in court. His is the only sculpture in the Yellowknife Courthouse Collection of Inuit Sculpture carved by a defendant.

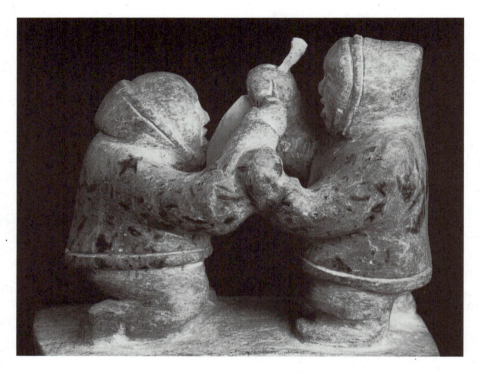

R. v. Angulalik or *R. v. Mingeriak*
Bob Ekalopialok, c. 1910–70s
Kugluktuk (Coppermine), NWT
Stone, bone
11.3 × 5 × 10 cm
Believed to depict *R. v. Angulalik*, this carving has also been thought to represent the murder of the child in *R. v. Mingeriak*.

1957

Regina v. Angulalik

Angulalik, a Copper Inuk of Perry River, was perhaps the first Inuit business tycoon. "A fascinating man of substance" is the way Sissons described him after he came before the judge on the charge of murder in Cambridge Bay in May 1957.[1] Angulalik cut an unusual figure among Inuit of the day; he was a successful independent trader who operated a trading post on Perry Island in Queen Maud Gulf (at one point he operated three licensed posts at various locations in the region), supplying goods to the camps in return for furs. He held the Queen's Coronation Medal in recognition of his "outstanding leadership" and "ability to acquire the new aptitudes needed to share in the work of modern Arctic Development." Amazingly, these aptitudes did not include reading and writing in either English or his native Inuktitut, but Angulalik successfully conducted his thriving enterprise nonetheless, with occasional help from a writing assistant. He also made use of a typewriter, on which he carefully copied trade names straight off the box, sending orders to HBC suppliers in Edmonton for, say, "5 cases Eddy Matches," "2 cases Klik Beef," and from time to time "10 Made in England," "24 Keep in Cool place," or "1 Doz Cheap Prices." Shippers had no trouble filling his orders, as they knew the boxes.

Like HBC personnel, Angulalik regularly undertook the extra tasks expected of the traders. "As the trader, Angulalik supplied the prizes for the community games on New Year's Day," explained Dr Robin McGrath, a specialist in the evolving field of Inuit literature, who knew Angulalik's family and has authored a biography and a number of papers about him.[2] "Shooting matches, tug-o-war, and races for all ages were traditionally held, and everybody who took part got some small prize. The games and prizes, which included needles, scissors, ammunition, and candy, ensured that anyone who could walk or sled into the post did so, and on the first day of each year Angulalik took the census, recording the names and disc numbers of all those present, noting who had died and the names and sex of the children who had been born in the camps. These records were handed on to the Mounties."

But on New Year's Day, 1957, in Perry River, "the mood was subdued. The previous night Angulalik had stabbed a man by the name of Otoetok." In a matter of hours Otoetok would die. Shortly afterwards Angulalik dictated a long letter in Inuktitut that included the words "I did it." He kept a carbon and dispatched two copies by dog-team to the RCMP and the Hudson's Bay Company post in Cambridge Bay, a two-day journey along the Arctic coast. Through bad luck and bad judgment, McGrath noted, tragedy had struck in a manner that no one who knew Angulalik could have imagined.

RCMP corporal Edward E. Jones, now of Nipawin, Saskatchewan, and Inuit special constable Jimmy Nahagaooloak travelled from Cambridge Bay to Perry River to charge Angulalik with murder. Corporal Jones had met Angulalik the summer before, when "he had come in on his boat to Cambridge Bay." He recalls that the accused had been generally "respected." When the officers arrived in Perry River, Angulalik "fully expected his arrest. There was no resistance. He was rather a proud individual, and after his arrest his son-in-law George Oakoak came along with us on his dog-team – I allowed it – and Angulalik drove with him. There were no problems." At the preliminary inquiry Angulalik was committed for trial by jury.

R. v. Angulalik can be described as the first major case to come before Mr Justice Sissons on the court circuits he had by then instituted. This murder trial attracted press attention across the county (QUEEN'S MEDAL ESKIMO CALLED KILLER, said a front-page headline in the Toronto *Telegram*),[3] and by holding it in Cambridge Bay, Sissons had succeeded, as he had vowed to do, in extending to the accused "the protection of the great principles of the British common law that the proper place for a trial is the place where the offense was committed; that every person accused of a serious offense should be tried by a jury from his own area." With respect to the latter principle, Angulalik may have been tried by a jury from his own area but the jury did not include Inuit, as Sissons believed it should have. The court would not find it an easy task at the best of times to obtain native jurors, since such jurors had to be bilingual. In *R. v. Angulalik*, according to Sissons, there was an additional problem:

There were qualified men of his race on the jury panel, and counsel for the accused and for the crown at first indicated they would accept Eskimos, but then Mr. Dunne [Frank Dunne of Edmonton] advised me that he had changed his mind. He told me he had found that Eskimos did not take a very serious view of a man using a knife instead of his fists. I agreed with this observation. An Eskimo's knife is very much a part of his ordinary life and is used at all times and for all purposes; on top of that he is very much averse to using his fists against a human being. I considered these the very best reasons for having Eskimos on the jury; they would understand how Angulalik regarded these matters. But the prosecution saw them as proving the opposite point of view, and stood aside all Eskimo jurors.[4]

Robin McGrath first heard the story of Angulalik and his fall from a pinnacle of power when she visited his wife, Ekvana, and her children in Cambridge Bay in the early 1980s. In the days of his youth, a time when multiple spouses were the rule, Angulalik had had two earlier wives. When he had wanted to become a Christian, he had refused to part with the second and younger wife, as the missionaries demanded. (He kept hidden away an oilcloth baptismal certificate received from a soft-hearted missionary who had christened him nevertheless.) When he was probably in his fifties, his two wives died within a year of each other. He then married Ekvana, who was about sixteen at the time, and together they had eleven children (Angulalik also had numerous adopted family members, including Red Pedersen, HBC trader and eventually speaker of the NWT Legislative Assembly.) Photographs exist of Angulalik and Ekvana in elegant Copper Eskimo costumes on their wedding day, an occasion when they both took the opportunity to be baptised, Angulalik for the second time.

Remembering her first meeting with Angulalik's family, Robin McGrath says, "We had tea and local foods and the interpreter explained I was a writer interested in Inuit who wrote things. Everyone rushed about and eventually they hauled out a clipboard that held many papers. Most were lists of trade goods that had been ordered and the daughters explained that their father had written these things. This was not exactly what I had in

mind but I went through them and in the middle was a letter to the police. A carbon copy. I asked what this was and the interpreter, a little embarrassed, said it is a letter about someone who killed someone. She added maybe they would let you borrow these and xerox them. I did this and then went camping in the company of Perry Island people who talked about [Angulalik] a lot and I got some idea of the man."

It was Captain C.T. Pedersen of the Canalaska Trading Corporation who set Angulalik up in business in 1928 as one of the rare aboriginal traders to work in the Canadian North, "launching him on a career unparalleled by others of his race," as the Toronto *Telegram* put it in its coverage of his arrest. C.T. Pedersen, a one-time whaler, used to cross into Canadian Arctic waters, his schooner laden with goods from Seattle and San Francisco, to trade with the Inuit on the Arctic coast. "Canadian authorities told him that he had to have a shore base and then that the operator had to be a Canadian citizen," explains McGrath. "The captain established Angulalik in business, and when he sold out to the HBC he made it a condition that the company assume responsibility for supplying Angulalik ... Angulalik made a ton of money. The one thing everybody said about him was that he loved doing business but he traded on Inuit terms – in a manner consistent with Inuit values. He'd charge a lot for needles, which were worth a lot to Inuit, but very little for other things. He brought in boats and sold them at a loss, virtually for nothing, because he knew this would increase trade ... He's one of the few clever illiterates I've ever heard of – virtually alone among all the other adult Inuit he could not read or write Inuktitut. I think he was dyslexic. But he could copy anything – and he could type.

Angulalik's business acumen paid off – he had a white man's house, a thirty-ton auxiliary schooner (the *Tudlik*), cameras and photographic equipment (his photographs are in the collections of the Prince of Wales Heritage Centre, Yellowknife), and the reputation of running his trading post as cannily as any HBC Scots factor. He was also flamboyant and something of a dandy. Captain Pedersen and his wife brought him clothes from

the outside – a leather bomber jacket, a French beret, and one time a leopard skin that he had made into a parka. By the 1950s Angulalik had made his name all across the Northwest Territories. He had also made enemies.

Robin McGrath wrote a reconstruction of the case:

Otoetok was a big man who loomed over Angulalik's five-foot frame: he had a reputation as a bully and a braggart. His two sons apparently took after him and had developed the habit of helping themselves on the sly to the contents of Angulalik's store. Like most Inuit, Angulalik was wont to frown upon such behaviour but tended to apply passive disapproval rather than overt punishment as a corrective. Whether such Inuit discipline was finally judged inadequate or whether Angulalik's storekeeper heart could no longer bear to see such an affront to his ledger books is unclear; what is certain is that he finally put a stop to it. An occasion came when one of the boys was confronted and forced to return the items he had stolen. Otoetok, who resented Angulalik's obvious prosperity, felt humiliated and angry over the incident, and from that moment on held a grudge against the trader. He frequently threatened him and told all and sundry that he intended to kill Angulalik at the first opportunity."

On New Year's Eve, just as people do everywhere, the Inuit who traded into Perry Island prepared to celebrate. They had come in from the camps for the games and races traditionally held on New Year's Day, and on New Year's Eve they gathered together at Norman Eevalik's small house, where a powerful concoction of home brew was on hand.

Alcohol has come to be the scourge of the North. By the 1950s, all over the Arctic home brew had long been a speciality. According to local lore, its manufacture in the Perry River area owed much to a man called Morris Pokiak who in the 1920s and 1930s used to come in and out of the region on the boats that traded along the Arctic coast. "Morris was Inuit – half Inuk, half black – so presumably his father was a whaler," says Robin McGrath. "He was famous as a mechanic. They claimed he could strip down

and reassemble an engine with a screwdriver and nothing more. But among local people he was also known as the man who introduced alcohol into the area. He showed them how to make home brew. He may even have built a still."

On this occasion Norman Eevalik's house was packed so full of revellers that it was difficult to follow the sequence of events. Wrote McGrath:

Perhaps it was the home-brew or the thought of Angulalik handing out the prizes the following day, as if he were a white man, but Otoetok judged that the opportunity had arrived … Otoetok threatened Angulalik, that much is known, and bullied and pushed him around the room …

The heat, the alcohol, the press of bodies in the tiny house, and the repeated threats of the bigger man caused Angulalik to suffer a fatal moment of panic. Taking a small knife from his belt, one he used for cutting food, he "poked" Otoetok to make him back off. The small blade seemed to do little damage, since Otoetok was wearing a bulky parka made of caribou fur, but it had the desired effect. Otoetok moved back and soon left the party.

[Otoetok did not go home but] spent the rest of the night visiting the igloos of those who had not been at Eevelik's. Angulalik's knife had caused a small cut on his forearm, not enough to cause him any discomfort, and it had pierced the skin of his abdomen, not deeply enough to do any internal damage but enough to slit both the outer and inner layers of skin. The wound was the source of considerable satisfaction to Otoetok: the imperturbable, smiling trader had stooped to violence and Otoetok had a fine, clean, one inch stab wound to show for it.

In the hours that followed, Otoetok visited half-a-dozen igloos and reportedly ate heartily of seal meat, washing it down with many cups of tea. He repeatedly told the story "of how Angulalik had 'poked' him, and he lifted up his parka to show the slit, now interestingly highlighted by a bulge of intestine," McGrath wrote. "As the doctor who testified at Angulalik's trial later pointed out, Otoetok would have been fine had he put a bit of

adhesive on the cut and gone to bed for a day. Unfortunately for all concerned, he did not do this."

On 4 January Otoetok died from a strangulated bowel. On 17 January the letters Angulalik had dispatched by dog-team arrived in Cambridge Bay, where George Washington Porter, half whaler and half Inuk and well known on the Arctic coast, eventually translated the Inuktitut text. Corporal Jones and Special Constable Nahagaooloak travelled to Perry River, were fed by Angulalik after their long journey, and took a statement from him on the death of Otoetok. This was interpreted by the special constable and written down by the RCMP corporal. Then they arrested him on the charge of murder.

During the trial the jury of white men heard witnesses describe the atmosphere at Norman Eevalik's New Year's Eve party and the quantity of home brew on hand – four pots – and they learned of the bad feeling between Angulalik and Otoetok. At the party the two men had been seen hitting each other, but onlookers had not realized that Otoetok had been hurt. One witness testified that in the morning Otoetok had shown him his wounds and that Agulalik had told him that he only had a small knife and did not think it had done any harm. Dr Frederick Fitch, who performed the autopsy, testified that elementary first aid could have saved Otoetok.

At the preliminary enquiry the letter of confession that Angulalik had sent to the RCMP and the HBC had been read into the record:

I say a few words to the police. I got scared of man and ran away from him. Since long he been go after me. How I get mad with him Otoetok. I don't want to kill him. I couldn't help it. With a knife. In a party and drinking. And I poked him. He got after me and I couldn't help it. People. Happy amongs them. Lots of people. Lots of them. They are fighting among them. He caught me and I poked him. In Norman's house. I was drunk. After that for myself when he died, when I got sober, I like to kill myself. I was thinking about my family. Got nobody to watch for them and nobody to keep them. I don't know that when he go after me. I got scared of him. I don't want to do anything bad for the people. He been

bothering me. He been go after me. Since a long time. He go after me and I got scared of him. I did it.

Robin McGrath points out that this translation does little justice to the verbal skills of a man who was fluent in several Inuit dialects. McGrath took the carbon copy of Angulalik's letter, which she had found on his clipboard, and had it retranslated by one of the able official government interpreters who serve the Legislative Assembly and the courts today. The pidgin English of the first translation illustrates one of the foremost difficulties that confronted the court throughout the Sissons era. In contrast, the second translation read:

I want to say a few things to the police. I was afraid and never thought of the consequences. For a long time Otoetok was after me; finally I got angry. I did not intend to kill him, but he kept after me and during a drinking party I poked him with a cutting knife because he kept bothering me. People were partying in Norman Eevalik's house; in the middle of all the people we were wrestling and it was there I poked him while I was drunk. The day after he died, when I sobered up, I thought of committing suicide, but I didn't because I have children. I thought of my children and how they have no one else to support them. This is my confession. I was afraid of him; I never bother anyone normally, but one person kept mocking me. Otoetok was following me all the time and I began to be afraid so I poked him.

But in the event, the letter of confession was not to form part of the evidence at trial. Mr Justice Sissons did not admit it, nor did he admit the statement Angulalik had made to the RCMP at the time of his arrest. The statement had been interpreted by the special constable and written down by Corporal Jones, but Sissons ruled that "it could not be established that the statement reported by the corporal was what Angulalik said or meant." As for the letter, as Sissons wrote later, "Angulalik had not written this letter. He had asked his host at the fatal party, Norman Eevalik, to write it for him

and he could not read what Norman had written. It was perfectly proper for the Hudson's Bay Company to guess what was meant by 'two cases of fragile' or 'three dozen handle with care,' and to presume further that the order was voluntary. But our courts cannot guess."

The jury returned a verdict of not guilty.

The case had a tragic aftermath. At the party thrown to celebrate the acquittal, the home brew was laced with methyl hydrate (wood alcohol), a supply of which was found at the RCAF winter survival school. The lethal concoction killed two people – interpreter Sam Carter, who worked for the RCAF as a guide and taught survival skills, and his wife. On his next circuit to Cambridge Bay, Sissons had to award custody of their orphaned children.

And Angulalik did not emerge from his ordeal unscathed. Because of fears that competition might lead to the depletion of wildlife in the region, Angulalik's was the only post licensed to operate in the Perry River area. When he was arrested, he realized that there would be no one to look after and attend to the needs of the Inuit in the camps that depended on his post. According to McGrath, he asked the Hudson's Bay Company to undertake the responsibility. "Whether he knew when he did this that he would never get his post back, I do not know. He ended his life as the post servant." Still, she says, Angulalik's last years were contented ones. In 1967 he moved with Ekvana to Cambridge Bay so that their children could go to school. He was comfortable there with the routine of settlement life, but every summer the family returned to Perry River. Angulalik died in 1980.

Today Angulalik's boat, the *Tudlik*, is a beached wreck a bit up from the shore in Coppermine. For a while it served as a store where children bought pop and candy. Perhaps Angulalik would have approved: Inuit say he had a true trader's heart.

R. v. Kikkik
Attributed to Peggy Ekagina,
c. 1919–93
Kugluktuk (Coppermine), NWT
Three carvings illustrate the
incidents that brought Kikkik
to trial.

(Opposite page)
Ootuk murders Hallow,
Kikkik's husband.
Stone, metal (wire)
20.8 × 10.5 × 16.5 cm

(This page, top)
Kikkik kills Ootuk.
Stone, metal (copper)
20.5 × 14.3 × 17 cm

(This page, bottom)
When Kikkik journeys for
help, two children are left
behind in a snow house so
that the others may survive.
Stone
12.5 × 10.8 × 12.8 cm

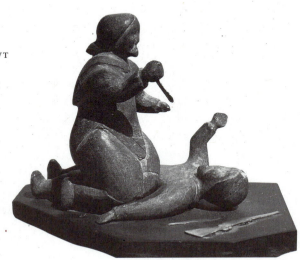

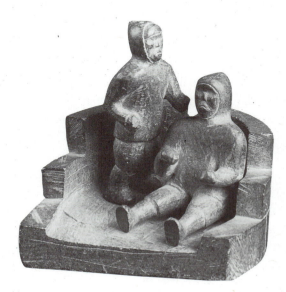

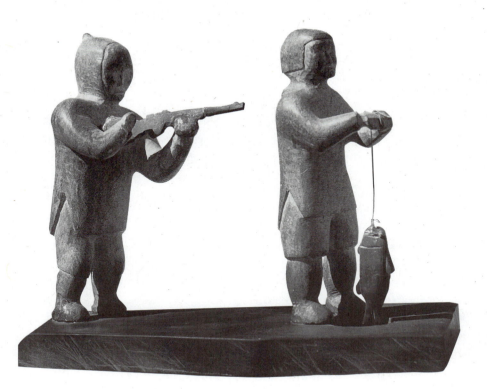

1958

Regina v. Kikkik

In 1990 in Rankin Inlet I have the good fortune to meet Elizabeth Karetak at the home of Sandy and Michael Kusugak – Michael is the Inuit writer whose *Baseball Bats for Christmas* has become a children's classic. Elizabeth, known as Elisapee, is visiting from Arviat, formerly Eskimo Point, and is on her way to Yellowknife to see her daughter graduate from high school.

Elisapee is a teacher, one of those, as Inuit sometimes say, who have "changed well." She is the daughter of Kikkik, whose epic struggle for life stood revealed in *R. v. Kikkik* – Elisapee was the baby Kikkik carried up on her back in the *amautik* over miles of arctic trail in harrowing winter. Kikkik's trial was sensational, riveting public attention. Wide press coverage and Farley Mowat's *The Desperate People* for a time made Kikkik's name

familiar in the south. Yet Elisapee grew up unaware of the circumstances of the journey she and her mother had made together. "My mother, my family, and all the community protected me," she tells me. Then, when she was about sixteen, her sister Annecatha came across *The Desperate People*, which relates a version of the events behind *R. v. Kikkik*. She said to Elisapee, "You know, our mother has a story." What a story it is.

In the Keewatin District of the Northwest Territories, where the events that led to Kikkik's ordeal unfolded, famines had been a fact of life throughout the history of the Inuit who lived there. "When the migration changed and the caribou didn't come, sometimes a whole tribe died out," says Mark Kalluak, of Arviat, a former editor of the *Keewatin Echo* and *Isumasi* and member of the Order of Canada for his contribution to Inuit culture. "In those situations even the fish don't seem to be there and the birds aren't there either." It was in just such a situation that Kikkik and her people – the Ennadai Lake Inuit – found themselves in the winter of 1958.[1] Their difficulties would lead to tragedy and to the presence in April of that year of Kikkik in Rankin Inlet, on the west coast of Hudson Bay, charged with shocking crimes: murder, the abandonment of a child, and criminal negligence with respect to a second child.

In the 1950s, to mitigate the frequent food shortages that occurred in broad areas of the Arctic, to alleviate the difficult social conditions, and possibly, on occasion, to demonstrate sovereignty in the High Arctic, the Canadian government undertook a number of initiatives – still controversial – which involved the movement of Inuit populations to new areas. One of these brought Kikkik and her people from Ennadai Lake and their traditional camping grounds to a region with a number of fishing lakes, collectively known as Henik Lake.

The Ennadai Lake Inuit were inland people, Caribou Inuit, so called, because in traditional times they had relied on the caribou for virtually all their needs: for meat, for hides for their boats, and for skins for their clothes.

In 1955 James Houston, the writer and artist responsible for popularizing Inuit art in the south, visited the Ennadai Lake region and reported that families there considered they needed between 150 and 175 caribou a year to supply themselves with food.[2] And not only food: as elders tell you, "People couldn't survive if they didn't have the caribou clothing they needed for winter months."[3] The caribou migrations, however, had been bypassing the Ennadai Lake Inuit in recent years. The move to the Henik Lake area was not the first attempt on the part of officers of the Department of Northern Affairs to relocate these Inuit to more promising territory. "They had already been moved from place to place," notes Mark Kalluak.

In the 1930s and 1940s the Ennadai Lake Inuit engaged in modest trade with fur traders and trappers, but when these entrepreneurs moved out in the postwar years, the Inuit had to rely once again on subsistence hunting – plus family allowance in the form of supplies and the occasional handout channelled through a Department of Defence radio station established in the territory in the mid-1940s. It was in this period that government officials charged with the welfare of the Inuit began to come into the North. There seems to have been a sense that the Ennadai Lake Inuit were becoming too dependent on the largesse of the station, and in 1950, after the caribou had failed two years running, in 1948 and 1949, in order to make them self-sufficient the decision was taken to move them to Nueltin Lake, where it was believed there was work for them in a commercial fishing operation. This work, as it turned out, did not materialize, and on their own initiative they drifted back to their traditional territory. There they had stayed, until, after failed migrations in 1955 and 1956, six aircraft transported the population (reportedly fifty-eight people) to the Henik Lake region in 1957.[4]

William Gallagher, now retired and living in New Brunswick, was the corporal in charge of the RCMP police detachment at Arviat at the time. He recalls having grave misgivings: "These people were now at Henik Lake but they were originally from Ennadai Lake, where the natural habitat – game

conditions, hunting and fishing – wasn't supporting them, and the department decided to move them to Henik Lake, where they'd be taught to fish. But what the department didn't understand was that fish was not their culture. They were people of the caribou – meat eaters – and the caribou migrations were not coming through Henik Lake. Migrations change.

"Lewis Voisey – he was half white, half Eskimo – was sent in to teach them how to fish – how to set nets, how to use creepers, how to run nets under the ice. When freeze-up came they sent in a plane to pick Voisey up and the plane was barely out of sight when the Eskimos had the nets out of the water and strung them through the willow and attempted to catch ptarmigan. Again the caribou didn't come and things went from bad to worse.

"Conditions were terribly harsh. I had sent Constable Lou [Jean Louis] Laliberté in there in the summer and he had come back and reported very adversely on the conditions. This was all reported to the authorities. But you're there by yourself with no authority to do a heck of a lot except report and hope they'll do more."

By the end of 1957 it was certainly known that the Inuit at Henik Lake were in for a hard winter. The caribou had been sighted by plane on the tundra some fifty miles away, but they did not go through Henik Lake. For three years running, the Ennadai Lake Inuit, now in the new location, had not had sufficient caribou for their winter needs. Their dogs had died or been eaten, they had little skin clothing, and by all accounts these Caribou Inuit had made little headway with fishing. Later there was speculation that ancient taboos on the part of caribou hunters might have played some role, though young people today discount this as a factor.

There was concern even in distant Ottawa. "At best the recent move seems to have been from one depressed area to another," wrote Graham Rowley, secretary of the advisory committee on northern development, in a memo.[5] Plans were already afoot to move these Inuit to yet another location the next year. For the moment, however, the new location was relatively close – about forty miles – from the Padlei Hudson's Bay trading post where Inuit came

for supplies; it was assumed that if there was serious trouble, those "outside" would know. Yet despite the presence of northern service officers thick on the ground and charged "with the welfare of the Eskimo people" (as one swore in court), the seasoned personnel of the RCMP, the missions, and the HBC, Inuit at Henik Lake starved to death in the winter of 1957–58.

It was in the midst of these harrowing conditions that Kikkik's ordeal began. "When you're in a desperate situation," says Mark Kalluak, "things get out of control."

R. v. Kikkik opened on 14 April 1958 in Rankin Inlet before Mr Justice Sissons and a jury, and continued for three days. John Parker appeared for the Crown and Sterling R. Lyon for the defence. Lyon was one of several prominent southern lawyers appointed by the office of the deputy minister of justice in the Sissons years to represent defendants charged in capital cases. Before setting up in private practice, he had been a Crown attorney, appearing in criminal court on a daily basis, gaining wide experience in criminal law. His days in private practice were numbered, however. He took the trial in April, returned to Manitoba, and ran in the provincial election. He was elected to office, eventually becoming attorney general and then premier of Manitoba. In 1997 he was a judge for the Manitoba Court of Appeal. *R. v. Kikkik* was his last major case as a lawyer.

Lyon remembers Kikkik's igloo jail: "I went up a day or two or three in advance of the trial and Kikkik was at Rankin Inlet. She was being kept in an igloo just outside the Department of Northern Affairs office in order that she would feel more comfortable than in a heated house. The Northern Affairs officers were attending to her needs. We'd brought in some meat on the plane and some of it was meat for Kikkik, and she had her own cooking utensils and so on in the igloo. Of course, I had to converse with her through an interpreter, Lewis Voisey.

"I was a smoker at the time and I remember taking out small cigarillos and she indicated she wouldn't mind one of those. She had a cigarillo with

me and she was quite happy with that. It was very difficult through an interpreter to establish what her emotions were. I couldn't speak a word of her language and we were entirely dependent on the interpreter. I took some time to explain what it was all about – why I was there and that I was her friend and was going to look after her interests in this strange proceeding which was new to her. I think I told her what the purpose of the trial was, and I think I told her what a bad outcome might result in ... so she would know it was serious. The death penalty wasn't abolished until '68. But I don't think I put it in those strong words because in my own opinion, if she had been found guilty of anything, it might have been manslaughter. At the worst."

Kikkik's drama had begun on 8 February, in the eye of a great storm. The Ennadai Lake Inuit had divided into four groups, each camping in the region of Henik Lake, perhaps a day's walk from each other. Kikkik, her husband, Hallow (whom government reports termed one of the region's best hunters), and their five children were in camp with Hallow's sister, Howmik, and her husband, Ootuk, a recognized shaman. Although the Ennadai Lake Inuit had met the missionaries and many were Christians, old beliefs and practices coexisted. The two families had built their igloos close together near the shore of a lake. While they did not always camp together, they often did. Because Howmik had had polio and was partially paralysed, Kikkik frequently did her sister-in-law's sewing, and since Hallow was the better hunter of the two men, he often supplied the food for Ootuk's family. But this February food was scarce; in fact, a child in the camp, the daughter of Howmik and Ootuk, had already died of starvation.

The Crown did not produce evidence to account for Ootuk's actions that fateful day. "I think they were starving and I think it was probably a question of food," says Lyon. "They were in pretty hard straits; he may have been deranged." In his *Maclean's* magazine article "The Two Ordeals of Kikik" (31 January 1959), Farley Mowat suggested that Ootuk had decided that in their near hopeless situation the two hunting partners of many years and

their families should die together. But Hallow, still able to travel, had indicated that he and his family would try to reach the Padlei trading post. Some think that Ootuk believed Hallow had food that he was not sharing. Others conjecture that Ootuk the shaman may have come to believe that neglect of the taboos that the Caribou Inuit once lived by had brought about the starvation.

"About half a moon" after the events, Kikkik told the RCMP her story through an interpreter:

Early in the morning Hallow got up and we had no food. He went jigging and caught two fish. He returned to the igloo and started to eat. Just before Hallow started to eat Ootuk came to visit us and ate with us. While eating Ootuk and Hallow discussed going for Family Allowance to Padlei. They did not talk any more and Hallow left to go jigging. Ootuk stayed in the igloo. Ootuk said that he would like to gather up the caribou hide as it would be good to eat. I said "I have no more caribou hide." Ootuk tried to eat a small piece of the caribou hide which were scraps from the boots I was sewing. When Ootuk finished eating the hide he said, "I would like to look for ptarmigan," and Ootuk went out. I told my daughter Ailoyoak, "you go out and see where Ootuk went." I asked her this because it was a very stormy day and I knew it was no good to hunt ptarmigan and I wanted to know which way he went.

Kikkik's own story, introduced as testimony, suggests that she was already worried about Ootuk's state of mind. As she described it, Ailoyoak went out and then came back and said that Ootuk was walking down towards the edge of the lake. A little while later he returned to the igloo, complaining of the cold. He wanted a cup of tea, and so Ailoyoak put some old tea leaves and a little water on the stove. After drinking the tea, he asked first the children and then Kikkik to help him fix the door of his igloo. They said yes but made no move to do so. Ootuk left and after a moment Kikkik followed. She found Ootuk cleaning Hallow's big rifle outside the igloo.

I asked Ootuk why he was cleaning the rifle and Ootuk answered, "I am taking the snow off it." I was afraid and told Ootuk to leave the rifle alone. Ootuk did not answer and continued to clean the rifle. Ootuk was rubbing the snow off the rifle with his hand. I took hold of the rifle and Ootuk held it also. Ootuk said, "I won't bother you and you let it go." I let go of the rifle and Ootuk started pointing the rifle at me. I was about five to six feet from him at this time. Ootuk had the rifle at his shoulder at a normal firing position and I jumped and grabbed the rifle by the barrel near the muzzle, and the rifle went off and the bullet just missed my head as I had pushed the rifle sideways as it went off. I had grabbed the rifle with my left hand. After the bullet we started to fight for the rifle. I got both hands on the rifle and fell down and managed to get up again. We were fighting at this time. When I got up I knocked Ootuk over. Ootuk was pretty weak and chilly and not strong. I was right on top of him and I called for my daughter Ailoyoak. She came quite soon … I asked Ailoyoak to take away the rifle and said, "As soon as you get it away you bring your father to help me."

Ailoyoak got the rifle and started running with it towards the jigging hole to get her father. Ailoyoak returned, was crying and saying, "My father is shot and is dead." I asked my daughter if this was true. My daughter said, "It's really true; my father is dead."

I asked Ootuk why he had shot and Ootuk answered, "It's not my fault, my wife told me to kill Hallow." I said, "I don't believe you as Hallow is Howmik's brother" … Ootuk said, "Hallow was Howmik's brother and does not look after his sister." I did not answer and Ootuk said, "You let me go now." I said yes but did not let go. Ootuk then offered to give me his deaf and dumb daughter to let him go. My daughter Ailoyoak went home at this time. I had told her to as she was getting chilly, cold. I asked Ootuk how I could look after my family now that he had killed my husband. Ootuk answered, "You will get lots of Family Allowance and will be all right after." I answered I could never look after them. Ootuk said, "I'll get lots of rations after and will look after everybody." I did not answer. We did not talk again and I still held Ootuk down. I then called, "Daughter, Daughter!" and both Ailoyoak and Karlak my son came out. I was still holding Ootuk and asked my

daughter to bring me a knife and both Ailoyoak and Karlak brought me knives which they got at the igloo. I then tried to stab Ootuk with the large knife my daughter Ailoyoak had brought me but it would not work as it was too dull. I stabbed once near the right breast with the large knife but it would not go in. Ootuk grabbed the knife with his right hand and took it from me and when he grabbed it away he struck his forehead someplace and I got the knife back and dropped it and picked up a little knife which my son Karlak handed me. Karlak was standing beside Ootuk and I. As soon as I got the small knife I stabbed in the same place. The knife went in and I stayed on Ootuk until he died.

Kikkik then told how she and her daughter Ailoyoak took her husband's sled and went to his body. It was doubled up, the feet and the hands in the water, the jigging hole being too small for the body to fall through into the lake. They loaded the body on the sled and took it to the igloo. Kikkik wrapped the body in deerskin, which she got from the igloo, and placed it beside the porch with snow blocks around it. Then she placed Hallow's rifle beside his body in the old Inuit manner.

Kikkik and her five children slept in the igloo that night, and in the morning they loaded the sled and left the camp, pulling the sled themselves, as they had no dogs. Kikkik carried her youngest child on her back. They travelled towards a big point on Henik Lake and there met up with Yahah, Howmik's brother, and his family. Together the all started towards the trading post at Padlei.

In her testimony, Kikkik described what followed: "Yahah went ahead and we followed. Karlak could not keep up so he and I walked behind and did not reach Yahah's camp but slept out. The rest of my family were with Yahah. The next morning we followed Yahah's trail and came to Yahah's igloo. Everybody was waiting for us. We started to pack. Yahah told me to remain at the igloo with my family and that he would go fast to Padlei with word of what had happened and that either an aeroplane or a dogteam would come for us and might bring food. Yahah and his family left and I

and my family stayed in the igloo for five sleeps. We then left following Yahah's trail as we had waited too long."

Kikkik dragged her young children on a piece of hide. When they stopped to rest, they boiled some water and then boiled the hide to get some sustenance from it to keep them going. "In the afternoon we made camp by digging a hole in the snow with a frying pan and covering the hole with a tent. We did not eat or drink as we had no food."

That night Kikkik covered her children with sleeping skins. "I had only two skins, and I sat up in my clothes. We slept all night … [In the morning] we – myself, Karlak, Ailoyoak and the baby Nokahhak – left walking, following Yahah's trail until we came to the cabin where the police found me."

Yahah had succeeded in reaching the HBC post at Padlei with his story of starvation and murder at Henik Lake. The news travelled from there. Corporal Gallagher says, "The first indication we had at Eskimo Point was when Henry Voisey, the HBC post manager at Padlei, about a hundred miles away on the barrens, got on the radio and told me. Immediately, without any authority, I chartered a Norseman aircraft from Churchill and also got an RCMP plane and we started searching, picking up people and bringing them in. We searched but we couldn't find Kikkik."

Gallagher and Constable Laliberté visited Kikkik's camp and rescued Ootuk's widow, Howmik, and her children. They also picked up other campers in the area. "The camps were scattered," Laliberté, who now lives in St Albert, Alberta, recalls, "and one of the problems we had was that the storm had caused snow to drift over the igloos, hiding them from view. We dug up one with two bodies." Some of the campers in the Henik Lake region had already started out for Padlei and several died on the trail.

Gallagher remembers the search. "On Sunday afternoon on the eighth day, some miles out of Padlei, we spotted three people in a little spruce grove at the edge of a frozen lake. We landed the plane and I walked up and said, 'Kikkik?' and she said, 'Eee – yes.' And I said, '*Qanuippi?* – [How are you]?'

and she answered, '*Nammak* [All right].' I said to her, 'How many children have you?' 'Two only,' she said, and there was the baby on her back. I asked, 'Where are the others?' and she said, '*Tuqulaurmata* [They are dead].' I asked, 'How?' She said, 'Terrible sick,' and she bent over double as though they had [had] cramps – she was telling the truth about their suffering. I said '*Qanga* [When]?' and she said, 'This morning.' When she said this to me, she looked away …

"We took her and the kids and put them aboard the RCMP Otter and took them into Padlei where we gave them a little bit of food.

"Constable Laliberté was with us and I asked Henry Voisey, the post manager, if his Eskimo assistant and his dogs could be made available. He said certainly, and I asked Constable Laliberté to go back to where we picked up Kikkik and with those dogs stay on their trail until they found the other two children. He and the Eskimo left with five dogs, a snow knife, and not much else than the clothes they were wearing."

Laliberté believes he left Padlei a little before noon and after about two hours reached the point where the plane had picked up Kikkik and her family. He then began backtracking her trail. "It got dark but there was some light – something they have up there – a reflection from the snow, perhaps. The first realization I had that we had come upon something was when the dogs' ears went up. Then a voice called, 'Let me out,' or something like that – in Inuktitut, of course. The sound of the sled and the dogs must have been transmitted through the snow."

There were some twigs on top of the snow blocks, and Constable Laliberté tore the shelter apart. Inside were the two children, naked from the waist down and wrapped in a caribou skin. Nesha was dead but Annecatha was alive, her body better protected by the skin. "I pulled her out, and said, 'Who are you?' She answered, 'Annecatha,' and she smiled.

"I took off my outer parka – Inuit call it a *qulittaq* – I took it off and turned it inside out because we wear them with the fur side out. I snuggled

her up in that. She was pretty rank from the urine. We had a bit of food with us. I heated up some water and gave her rolled oats. She didn't like it very much but she ate it.

"I was greatly taken by Annecatha. She was a remarkable child. She showed little sign of stress, although she must have had some sense of the situation. Her faculties were good. Whether she thought anyone would come back for her I don't know, and I don't know whether she knew her sister was dead beside her. The language was a problem of course, and the only opportunity to talk was when we were still and I was constantly getting on and off the sled – running along beside it and helping with the dogs. We spent the night at a trapper's cabin, and in the morning we went on to Padlei and got there right around one o'clock."

Gallagher says, "I got word in the morning from Padlei that Laliberté had found the kids and that one was alive. Kikkik had said, *Tuqulaurmata* [They are dead], and that they had died that morning, but when she said it, she looked away and I knew then that she lied. That was the trigger that made me send Laliberté back that night to find them.

"When she told me the children were dead, they were buried alive in the snow. She couldn't drag them any further – they'd been ten days without food. If you had seen how weak they were ... she couldn't carry them any further, she couldn't drag them any more on a caribou skin in the snow. She abandoned them out of necessity."

In recalling the trials – there were two – Lyon says, "The great concern we had, of course, was the murder trial. There was no question that she'd held this man down and called one of her daughters to get the knife and that she knew how to use it." Lyon did not put his client on the stand. "I didn't think I had to. That's always a risk that the defence counsel takes. But in this case, through the Crown's case I had gotten in most of what I had wanted to get in. Her statement to the police was really not an inculpatory statement in

the sense that she admitted murder. She admitted the homicide of a man but it was clearly self-defence.

"There was a general sympathy for her position – what she had had to do and the ordeals through which she went. Losing her husband and losing one of her children."

The Crown did not ask for a verdict of murder (that would be wrong and unsuitable, the prosecutor had said), but did ask for a verdict of manslaughter. Kikkik had had Ootuk under control, the Crown charged, and had then knifed and killed him. "What was she supposed to do?" court reporter Everett Tingley, who prepared the transcript, asks rhetorically, looking back on the case in retirement. "Go down to the nearest phone box?"

As counsel for the defence Lyon argued that Kikkik had done what she had had to do in defence of herself and her children. She couldn't have continued to hold Ootuk down, and if she had let him up, there had been the chance of immediate or continuing danger. She had believed on reasonable and probable grounds that she could not otherwise conserve herself and her children. It had been either him or her.

Then it came time for Mr Justice Sissons to charge the jury. "Sissons was one of a kind," Lyon declares. "He was sort of a senior defence attorney, although he was on the bench. He gave a very sympathetic charge, quoting some cases from colonial areas. Lord Goddard, who was still around at that time, said you must take these cases according to the lifestyles of the people. For this case the British common law definition of what is a reasonable man is not a reasonable man living in Edmonton or Winnipeg; it is a reasonable man living in the Arctic. What would this person regard as reasonable?"

In his charge Sissons said, "The privy council of Great Britain knows the common law and has been for centuries the final court of appeal for British colonies, and has a wide experience with, and knowledge and understanding of colonies and native peoples. I think we should follow the privy council thinking and approach. It is by far the best there is."

Sissons instructed the jury that according to the British Privy Council the application of common law principles is controlled to some degree by the evolution of society:

Self-defense and provocation have been differently estimated in differing ages. The common law has not changed but in earlier times, when our society was less secure and less settled in its habits, the courts took a more lenient view towards provocation and self-defense, as an excuse or justification, than is generally taken in our society today, when we are more secure and life is guarded by an efficient police force and there is a policeman at every door ...

In this present case we have a very primitive Eskimo society, which has not changed very much and is still very insecure and unsettled, with no policeman within one hundred and fifty miles.

Justice demands that we revert in our thinking to an earlier age and try to understand Kikkik and her life and her land and her society ...

If you find that the accused acted in self-defence or in defence of her children as I indicated to you, there is no crime and you will find the accused Kikkik not guilty.

It took the jury ten minutes to reach the verdict of not guilty.

But two and a half hours later Kikkik stood trial on the remaining charges: "That she the said Kikkik, about twenty miles southeast of Padlei, NWT, on or about the 16th day of February 1958, did unlawfully by criminal negligence cause the death of her daughter Nesha; and secondly that she did unlawfully abandon or expose her daughter Annecatha, a child under the age of ten years, so that the life of the said child was endangered by leaving the said child without adequate food, shelter, clothing or protection and failing to secure assistance for the said child when she had the opportunity to do so."

Such tragic abandonment was sometimes a necessity when Inuit lived "the old way." Cape Dorset's great graphic artist Pitseolak Ashoona, who made drawings of the traditional Inuit life, in the 1970s gave a poignant

account of how her brother, starving and exhausted, carried his child on such a desperate journey, until he could go on no longer. "He made the decision to stop carrying her," she explained. "The little girl and an old woman were left behind in an igloo. The child had become partly frozen as he carried her and her cries could be heard as he walked on. It was not possible to go back later and find them."

Northerners following the trial in Rankin Inlet knew the lengths to which the Inuit were sometimes driven in order to survive. But what worried many was why Kikkik had not told the truth to the RCMP officers on the day they rescued her. She had said that when she buried the children both were dead. (Constable Laliberté does not believe the outcome would have been different. "We found them the same day," he says, noting that it was the position of the skin in which the children were wrapped that allowed Annecatha to live but caused Nesha to die.)

Corporal Gallagher had asked Kikkik to explain her actions when he had taken her original statement, parts of which were admitted as evidence. Why had she buried them alive? Kikkik had answered, "They could not walk. I had dragged them a long way. They were heavy." And why had she not told the police when they met her a few hours later that the children had been alive when she left them? "I was afraid to say," she had answered.

Writing about the case later, Sissons said, "I considered that a reasonable explanation for Kikkik's action. She was afraid. It would not excuse you or me in the same situation, but we are brought back again to Lord Goddard's judgement on the tests to be applied to an ordinary member of a primitive society. She was afraid."[6]

Observers at the trial recall that in his argument for the defence, Sterling Lyon had expressed a belief held by many in the North: that the moment Kikkik put the children in the snow she considered them dead. "Yes, I formed that impression," Lyon recalls. "That is certainly the way I argued it before the jury. In her mind, the logic of the land was that if she tried to carry on with these two children, everyone was going to die. So the only

alternative was to abandon the two in order to save the others. Then having come to that determination, the minute she left those two children it was as though they were dead. It was the basic law of the land she was following."

Constable Laliberté remembers some evidence that supports this view: when he tore apart the snow shelter the sticks on the top were in the form of a cross.

In his charge to the jury, Sissons said that there is no abandonment if a person cannot supply, or cannot furnish, the support required.

All through the two trials, Kikkik had sat at the side of the improvised court room in *qallunaaq* (white man's) clothing bought at the HBC post by the Northern Affairs officers. Southerners in attendance recall that at least to southern eyes, Kikkik's face betrayed no trace of emotion throughout three long days. Some wondered if Kikkik had understood the reasons for her legal ordeal. There is no doubt she did. "I can tell you that we spent hours and hours briefing her on what was taking place and why," says Corporal Gallagher. "All the time we had her with us at Eskimo Point prior to going to trial at Rankin, she was most cooperative. She told everything openly and evaded nothing. I think she had an acceptance that the white man's law had to be honoured. She accepted what had to be but I think there was a great deal of anxiety on her part. We did our best to brief her positively because nobody wanted to see her convicted."

How did the Inuit feel about the trial? Mark Kalluak says, "In view of what had happened, I think people realized there had to be some procedure. I don't think there was any resentment." Kalluak's mother, Helen, was hired as the matron to look after Kikkik while she was in Eskimo Point prior to the trial. She told family members that she felt Kikkik was trying her best to reassure people. "If you're living with someone who has murdered, you might feel he or she could turn on you. Kikkik was always thoughtful, cooperative," Mark Kalluak remembers. "She was healing after the ordeal; she tried to lead a normal life."

The jury acquitted Kikkik, believing that she had abandoned two of her children so that the others might survive. Bill Munro, an HBC man serving on the jury, says, "I felt she acted in the best interests of her children." And Harry Leavitt, a Montreal geologist working in the North who acted as a jury foreman, told the press, "She had a hard choice to make, and the jury felt that she had made the right one. The Arctic is like that. It's full of hard choices."

Sissons told Kikkik she was free, and a Northern Affairs officer who spoke the Inuit language took her to a small kitchen and made her a mug of tea. "It's all over," he said. But of course it was not over.

In the aftermath of the trial, blame was liberally bestowed. Mr Justice Sissons said bluntly that mandarins had bungled again: "Many courtroom scenes are played against the backdrop of a larger drama. I was forced to conclude that Kikkik's tragedy was played against the backdrop of high official farce. Well intentioned ignorance in high places had trapped her in deep below-zero winter out on a trail as hard to follow as some of the reasoning of the Northern Affairs Department."[7]

With regard to mortality, the starvation at Henik Lake was not the worst that dreadful winter; greater numbers died of hunger almost simultaneously further north at Garry Lake. However, the proceedings of *R. v. Kikkik* focused public attention on the plight of the Ennadai Lake Inuit, making headlines around the world.

R. v. Kikkik effectively ended life on the land for most Inuit in the Keewatin District. With government encouragement the Inuit moved into communities where shortly there were schools, nursing stations, and government services. Many Inuit have accepted the changed lifestyle. Joan Attuat, a respected elder whose husband served as a juror on the *Kikkik* case, said in 1988 that she was grateful that people no longer starved to death: "I want to thank the white man for that." But others have the sense of a

heritage lost. Mark Kalluak says, "Young people feel something was snatched away from them – they weren't given the opportunity. Young people today would know only a quarter of what would be needed to survive on the land."

Many of the Ennadai Lake Inuit now live at Arviat. It was to this settlement (then called Eskimo Point) that Kikkik and her children were flown after the trial. There Kikkik remarried and continued to look after her family. Today her daughter Elisapee Karetak teaches school in the town. Speaking of the long-lasting effect on her family of the winter of 1957–58, she says, "My mother was always protective of me. She died shortly after I found out her story and she never knew I knew. She never mentioned it to me and I felt that it was because she wanted to protect me – so, I wouldn't have hangups like my brother and two sisters. They were always having bad experiences. It really affected their adult lives. My older sister – she was the one who found my dad – always had problems. She died when I was just turning twenty. I really believe she had post-partum depression. She walked out into a storm and they looked for her for two days. My sister Annecatha – she uses 'Margaret' – was angry for a long time because she witnessed what happened and because she was left behind and because her little sister died. It's always been hard for her. But she's coming to terms with it because she can talk about it now.

"When I became aware of the story – conscious of it – I would pick up and listen whenever my mother was reminiscing. But nobody ever discussed the events with me, neither my aunts or uncles or anybody. I think they preferred to forget. It was such a sad tragedy that nobody wanted to remember."

Elisapee believes that her father's was not the only murder to occur during times of starvation. "There were lots of murders committed in desperate situations that we don't know about. And people are very understanding. They never accused my mother. Because if she hadn't killed my uncle, we would all be dead."

Elisapee is currently taking the training that she needs to become a vice-principal. "I'm learning new skills," she says. She and her husband, James, have five children, two of them high school graduates, two still in school, and a baby. "I called my little baby Sterling – Joe Sterling – after my mother's defence attorney."

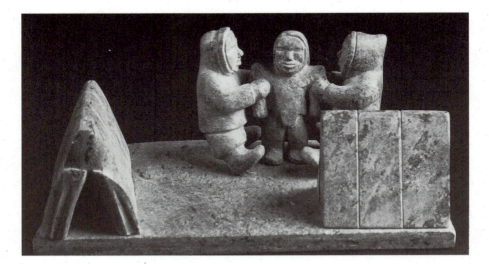

R. v. Pitseolak
Artist unknown
Kugluktuk (Coppermine), NWT
Stone
19.7 × 12 × 9.5 cm

1959

Regina v. Pitseolak

Looking at the photograph of the carving that illustrates *R. v. Pitseolak*, Julia Ogina of Holman Island sums up the situation quickly. (Julia has interviewed the Holman elders and, with the anthropologist Richard G. Condon, published *The Northern Copper Inuit*, she has also studied native clothes design.) "They are fighting over a woman," she explains. She adds, "That's why the women had those big shoulders, so the man could pull on the woman – so he'd have something to grasp." The clothing the little figures wear is recognizably Copper Inuit clothing and the sculpture in all probability is the work of a Coppermine carver, but the carving depicts a case that came to trial on different terrain – across the Arctic on south Baffin Island.

R. v. Pitseolak is a case that has had great bearing on the lives of Inuit women. In this case Mr Justice Sissons overrode traditional custom to uphold legislation that would improve women's lives.

In a trial held in Cape Dorset in September 1959, Peter Pitseolak, a powerful camp leader and a complex, talented, multifaceted personality, was brought before the court on charges of statutory rape – sexual relations with an underage woman. Long-time court reporter Everett Tingley says, "He sent for a little girl to come to him and being the headman they couldn't refuse him, you see. He said, 'I want that girl.' Because a man in authority could order this, I guess the judge decided to bring it to an end. So they made an example there."

Tingley remembers the crowd assembled for the trial. "I couldn't say from those people in the room how they felt. They were expressionless, so I couldn't say whether people felt very strongly he should have been left alone, as it was the custom of years, of generations, or whether they were getting weary of it. Most certainly people were becoming more educated."

Peter Pitseolak, who was born in 1902 and died in 1973, left his own account of how change came to Baffin Island. Shortly before his death he put on record, in many hours of interviews, a social history of his times.

Excerpts from these interviews, combined with a handwritten manuscript translated by Ann Meekitjuk Hanson, appeared posthumously in *People from Our Side*, illustrated with his own photographs, some of them developed with the use of a three-battery flashlight covered with red *qallunaat* cloth in hunting igloos out on the land. In Peter Pitseolak's youth many Inuit men had more than one wife (Peter Pitseolak's father, the great Inuit leader Inukjuarjuk, had four). Wife exchange was usual and during certain old Inuit festivals appears to have symbolized fertility and the renewal of life. Peter Pitseolak told how, though Inuit did not know about Christmas, in the very short days at the time of the midwinter moon, they used to have celebrations. "They used to build a giant snow house – a *kagee* … The shamans were there in the *kagee* and the shamans would perform. They'd dance and they'd put all the women in the middle and join hands and go round and round. Then they'd stop and kiss the women – whoever they wanted to kiss. He who got jealous first when his wife was kissed, he was out of the game!"[1] Much changed with the coming of the missionaries shortly before and after the turn of the century, but old habits and attitudes prevailed for decades. Some retired Hudson's Bay Company traders still recall how Inuit hunters would appear at the post at the time of the annual sea lift and order yards of printed cloth – enough for two wives.

In traditional life marriages were arranged. Bob Pilot recalls that as late as the early 1970s, while he was with the RCMP detachment at Pond Inlet, a young woman burst into his office and demanded, "I don't have to marry *him*, do I?" He had answered, "No, of course not. You can marry anyone you want." Pilot says, "In fact, the man selected was not a particularly promising individual." Pilot took the problem to Pond Inlet's famous special constable, Kayak. "He discovered the two were too closely related and I heard no more about the matter."

Well into the 1960s women were taken in marriage soon after the start of the menses – and in the memory of women still living, sometimes before. In Cape Dorset an old woman called Ikayukta, who died in 1980, once described how she became a wife: "In the old days the marriages were

arranged. The women would be forced to marry a man they didn't want. The girl would cry and the man would drag the girl out of her home. The girls were quite young when they married. And when I was young there were some men looking for wives who already had a wife. Tunillie had a wife when he asked for me. I was just a young girl who had never had a menstruation. My mother and father did not want this marriage but my father was afraid of this man so he agreed to the arrangement. That's how I was since before I hardly began."

In *R. v. Pitseolak* tradition and custom came into sharp conflict with new concepts of marriage and laws new to native people concerning the age of consent.

The case was a dramatic one because Peter Pitseolak as a powerful camp boss was respected and, possibly, feared. "He was a king in that country," says Mark de Weerdt, the prosecuting attorney. The case came to trial because the father of the young woman who was the focus of Peter Pitseolak's attentions protested. (A sophisticated granddaughter believes he was manipulated to do so.) James Houston, famous today as Inuit art's foremost promoter, was the northern service officer in the community at the time. "Once Towkie [the girl's father] complained, I had no alternative but to take action," he said, commenting on the case many years after. In *People from Our Side* Peter Pitseolak described his emotions at the time: "It was when I had my fight with Sowmik [the left-handed one] that I felt I was the worst man in the world, that I was different from other people … when I wanted to take a second wife, Sowmik said, 'Do that and you'll go to jail.' I thought, why? Why pick on me? Because the people around me – the white men too – were doing the same thing."[2] Houston once described Peter Pitseolak as "the most interesting man on the coast," but as leading representatives of colliding cultures, their relationship was often stormy.

When the court party arrived in Cape Dorset, Houston approached the Crown prosecutor, Mark de Weerdt. De Weerdt recalls, "Jim Houston told me that they had a heavy situation on their hands, and could we do anything about it? We decided to grasp the nettle and away we went. We had an

interpreter sworn, we had the girl come forward and testify, and a letter was produced written in syllabics which was a confession. It said, in effect, 'I know that you don't approve of what I have done or what I am doing with your daughter but I am going to do it anyway. If you don't like it you can get out of my country – signed, Pitseolak.' Mr Justice Sissons, the great defender of the rights of the native people, convicted."

The next morning Peter Pitseolak was flown down the coast to Lake Harbour. In a *New Yorker* article that profiled his adventurous life, Houston described himself as in tears when Peter Pitseolak departed. His wife Alma (they later divorced) had felt unable to attend the trial, and Peter Pitseolak said to her on leaving, "Thank you for not coming." She says, "Nobody believed they would ever send Peter Pitseolak to jail." Under the eye of the RCMP but not in lock-up, he spent three months whitewashing the stones of the pathways around the police post and, it is remembered, carving wood decoy ducks.

According to members of the court party, there was a suggestion that the altercation between the girl's father and Peter Pitseolak had created a potential for violence that might have ended in the murder of Pitseolak or somebody else. Interviews in Cape Dorset could not confirm this. "I certainly never heard that," said Tommy Manning, Peter Pitseolak's son-in-law. (As one of the few fluent English-speaking Inuit he had served the court as interpreter.) But Tommy Manning did not believe that Peter Pitseolak had right on his side; it might have been different, he said, "if Towkie had agreed."

By the time Peter Pitseolak returned to Cape Dorset, the young woman in question had been married off. In camp days an elderly or otherwise not very promising man was the fate in store for a young woman who became an embarrassment. "You will have to marry an old man" was the threat sometimes levelled at troublesome girls.

Few Arctic women regret the passing of the old marriage customs. Through their organization Pauktuutit, they have become stalwart fighters for women's rights.

Mark de Weerdt returned to the community some months after the trial. "The next summer Pitseolak was on the beach with the other fellows rolling drums. He had become one of the people after having been the big boss." Perhaps Peter Pitseolak felt some momentary decline in prestige. At least during south Baffin fur-trading years the camp bosses had been "powerful like mediaeval kings," as James Houston once told a researcher (they have also been likened to the Mafia), and the generation of Peter Pitseolak and his brothers was the last to exercise that power. "The teachers came in 1950 and the government came in '56. After this we started coming in to the settlement," Peter Pitseolak recalled in his account of the end of camp life. Like people all over the North, he left his own camp when his children had to go to school. "For myself I am sad that the Eskimo way has gone."[3]

The day of the camp bosses was almost over when *R. v. Pitseolak* came to trial. As new community structures developed in the settlements, new positions of leadership evolved and eventually young Inuit achievers appeared to fill them.

But in contemporary life Peter Pitseolak's name is far from forgotten. After his death the Department of the Secretary of State of Canada bought from his estate the negatives of the photographs he had taken of camp life from the 1940s, to the 1960s – usually developed and printed by his wife Aggeok. Peter Pitseolak used to say he took pictures "to show how for the future," so that his grandchildren and great grandchildren would know how life used to be. Increasingly, in Canada and beyond, his photographs are recognized as an important visual testimony of the last days of one of the world's great hunting cultures, taken by a member of that culture. The school at Cape Dorset has been named in his honour, a plaque in his memory has been affixed to a rock, and at last count fifteen children, both boys and girls, had been given his name. "He took pictures," Cape Dorset people like to remember, "before any white man told him to."

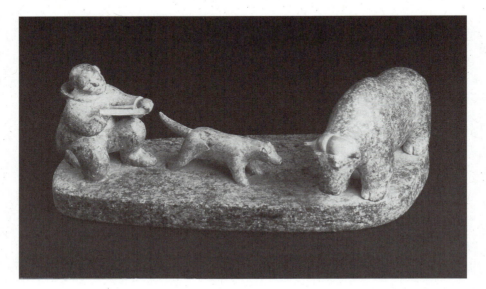

R. v. Kogogolak
Attributed to Bob Ekalopialok, c. 1910–70s
Kugluktuk (Coppermine), NWT
Stone, wood, sinew, copper
19 × 8.5 × 7.3 cm

1959

Regina v. Kogogolak

Two exhibits once represented *R. v. Kogogolak* in the Yellowknife Court-house Collection, but the massive musk-ox skull has recently been removed – it awaits a display unit of its own – leaving only a carving by Bob Ekalo-pialok of Coppermine (the artist's son Sam Tablo still remembers his father making it). The work shows Jimmy Kogogolak[1] shooting a musk-ox, an act contrary to the NWT game ordinance. No laws imposed in the Northwest Territories were more disliked by native people than the NWT game laws. James Kavana, now of Coppermine but for years a superb interpreter for the police, the courts, and white authorities in the Cambridge Bay area, says, "I tended to keep away from that kind of thing. I hate seeing someone become a victim, being tried by laws to which he is not accustomed."

But Kavana, nonetheless, was interpreter for the court in *R. v. Kogogolak* and present for the opening salvos Mr Justice Sissons fired in what was to be a seven-year battle to protect Indian and Inuit traditional hunting rights. In this he was joined by Morrow, who as counsel argued Sissons' view of the law. The struggle took them from JP court, to the NWT Supreme Court, to the NWT Appeal Court, and finally to the Supreme Court of Canada. It is often said that they lost the battles but won the war.

"Sissons could not have foretold what an incredible impact his decision in *R. v. Kogogolak* would have," declared Toronto lawyer Andrea Rowe in her study of cases that came up before the Sissons and Morrow courts.[2]

On or about 26 February 1959 Jimmy Kogogolak shot a musk-ox on the ice of Cape Colborne in Queen Maud Gulf in the Cambridge Bay area. "While the shot was not exactly one heard around the world, it was certainly heard in Ottawa," Sissons later wrote.[3] After Kogogolak returned to Cambridge Bay with his dog-team, he was informed at the HBC post that RCMP officer Corporal R.N. Milmine wanted to see him, as he had heard a musk-ox had been shot. Milmine took the following statement from Kogogolak:

Arthur Apathok and his wife were with me. I shot at the musk ox once and hit it, then Arthur took over with his gun and fired two more shots and killed it. The skin and head are at Cape Colborne. We ate all the meat. The reason that I shot the musk-ox is that we were out of grub. Arthur and I were at Cape Colborne tending traps. We had been camped there quite a while before we shot the musk ox. We did not come back to Cambridge as we had to tend the traps even though we were short of grub.

Cape Colborne is only two hours away by dog team from Cambridge. I have no money at the Hudson's Bay Company. I know I was not supposed to hunt musk ox. I was going to tell the police right away about shooting the musk ox but other people told me not to …[4]

Milmine went to the scene and dug up the head and skin near Port Colborne, and Kogogolak was charged with shooting a musk-ox in contravention of the NWT game ordinance, an offence that carried a hefty penalty in terms of fines and/or imprisonment.

Originally *R. v. Kogogolak* was one of several musk-ox cases slated to come up before Magistrate Phinney, but when Phinney suggested Sissons take them on instead, Sissons found the invitation "irresistible"[5] – indeed, he had probably been waiting for just such an opportunity.

At the trial, Sissons came quickly to the point as he addressed Crown attorney Mark de Weerdt:

The Court: Well, Mr. de Weerdt, what bothers me is the question as to whether the Game Ordinance does apply to an Eskimo.
De Weerdt: If I might offer a simple argument, the Ordinance applies to all persons in the Territories, and not just to one or another class of persons.
The Court: It is not on that ground I would base my doubts.
De Weerdt: Perhaps I haven't grasped the point.
The Court: Well, I may as well give my judgement, because I can explain it better by giving my decision. It appears to me there is a very important point involved here.

Sissons held that the NWT game ordinance did not apply to Inuit and that their hunting rights could not be extinguished except by the Parliament of Canada (that is, not by any law of the Northwest Territories). He held that Inuit had the right to hunt freely for food all over unoccupied Crown lands, and that the Royal Proclamation of 1763 still guaranteed to the Inuit the right to hunt and fish in the manner they had followed since the days millennia ago when they first populated the Far North.

Sissons found Kogogolak not guilty and in his decision eloquently explained the rationale that would underlie his judgments in future game cases. It reads in part:

Traditionally, this is the land of the Eskimos – the Inuit i.e., – the People (par excellence) – and from time immemorial they have lived by hunting and fishing.

Historically, in accord with the equitable principles of the British Crown, they have been assured of their right to follow their vocations of hunting and fishing.

In the early days the Eskimos were considered as a tribe or nation of Indians. The Supreme Court of Canada has held that Eskimos are "Indians" within the contemplation of sec. 91 (24) of the British North America Act, 1867 … and under the exclusive legislative juridiction of the Dominion …[6]

In 1763 a Royal Proclamation was issued following the *Treaty of Paris*. This proclamation conserving the hunting rights of the Indians has been spoken of as the Charter of Indians Rights. It is the *Magna Carta* of the Eskimos. Indians have their treaties. Eskimos have none … This proclamation is the only bill of rights the Eskimos have as Eskimos. They seem to have nothing else. What they have is extremely important and far reaching, and must be guarded and upheld by the court …

In these days when there is much talk of a Canadian Bill of Rights [the Canadian Parliament would adopt the Canadian Bill of Rights the following year, in 1960] it is well to keep in mind the rights of the Eskimos. Talk of a new Canadian Bill of Rights would be rather strange and futile if at the same time we treat the old Eskimo Bill of Rights as a dead letter.

I think the Royal Proclamation of 1763 is still in full force and effect as to the lands of the Eskimos ...

There has been no treaty with the Eskimos and the Eskimo title does not appear to have been surrendered or extinguished by treaty or by legislation of the Parliament of Canada.

The Eskimos have the right of hunting, trapping and fishing game and fish of all kinds, and at all times, on all unoccupied Crown lands in the Arctic.

But in the last paragraphs of the decision, Sissons noted that while laws passed by the Council of the Northwest Territories could not do it, the hunting rights of the Inuit might still be taken away from them – by legislation of the Parliament of Canada.

The ground was now set for some fancy legal footwork. The Crown did not appeal *R. v. Kogogolak*, but the bureaucrats followed Sissons' advice. On the recommendation of Northern Affairs, the Canadian Parliament made several amendments to the Northwest Territories Act. These, Sissons later contended, were slipped through a sleepy Parliament in the dog days of summer. As a former member of Parliament, he said he well knew how easily this could be done. The amendments, whose purpose was to give the territorial game laws the force of dominion legislation, made all laws of general application in force in the Territories – except where otherwise provided – applicable to Eskimos in the Territories. Further, the powers of the commissioner (then Gordon Robertson) were changed to allow him to make ordinances relating to game that would apply to Indians and Eskimos, although nothing in this amendment, it was carefully stated, was to be construed "as authorising the Commissioner-in-council to make ordinances restricting Indians or Eskimos from hunting for food, on unoccupied crown lands, game, other than game declared by the Governor-in-Council to be game in danger of becoming extinct."

Then hard on the heels of the amendments came the ordinance: "His Excellency the Governor General in Council, on the recommendation of the minister of northern affairs and natural resources, pursuant to Subsection 3

of Section 14 of the Northwest Territories Act, is pleased hereby to declare muskox, barren-ground caribou and polar bear as game in danger of becoming extinct."

Sissons was furious. It was sport hunting by southern white men, he believed, that endangered the game stocks, not hunting by aboriginal people. Parliament had been led into an attempt to repeal the Royal Proclamation, but as Sissons saw it, the tricky legislation – a combination of amendment and order-in-council – had not accomplished what it had set out to do. He waited to see if Northern Affairs would appeal his *Kogogolak* ruling or ignore it. It soon became apparent that they would ignore it, an approach for which they were harshly chastised by C.A.G. Palmer, managing editor of *Criminal Reports*, who wrote that the dominion government, through the Department of Northern Affairs and encouraged for the most part by the Department of Justice, had acted "in complete disregard for the rule of law, with, as its only excuse, its own untested opinion of the effect of the 1960 amendments to the Northwest Territories Act to weigh against the clear decision of *R. vs Kogogolak*."[7]

Justices of the peace, presumably following instructions, continued to convict Inuit for hunting musk-ox. "You can't prove it of course but it is obvious these JP fellows are getting their advice from Ottawa," Sissons declared.[8] In the two years following *R. v. Kogogolak*, JPs handed down at least eleven guilty verdicts in such cases. These came to Sissons' attention thanks to eagle-eyed secretaries who spotted the records of these trials as they came in from JP courts across the Territories. Sissons demanded that the verdicts be quashed, and when the Department of Justice, in consultation with Northern Affairs, took no action, he began to hear appeals. Shortly he would overturn guilty verdicts in *R. v. Koonungnak* and *R. v. Kallooar*.

Doing much of the Crown work at the time was David Searle. "Dave was a nice kid, but ...," says court reporter Everett Tingley, who had a ringside view of the court at this time. Dave was scrappy. And there was considerable provocation. As the appeals went against him, his frustration mounted. "You're bound to win if you represent a native," he told Elizabeth Hagen Bolton.

Tingley says, "I remember the day the judge ruled on the *Kallooar* case. Dave Searle was arguing in front of him, and as you know the judge was a typist – he did his own typing. He was sitting there with his eyes half open and Dave talked and talked to make his point. Finally the judge's eyes popped open. 'Finished?' Dave says, 'Yes.' And the judge says, 'Oh, by the way, here is my judgment,' and he hands him a paper. Dave wanted me to do a transcript of this but I said, 'Ohh no, I don't want to make trouble with the judge, I don't want to get fired.' Dave said, 'He had that all cut and dried.'"

Searle now lives and practises in Vancouver. Looking back on those days, he says, "Sissons was a good judge. On a scale of one to ten, he was an eight. If you had just an ordinary good murder, manslaughter, rape, buggery, whatever, you could count on him rendering a verdict true. But his Achilles' heel was when he thought he was in a position where he was protecting the rights of the underdog – then he would render some of the most incredible judgments.

"He kept his eye on the list of records that came in from the field from justices of the peace – convictions for small offences and any case where an Inuk had a fine for hunting musk-ox. He'd say, 'Ha!' and ring up one of the local defence lawyers and say, 'I want you to come over and take this case on.' He was monitoring the institutions that were hearing these cases. In any normal society that would be scandalous. Then he would hear them and of course he would decide that the resource was owned by native people and they could do whatever they wanted. Then he'd say, 'Based on this previous decision …,' and he'd rely on a precedent he'd manufactured to then form the basis of the next precedent."

Sissons was of the opinion that JPS in the NWT were often pressed into service with too little knowledge and training, and he believed it his duty to review the verdicts of the JP courts to make sure all before them had fair trials.

A legal stand-off now existed. Letters in the National Archives of Canada document the concerns of Northern Affairs' game officials at the time Sissons prepared to hear *R. v. Koonungnak:* "In view of past performance it is entirely possible that Judge Sissons will reverse the verdict on the basis

that the Game Ordinance does not apply to the Eskimo. Should this occur, implementation of any game management measures, which may be necessary but unpopular with the Eskimo, and therefore necessitate application of the Game Ordinance, will be impossible." After the expected reversal another official wrote, "May we be advised whether consideration has been given to the appeal of this case to a higher court, in order to establish the validity of the Game Ordinance?"

Sissons fully expected that the Crown would test his rulings, but the Crown bided its time. The original proceedings in JP court in *Koonungnak* had been full of legal error, inspiring an article – "Koonungnak's Day in Court" – in the *Time* magazine issue for 20 December 1963.[9] (Sissons enjoyed excellent relations with the press, periodically taking reporters along on the judicial plane.) As portrayed in the *Time* article, Matthew Koonungnak was definitely the hero, Ottawa bureaucrats plain silly looking, and Sissons was a white knight come to the rescue. Koonungnak had had a good defence – self-defence – and thereafter Sissons often used this case to illustrate the difficulty Inuit in those days had with the concepts of legal and moral guilt. In its abbreviation of the court transcript *Time* made the point:

The JP (to interpreter): Does he understand what the charge is? Does he say that he did this, or does he say that he didn't do it?
Matthew: Yes, I did this.
The JP: Matthew Koonungnak, you plead guilty. You admit you killed the animal. The law was made, Koonungnak, because so many have been killed that very soon this type of animal is going to disappear. Do you understand this?
Matthew: I understand now.
The JP: Let me ask you one more question. Should you see another musk ox, what are you going to do then?
Matthew: If he comes towards me, I would kill it.

There were other errors, too, and in *R. v. Kallooar*, Sissons' next reversal, in which Kallooar was charged with abandonment of game fit for human

consumption, the evidence for the charge was not clear-cut. The definitive test for the game laws came after *R. v. Sigeareak*. This case was to go all the way to the Supreme Court of Canada.

In July 1964 Sigeareak, from Whale Cove on Hudson Bay, shot some cari-bou, cut out their tongues, and left the carcasses to rot. On 27 February 1965, he was charged with abandoning game fit for human consumption contrary to the game ordinance. He was to come up before Magistrate Peter Parker. By now David Searle, acting for the Crown, had formed the opinion that Sissons was handing down "crackpot law," as he said in Jack Batten's *Lawyers*, and he was prepared to play a Machiavellian hand – "I wanted an acquittal the first time round."[10] Searle called on Parker and together they worked out a strategy. As a first step Parker found in his judgment that the Crown had made out a case for abandonment: "If the respondent had been a white man I would have found him guilty. However, I held that the decision in *Regina v. Kallooar* was binding on me. Consequently, since it appeared to me that the game ordinance must be deemed not to apply to an Eskimo, I acquitted the respondent."

The way was now clear for Searle, acting for the Crown, to appeal Parker's judgment through "stated case" – a legal procedure that allows an appeal against a proceeding in magistrate's court on the grounds that the verdict was erroneous in law.

Sissons, sitting on the NWT Supreme Court, now had to rule on the appeal: "Was the magistrate right in holding that the game ordinance, and particularly Section 15 (1) (*a*) thereof does not apply to Eskimos?" In his memoirs, Sissons wrote, "Naturally I held that the magistrate was indeed right. The crown then had a clear road to get the question before the appeal court of the Northwest Territories."[11]

William Morrow argued the case and when he lost in the NWT Court of Appeal, he took the case to the Supreme Court of Canada and lost there, too. In its decision the Supreme Court also found it "desirable to say specifi-cally that insofar as *Regina v. Kallooar* and *Regina v. Kogogolak* hold that the game ordinance does not apply to Indians and Eskimos in the Northwest Territories, they are not good law and must be taken as overruled."

Lawyers today appear to believe that Sissons was never on solid ground. His argument was that a royal proclamation was superior to any legislation of the Territorial Council. But constitutional scholars say that since the time of Charles II legislation by a properly constituted legislative body does not give way to a mere decree from a monarch. "George the Third could come out with a royal proclamation every second Tuesday," says Mark de Weerdt. "A royal proclamation cannot trump Parliament. And it could not trump Legislation of the NWT Territorial Council, under Parliament a properly constituted body making legislation within its proper sphere." Today NWT legal opinion has it that Sissons was ahead of his time. "His instincts were right but his methods left him open to criticism. And he was criticized, eventually by the Supreme Court of Canada," says de Weerdt.

Even as Sissons accepted defeat, the tide was turning in his favour. The Supreme Court decision had come in the wake of another Morrow defeat, *R. v. Sikyea*, destined to become known as the billion-dollar duck case. The decision in *R. v. Sigeareak* added to the consensus beginning to build in both legal and non-legal, native and non-native, quarters that there had been a breach of faith. This would grow. Sissons' career on the bench was coming to a close; he had already resigned when the ruling in *R. v. Sigeareak* came down, but he told Elizabeth Hagel Bolton, "It's going to be big – when the natives claim their rights." She remembers, "He was waiting for it – he knew it was coming."

Through the lens of hindsight, David Searle says, "He was one of the few who saw it." In 1982 the Constitution Act of that year guaranteed aboriginal rights – and the act can trump the ordinary legislation of Parliament. Searle has certain reservations. "It's one thing to recognize certain rights and it's another thing to absolutely slice up the farm and give it away." But he gives the judge his due: "To put it in today's context, he was probably thirty years before his time. Back then native rights were more or less ignored. He was forging ahead. If he'd been alive now, constitutionally his position would have been stronger. He was a leading advocate of native rights."

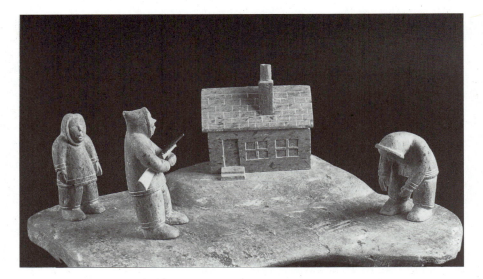

R. v. Ayalik
Attributed to Sam Anavilok, 1936–82
Kugluktuk (Coppermine), NWT
Stone, wood
31 × 12.5 × 15 cm

1960

Regina v. Ayalik

Mr Justice Sissons did not collect a carving to illustrate *R. v. Ayalik* – he remarked that no Inuk would want to carve a scene depicting the killing of an RCMP officer. But some time later Mr Justice William Morrow, who had acted for the defence on this case on his first circuit tour as a lawyer with the NWT Supreme Court, acquired a fine carving that illustrates the crime. The piece is attributed to Sam Anavilok, who had lived in Cambridge Bay at the time of the trial and had observed it at firsthand.

In its day, *R. v. Ayalik*, heard at Cambridge Bay on 22–23 April 1960, stirred more controversy among white northerners than any other Sissons case. Jimmy Ayalik, aged twenty-four, stood trial for murder in the shooting death of twenty-two-year-old RCMP constable Colin Eric Lelliott. Both the verdict and the sentence were unpopular, and the Crown appealed the sentence at the new NWT Court of Appeal when it sat in Yellowknife for the first time.

Court reporter Everett Tingley describes the atmosphere in the community of Cambridge Bay after the verdict: "They found him guilty of manslaughter and Judge Sissons gave him five years. Oh, there was bedlam in the courtroom. They said, 'Five years … is that all a policeman's life is worth?' There was almost a fight. I stayed with the judge and the clerk at the house of the area administrator and he just kicked us out. He had us thrown out. The community was divided. On the one side there were the parents, the clergy, and on the other side the government, the area administrator, and the police. They were just fighting-mad at each other – the police wanted death, they wanted blood, and naturally the parents and the clergy, they were happy with what happened. But, oh boy, things were tough – the police wouldn't give the pilot any gas."

Details of the crime first emerged in the preliminary inquiry on 7 March 1960 before Police Magistrate L.H. Phinney. Mark de Weerdt acted for the Crown and William Morrow, QC, taking his first murder case in the NWT, for the defendant.

The first witness was Mary Ellen Milmine, wife of Corporal R.N. Milmine. She recalled that on 12 January her husband was getting ready to escort a mental patient to Edmonton when, at about 6:30 a.m., a woman called Bessie came to the door and asked for help. She had left her husband, Peter Okalitana, at home trying to hold down a drunk.

The story elicited in court was that Bessie and Peter Okalitana had been out visiting playing cards with other Inuit when Jimmy Ayalik came into the house and started to play, too. Drunk on home brew, he became increasingly rowdy. Hoping to prevent a fight, Peter and Bessie took him home to their house, but once there Ayalik became violent. Peter Okalitana then sent Bessie for help.

Corporal Milmine first had Constable Lelliott accompany Bessie to her house, but when he received word that more help was needed, he went himself. He found Ayalik sitting on the floor in a drunken state. "I could smell the home brew on his breath," Milmine recalled in his testimony. Though it was hard to move him, Milmine and Lelliott got Ayalik up and took him first to the RCMP lock-up, but because there was no heat in the cells, they decided to install him in the single men's quarters of the detachment, where Lelliott would guard him. Police weapons were on the walls.

About 7:30 a.m. Bob Milmine re-entered his house and began changing his clothes for the trip to Edmonton. "A few minutes later Colin came running in," recalled Mary Ellen Milmine. "My husband and Colin both ran out the door. Then I heard them shouting down on the ice, and I heard a shot …"

Corporal Milmine described what happened: "As I rounded the northwest corner, Constable Lelliott was a short distance ahead of me. I saw the accused standing in the yard directly opposite the detachment steps … he turned and ran for the sea ice."

Milmine and Lelliott had followed. "I shouted, 'Jimmy, come back here.' Constable Lelliott and myself ran down following him … Constable Lelliott was very close to him at the approximate juncture of the sea ice and the

land. However, he [Lelliott] tripped, he didn't fall, he recovered himself, but he lost a big of ground. He continued running out on the sea ice. Constable Lelliott was to the right of Ayalik. Ayalik stopped and turned to his right. I saw the gun, saw a rifle. I shouted to Lelliott. [Ayalik] turned and fired from a hip position. Constable Lelliott fell to the ground. Ayalik turned and ran off towards the native camp."

Milmine ran to Lelliott, who was lying on his back. He was conscious. "He spoke to me. I attempted to move him. I was unable to do so, and immediately ran back to my dwelling, where I phoned the Department of Transport."

"My husband came running back into the house," Mary Ellen Milmine told the court. "I started putting my clothes on and ran down to the ice, and I found Constable Lelliott lying down on the ice. I came back to the house and got some blankets and went back down and covered Constable Lelliott and stayed with him."

Mary Ellen Milmine had brought a flashlight – there was little light in the Arctic early morning; the sun rose as 11:15 a.m. – and while she waited for the Department of Transport truck to arrive, she held the flashlight on Lelliott. "It appeared to me he was dead."

Constable Lelliott died of hemorrhage caused by a wound to both lungs. He was pronounced dead at the nursing station by Dr R.G. Pledger from the nearby DEW Line site. Dr Pledger also took a blood sample from the accused, who had been pursued and found running over the arctic terrain two and a half miles out of town. "He continued to run until the Bombardier was practically along side of him," Milmine said. "I got out of the Bombardier and we took the accused into custody. At this time I struck him and knocked him down."

Prior to the chase, Milmine had gone to the RCMP post to get firearms. "At the time," he said, "I noticed that a 30–30 Winchester rifle was missing from the arms rack in the detachment office. I also noticed two rounds of ammunition 30–30 which was lying on the office desk."

The preliminary inquiry heard that after his capture three statements were taken from Ayalik with the help of an interpreter, two through questioning by a Constable French and the last through questioning by Milmine. The record shows that a distraught Milmine had said that he wanted to kill Ayalik but would not do so.

The inquiry also heard evidence relating to Ayalik's mental health. A nurse testified that one of his uncles had spells and blackouts, and Dr Pledger testified that he had treated people in Cambridge Bay for petit mal, a form of epilepsy. "It transpired that Ayalik was an epileptic," de Weerdt recalls, reviewing the case many years later. (He notes that a medical paper suggested that the incidence of epilepsy in the area might have had something to do with trichinosis. He also remembers that a week before Lelliott's death the community had watched an action-packed movie containing a scene in which a cowboy swung around and fired from the hip.)

At the end of the preliminary hearing, de Weerdt moved that there was sufficient evidence to place the defendant on trial as charged and Morrow responded that the accused had had the benefit of an interpreter, had nothing to say, and that the defence was reserved. Ayalik was remanded for trial.

The trial took place on 22 and 23 April. As usual Sissons and the court party flew in and billeted themselves in the only way possible in those days – with community members, willing or otherwise. They found the community grieving and wracked by tension. Mark de Weerdt had a bed in the police barracks, but he moved when he discovered that Morrow, appearing for Ayalik, was billeted in a Quonset hut with holes in the door that let in the gusts of a mighty gale. He felt he had to share this accommodation or be considered party to what the police had arranged for the defence. He and Morrow slept fully clothed in their sleeping bags on tables they arranged on either side of the stove.

At this point Morrow was midway through his first court circuit, at the end of which (he revealed in his memoir *Northern Justice*) he had appeared in eleven cases in ten days at the rate of $10 a day and had travelled six

thousand miles in a single-engine Otter on skis. Certain that on this trip he had a defence counsel, Sissons had planned his longest circuit ever: from Yellowknife to Aklavik, Inuvik, Sachs Harbour, Cambridge Bay, Repulse Bay, Coral Harbour, Cape Dorset and Iqaluit, then back through Lake Harbour and Hall Beach to Yellowknife. Recalling this initiation, Morrow wrote:

During this trip I discovered what was required of a circuit judge, and the lessons learned proved to be extremely valuable to me later when I began arranging my own circuits. I also acquired some idea of how important it was for the judge of that vast area to show an empathy for the people and their unique problems. Over the course of those many miles I developed a deep admiration for "Ekoktoegee," as Judge Sissons was called – "the man who listens and thinks." In addition I lost several pounds from tugging on a rope at the tail end of the plane so the pilot could head into the wind, and then running to jump aboard the plane before it was airborne. I was already beginning to "get hooked" on the north.[1]

Tension was heavy in the air when Sissons began to hear *R. v. Ayalik.* "The effect of Ayalik's home brew on his mental condition was the key to the defense," Sissons later wrote. "There was expert testimony on what the effect might have been. Dr. Blake Burgess Caldwell, senior chemist of the RCMP at Ottawa, said there was evidence of gross intoxication and the accused would be affected both mentally and physically."[2] Apparently the home brew Ayalik had made was 25 per cent alcohol. He had brewed it from a mash of rice and yeast and had placed it in the porch of his snow house. Before going over to the card game, he had drunk it all. "He had a reading of .38 in his system. That's phenomenal because we had evidence that with .25 you could be dead. He was a tremendously solid little man," de Weerdt recalls.

In a statement admitted as evidence, Ayalik said that while detained in the single men's quarters of the RCMP post, he had decided to do away with himself in the old Inuit manner and had tried to stab himself with a knife.

Lelliott had wrestled it away from him. Then, while Lelliott had run to get aid, he had taken a gun from the rack. "He took one shell and loaded the rifle. Then he thought he would not shoot himself in the house and make a mess but would go outside," Sissons wrote in his memoirs.[3]

In most of the jury trials that came before Sissons, jury deliberations were exceptionally brief. "I only have time for one cigarette," Sissons once told Tingley. But in *R. v. Ayalik* the jury was out for an hour and a half, allowing Sissons the time to smoke more than his usual quota. Sissons also deliberated. The jury might find the accused guilty of murder, guilty of manslaughter, or innocent. From his experience at the Orillia mental asylum he knew that epilepsy often ran in families (besides Uncle Bob's petit mal, Ayalik's mother had blackouts) and that alcohol exacerbates the problem and may produce something similar to DTs. Sissons wrote, "I felt that a proper verdict would be not guilty by reason of insanity, but the trial judge is not entitled to an opinion."[4] When the jury returned, they found Ayalik guilty of manslaughter, and Sissons sentenced him to five years in the Saskatchewan Penitentiary at Prince Albert. He believed that Inuit had shorter life spans than white people (this was probably true in traditional days because of the high incidence of kayak accidents, other accidents, and high infant mortality) and that therefore the five-year sentence he imposed was equal perhaps to a life sentence in the south.

Tensions in the community exploded when Sissons announced the length of the sentence. "Is that all a policeman's life is worth?" Tingley remembers people asking. With difficulty the court party gassed up its plane. "The pilot was very tactful with the police," Tingley says. Defence counsel Bill Morrow later told his wife Genevieve, "I was certainly glad to get out of there."

The Crown appealed the sentence (though not the verdict), but de Weerdt chose not to act for the Crown. After the conclusion of the trial, a new fact came to light. While talking to a firearms expert over at the RCMP post, de Weerdt asked if the guns on the police rack were ever left loaded. "Oh no, never" was the answer. De Weerdt asked casually, "Why don't you

show me?" The man picked a gun off the rack, opened it, and out sprang a live round. According to Tingley, de Weerdt stalked out of the post. He notified both Sissons, who had already delivered his judgment, and Morrow that he had found a loaded gun on the rack. De Weerdt points out that while Ayalik's crime might still have been manslaughter, it would have made for a more sympathetic case if he had pointed and fired the weapon not realizing it was loaded. But Morrow chose not to bring this information forward at the appeal, perhaps considering that should it give cause for a new trial, considering the mood in the North, there was the possibility of a less favourable verdict and sentence.

The new NWT Court of Appeal upheld Sissons' sentence. Its judgment read in part: "It should be noted that in the present case the learned trial judge has a distinct advantage over the members of this court, for with his wide experience in the far flung areas of the extensive jurisdiction of the trial division, he has knowledge of local conditions, ways of life, habits, customs and characteristics of the race of people of which the accused is a member … We cannot say in reviewing his decision that he failed to take any circumstances into consideration or proceeded under any wrong principle."

Sadly, the story of Ayalik's involvement with the courts does not end here. Ayalik killed again and served another sentence. In the mid-1990s, however, he could be found living in Cambridge Bay, where people spoke well of him. He no longer drank, and his demons appeared subdued.

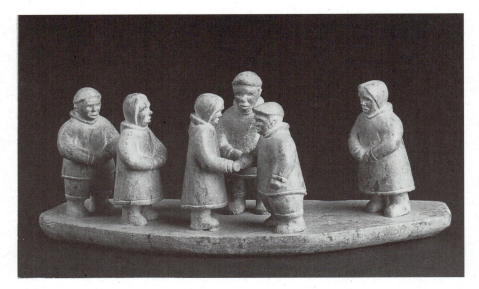

Re Noah's Estate
Artist unknown
Kugluktuk (Coppermine), NWT
Stone
27 × 10.5 × 11 cm

Re Noah's Estate

Cases like *R. v. Kikkik* and *R. v. Angulalik* were much reported in the press, but in less publicly discussed cases Sissons brought down judgments that touched the lives of native people across the Territories. Such a case was *Re Noah's Estate*, which upheld the validity of marriage by native custom. Noah, a young man from Broughton Island off the coast of Baffin Island, died on Christmas Day, 1959, in a bunkhouse fire at Cape Dyer, a site on the DEW Line (the line of radar stations built across the North) where he had moved to work.

Poor Noah left a wife, Igah, and their child, Jeannie. As an employee on the DEW Line defence project, his life was insured for $25,000, but as Noah had left no will, the question arose as to who should get the money. Officials in Ottawa noted that there had never been a marriage licence issued to Noah. How then could Noah have a wife?

There were thousands of marriages made in accordance with custom in the NWT. If they were invalid, it followed that there were thousands of illegitimate children.

Sissons ruled on the case in 1961, the year after the 1960 amendment to the Northwest Territories Act had been slipped through a sleepy Parliament. That act had made all laws of general application binding on all persons, whether they be whites, Indians, or Inuit. It was during this case that Sissons' relations with officialdom reached what may have been their nadir.

Elizabeth Hagel Bolton was acting as public administrator. She remembers the case: "I was administering the estate left by Noah in my official capacity, and I took the view that there was a marriage and therefore the widow and the child were entitled to the estate. But apparently the government took a different view. Noah and Igah had never been married in the official sense, and I was given to understand Igah and Jeannie would not be legally entitled. I think I got some sort of message to hold everything.

"Judge Sissons was furious when he heard the view that was going to be taken. They had used the word 'concubine' and that made his furious. And

I think that it was then that he made arrangements to go to Broughton Island and investigate the matter of Eskimo marriage. I had to hold the estate for the results."

From his ringside seat, court reporter Everett Tingley heard Sissons make his much-quoted remark, "No Ottawa bastard is going to make ten thousand bastards up here."

Sissons' next circuit took him to Iqaluit on 2 August 1961. He had been advised. that an application would be put before him there for an order ascertaining Noah's next-of-kin. He had decided to take the court the next day to Broughton Island, three hundred miles away, for a hearing to "establish the facts and circumstances of the marriage of Noah and Igah, and since there seemed to be some question about the status of the union it would include the customs of Eskimo marriage."[1]

Sissons had appointed Mark de Weerdt to act for Noah's brothers and sisters, who would inherit if Noah's marriage was not upheld. De Weerdt recalls that on this Iqaluit stop the court had quarters in a series of little rooms with beds in them and a bathroom down the hall. "We all came in there to do other work, and the public administrator from Ottawa arrived. That was Frank Smith in those days. He was carrying a brief which in somewhat grandiloquent terms told the judge he couldn't go to Broughton Island, which he was pretty determined to do, to hear evidence, as was the court's practice, on the ground in the place where the people should know what they were talking about."

Frank Gramani Smith, in the Legal Division of the Department of Northern Affairs and at the time public administrator for the eastern Arctic, had been instructed to advise the court not to go to Broughton. He had also been given an argument to put on record, which read in part: "Only evidence that is relevant to the issue should be accepted by the court. Such evidence is limited to the existence of persons in a degree of consanguinity to Noah, and the existence of persons having gone through the form of marriage with Noah, pursuant to the laws of the Territories, which in this instance are

exhaustively set out in the Marriage Ordinance. Any other evidence, e.g. evidence relating to the Eskimo custom of concubinage, is irrelevant."

If Sissons were to persist with his plans, more arguments had been prepared. These were now put on record before an astonished audience:

The Eskimo custom of concubinage is distinguished from the relationship of man and wife ordained by western Christendom and sanctioned by western civil law ... [The relationship] is not a bar in the community to the male paramour making his paramour available to his guests and friends, nor to the male paramour availing himself to other men's concubines ...

The group of Eskimos of which Noah and Igah are members are not barbarous aborigines. They have had the benefit of communion with and teaching by the Anglican church for some eighty years and it is fair to say that they are aware of the concept of Christian marriage and are aware of the privileges of civil law.

The court should be careful not to impose its wish as opposed to accepting the wish of Noah. It is reasonable that Noah voluntarily chose to take Igah as a concubine rather than as a lawful wife. His life and associations with the church, the government and the white man lead to the conclusion that he was aware of the concept of a lawful wife and her privileges but chose rather another relationship whose incidents we must assume were more to his liking.[2]

According to court reporter Everett Tingley, a witness to the drama, Sissons right there and then considered charges of contempt. Such conflicts have been played out since the days of the Stuart kings, who on occasion might tell judges how they wanted cases to come out. Tingley says Sissons summoned the RCMP. But Frank Smith was merely a spear carrier. The man Sissons would have liked brought before him, the actual author of the brief, had not acknowledged his handiwork and was safely in Ottawa, although Sissons knew his identity. "He was stuck with Mr Smith," one officer of the court observes. Sissons saved his wrath for his judgment and his memoirs, calling the Northern Affairs argument "monstrous" and "crass, cruel, smug

and sly." Northern Affairs had presumed to read the mind of a man safely dead and to coerce the court into a precedent-setting judgment that the marriage of Noah and Igah was not valid.[3]

What possessed the distant bureaucrats to put forward such distasteful arguments? Apparently more than met the eye. At the time, many Inuit children, some still living in remote camps, received education in the so-called religious residential schools. The reputation of these schools has suffered in recent years as the result of exposure of sexual scandals, but the current generation of Inuit leaders, many of whom attended these schools, will frequently attribute their success to an elite education. ("We see them all the time on TV; we're so proud of those boys," a member of the Grey Nuns in Chesterfield Inlet declared in the 1980s.) A veteran court watcher says, "Senior bureaucrats were placating certain constituencies and I wouldn't want to be quoted as to which religious denomination. Catholic or Protestant? Well, it could be both. In those days they played footsie over the schools. You had all these residential schools, to which native people were going, staffed by nuns and priests and Anglican clergy. The churches felt they were doing a good deed, which they no doubt did in certain cases. And the government had these people going to school and could feel they were doing good things for them. The churches were also recruiting for their particular faith, for their particular clergy. So a lot of objectives were being served. But it all fell apart when the Pentecostals arrived on the scene and wanted equal time. No crucifixes on the walls, please, for our guys! The government began to realize they could only make deals, as it were, with the majors and these very irritating minors were coming along upsetting the apple cart. *Noah* is a case that couldn't have happened if the government hadn't been so close to the churches which were running the schools and also little hospitals, and getting lots of money from the government."[4]

The court set off for Broughton as planned. "Sissons, very much according to character, wasn't going to let anybody tell him what to do. He had every right to take that position, and he no doubt felt he also had a duty to

do so," says de Weerdt. "We had a hearing in Broughton and heard evidence [to the effect] that in that part of the world when a preacher was not around people did not stop having families. The parents of the man and woman would get together and would agree that they were married. The young people accepted that and it was just as good as any other marriage."

The court party installed itself in a teacher's house and collected evidence from Igah, who held Jeannie on her knee, her parents (her father was the Anglican catechist), and others. "I remember the day in Broughton," says Everett Tingley. "The judge asked how marriages were conducted and the answer was that all the relatives would gather and they'd sit around and talk … I knew how they talked. They'd drink tea and smoke their pipes and when they were happy they'd go 'Eeee!' and they'd agree. And the judge asked, 'Now what happens if one person doesn't agree?' Then there would be no marriage." At one point Ottawa's representative introduced the concubine theory. Tingley recalls the question: "'Is there any truth to the stories I hear that Eskimos loan their wives to visitors?' The answer was no. Judge Sissons spoke up and said, 'That's the way people like it to be though.'"

It became clear from the responses that Igah and Noah had been validly married according to Inuit custom. "The distinguishing feature seems to be that marriages in Eskimo society are very much a family and community affair – as they were in the early days of our society," Sissons noted.[5] But was the union of Noah and Igah valid under the law of the Northwest Territories? Their marriage had not been solemnized under the marriage ordinance or registered under the vital statistics ordinance. There was no reason why this couldn't have been done, officialdom considered: the RCMP and an Anglican minister were in Pangnirtung, 120 miles away. The man from Northern Affairs had been instructed to say that Broughton Island and Pangnirtung "were separated by a range of high but not altogether impassable mountains."[6]

Back in Yellowknife on 15 November 1961 the lawyers presented final arguments, citing cases where the courts had upheld Indian custom marriage. In

his ruling Sissons found the Northern Affairs' description of marriage according to Inuit custom (as a system of concubinage) "fanciful and scandalous as regards the Eskimos and as regards Noah and Igah." He found that their marriage "complied in every respect with what was known according to the old law of England, as consensual marriage, that is, one formed or existing by mere consent." Furthermore, the old law of England and the general law of Europe recognized this type of marriage as "in all respects perfect." Consequently, he ruled that Igah and Jeannie were Noah's legal heirs and could inherit.

Sissons' ruling was not popular in Ottawa. "Yes, there were a lot of people who felt the judge was overstepping the mark a lot," says Elizabeth Hagel Bolton. "My own opinion was that every opportunity was taken to try and step on his toes. But maybe that was just my view. He was very jealous of Eskimo rights, native rights of any kind, and so he was forever making waves, which was a wonderful thing for them but it really upset Ottawa. His advantage was that he was a judge. They would have had a very hard time taking his judgeship away from him, and I think they would have done it if they could. I'm sure he gave them many headaches but then they gave him many, too. He felt the bureaucrats didn't understand the natives and that the natives needed protection from them. The Ottawa civil servants were so distant whereas he was right on the ground among them."

During November 1961 R.G. Robertson, in his capacity as commissioner for the NWT, made a visit to Yellowknife. Letters later exchanged between Robertson and Mark de Weerdt suggest that de Weerdt attempted to pour oil on the troubled waters. On 30 November 1961 he wrote to Robertson:

Your generosity in taking time out to discuss Territorial problems with me during your recent visit to Yellowknife was much appreciated.

I noted your concern over the application of local law to the Eskimo people and the dangers which differentiation between them and others may create. This is a very real problem and one which continually presents itself both in and out of Court.

The impact of our ways upon the Eskimo may perhaps be quite profound insofar as personal property and domestic relations are concerned, as in a case such as that of Noah, Eskimos perhaps having very deepseated convictions, expectations and customs which we may ignore at the peril of much discontent and loss of respect and co-operation from them to say the least. It is in this spirit that counsel urged the Court not to ignore customary marriage.

Robertson answered on 6 December 1961:

I had a very useful conversation with the Judge at lunch on the same day I saw you. I am grateful for your suggestion that I ought to talk to him. I think we both found that our views are not nearly so far apart as, on the surface, they appear to be. He told me that he felt that the areas in which there should be some recognition of special Eskimo custom were quite limited and that most, if not all, of them had been touched upon already in some cases before the court. I still feel a good deal of concern about difficulties that can arise even on this limited front. As I mentioned to you, in many areas it would be impossible and certainly completely arbitrary to apply anything like a clear definition of the concept "Eskimo." I certainly feel that establishment of two laws differing on a race basis could have undesirable implications.[7]

In his memoirs Sissons described his meeting with Robertson: "He told me his department felt, and he himself agreed, that I was trying to establish for Eskimos laws different from those in effect for others, and that I was trying to prevent integration of the Eskimos." Sissons told Robertson that he was not making new laws for Eskimos – the old common law of England was good enough for him and for the Inuit.[8]

Mr Justice Sissons' ruling in *Re Noah's Estate* was not appealed and was a precedent-setting decision that secured important rights for native people.

Re Katie's Adoption
Alec Banksland (Peter Aliknak), c. 1928–
Holman Island, NWT
Stone
19 × 12 × 13 cm

1961

Re Katie's Adoption

"When people thought about adopting a baby from another family, they would talk about it together first … It was just like having a little meeting," explains Alec Banksland (also known as Peter Aliknak) of Holman Island. The two families would talk "about how the adoption would be – because the parents were going to give the baby away."

Alec Banksland's carving that illustrates *Re Katie's Adoption*, still an important legal ruling for the Inuit, comes out of his own experience. "Nobody told him to make that carving," says Elizabeth, Alec's wife, whose English is perfect as a result of years of hospitalization for tuberculosis. "Because he has an older stepbrother who his parents adopted, that's what he was going by."[1]

Both Elizabeth and Alec are surprised to hear that Alec's carving – "a true story" – is on display in the Yellowknife Courthouse. They don't know how it got there. "He did so many carvings long ago and the white people who came around bought them," says Elizabeth. But she vividly recalls the occasion when the court flew into Holman Island to register "custom" adoptions. "I had to sign papers myself. My first baby boy was adopted out. His name is Billy. When he was about five months old, I was sent to the hospital in Aklavik with TB. My uncle and aunt adopted Billy in Aklavik in September 1949." Billy's adoption was made legal under the laws of the Northwest Territories more than fifteen years later.

The registering of custom adoptions came about as a result of Mr Justice Sissons' ruling in *Re Katie's Adoption* in Iqaluit in October 1961. He found that custom adoptions were valid even though they did not conform with the new NWT child welfare ordinance. The new law was an impossible piece of legislation, Sissons considered, impractical from the point of view of native people in much of the Territories. Once again he expressed himself appalled at the ignorance displayed by those who legislated for the Arctic.[2]

The Katie who figures in this important case is Kitty Noah of Iqaluit. On a visit there I looked for her without success, but I finally caught up with her by telephone when she was visiting Grise Fiord. "It all worked out great," she said of her adoption. In fact, I knew her adopting father, Noah, born at the turn of the century, and I had met his wife, Kiakshuk (in the court transcript Keeatchuk), a daughter of the American whaling personality George Cleveland – she was always helping out with parka making at the Iqaluit craftshop. They were famous south Baffin elders, and in the early 1970s when Noah was in hospital near Montreal, I used to go up and interview him about "the old way" and hunting techniques. He didn't mind, he told me; it helped pass the day. He missed home most, he said, "during *olotosie* (the long days) when the young seals were popping up." At that time of year he "wanted to be home to eat those young seals." And Noah passed on to me an Inuit maxim handed down by his father, Nuna, which I have found translates well: "Don't be lazy to go hunting so the seal will not be lazy coming to you."

Noah and Kiakshuk's petition to adopt a female child was first in line when Sissons decided to make his important ruling, and thus the judgment bears the name of their adopted child. Inuit knew it was good to have a paper, a legal document, for purposes of family allowances as well as for other sound reasons, but since they tended still to be camp dwellers, they could rarely provide the documents the NWT child welfare ordinance demanded. It would "require an army of welfare workers in the field to acquire the necessary information," Sissons wrote in disgust in his judgment.[3]

Later, in his memoirs, he wrote, "I declared in my judgement that adoptions in accordance with Indian and Eskimo custom were as good before the law of the Territories as those under the new ordinance. I ruled pointedly that adoptions in accordance with native custom had not been abrogated although that was in part the design of the iniquitous amendments to the

Northwest Territories Act, slipped past the dozing Parliament which also passed the Bill of Rights."[4]

His judgment was explicit: "Although there may be some strange features in Eskimo adoption custom which the experts cannot understand or appreciate, it is good and has stood the test of many centuries and these people should not be forced to abandon it and it should be recognized by the court."

Adoption was an important social custom when Inuit lived "the old way," and it is frequent in Inuit life today. There are adopted children in many, perhaps most, Inuit homes. But custom adoption conformed and still conforms to very different rules from those that govern adoptions in the south, frequently, but not always, taking place within the extended family. For instance, in camp days the first child of a young couple was routinely given to grandparents so that the child would be a support in later life.

At the Iqaluit Elders' Hostel in 1994 Naki Ekho discussed some of the reasons Inuit adopted in traditional times: "I think there were two main reasons for adoption. In a particular family, if there weren't enough of them any more, if they were dying out from illness or something else, then another family would realize this, and although they may not really have wanted to give up a baby, an adoption would occur. Also, within families, older people were given children so they would have someone to look after them."

Naki herself gave up one of her children to her sister. "I felt great love for my sister Kudlu Pitseolak when her son didn't come back from the ice floes and was lost in the water, so to show my love I gave her one of my twins." And "two of my own," she says, are adopted. "It was thought that a person being given a baby was receiving a present. When the trade goods were beginning to come up around here, we had those old hand-cranked sewing machines. When I got a baby from one woman, I gave the hand-cranked sewing machine because I could not express how grateful I was, how happy

I was." All adopted children know who their natural parents are, Naki says. "There are no hard feelings at all but, rather, friendly feelings."

In ruling that custom adoption was legal, Sissons noted that it was virtually impossible for Inuit, who in most cases could not read or write in English and who lived in isolated communities, in some cases still in igloos, to comply with the requirements – affidavits of execution, notifications of placement within thirty days to the superintendent (a distant authority in Ottawa), medical reports, home study reports – all demanded by the adoption law southern bureaucrats had introduced. As for the requirement to supply last names, Inuit had no last names, only given names. It would be 1970, after a campaign across the Territories known as Operation Surname, before Inuit adopted last names as a measure of convenience.

"It is a shocking provision which makes it a crime for an Eskimo to follow his ancient custom in the traditional way," Sissons roared in his judgment. His ruling was not appealed, although bureaucrats would have liked to do so.

In a 20 November 1961 memorandum for Minister of Northern Affairs Walter Dinsdale, which accompanied a letter for the signature of the Minister of Justice the Honourable E.D. Fulton, NWT Commissioner Gordon Robertson expressed the exasperation of officialdom:

About three years ago he [Sissons] handed down a judgement on the application of Game legislation [see *R. v. Kogogolak* chapter] that would have had very unfortunate results. To make sure that this kind of thing could not happen again the Northwest Territories Act was amended by Parliament to provide specifically that "all laws of general application in force in the Territories are, except where otherwise provided, applicable to and in respect of Eskimos in the Territories." In the present judgement Sissons is ignoring this specific legal provision and deciding that the Child Welfare Ordinance does not apply to Eskimos in the way that it applies to other people in the north.

The general line of Sissons judgement goes completely contrary to the policy of avoiding racial distinctions and treating all people on the same basis.

In due course Robertson received a "Dear Colleague" reply from his minister: "It is frustrating to say the least to try to cope with this performance by the judiciary ..."[5]

Still, no action was taken, although Sissons believed that bureaucrats sought to ignore his ruling. In 1965, with a new commissioner in power, he took the court on a circuit that touched down at both eastern and western Arctic settlements with the express purpose of registering custom adoptions. During the circuit Sissons issued two hundred declaratory judgments.[6]

"When Sissons began dealing with adoption cases, he used to visit the natural parents, the adopting parents, see the baby, and prepare all the necessary documentation himself," remembers Mr Justice Mark de Weerdt. On this circuit Sissons took with him as a friend of the court RCMP corporal Bob Pilot, who interpreted for the judge and often filled him in on family backgrounds. Pilot remembers: "At each community we'd settle in at a table," and all involved in the adoption would present themselves. Sissons was aware that custom adoption could have a dark side. Orphaned children or, occasionally, children adopted as payment for a debt of some kind were sometimes reared as "slave children," doing the dirty work for the family. Bob Pilot says, "I think that's why he'd seek out the original parents and through the interview try to determine that they'd given the baby away without pressure, that they had not felt obligation." Eventually routines were established so that all applications could be documented before they reached the court.

In the modern North, of course, it is possible for Inuit to comply with the demands of the ordinance, but adoption the Inuit way in accordance with well-defined custom is preferred by native northerners and later judges

upheld its validity. Even so, aspects of custom adoption are changing with changing times.

Back in the 1970s Eleeshushee Parr, born in the 1890s and the oldest person in Cape Dorset, told a researcher of the pain she had felt when her first baby was taken away by older family members "because they wanted a hunter." Her baby was born early in the second decade of the century when the missionaries were introducing syllabics and reading and writing, and in return for the baby the adopting parents gave Eleeshushee two Bibles. "I felt very alone after they took away Paulassie," she remembered, "and for a long time I did not get pregnant again." During this lonely time Eleeshushee tried to forget her baby by learning reading and writing from the syllabics in the back of the Bibles. "I thought of reading – of learning to read – as like a river, how it starts small and grows and grows."

Such resignation and accompanying sublimation are probably not found today. In 1994 Madeleine Qumuatuq, a young woman currently taking training to fit her for a management position in Nunavut, discussed this type of custom adoption: "I was the youngest child of older parents and grew up on the land, and I was always told you can't do certain things – or you must do certain things – for survival. It was part of the customs that you took your first baby and gave it to your husband's parents. The couple didn't have a say. Today a couple could refuse; ten years ago, perhaps they could; twenty years ago, maybe not. But even ten years ago, you had to obey, especially if you had grown up in camp, knowing the customs. It did hurt me to give my baby away. The baby died – I think otherwise it would always have been a problem. You really didn't have a say because the custom had been drilled into your head. In today's society, anyway, I don't think it is right to do that. Some customs that aren't working in today's society we have to let go; just as we have to take some customs with us – for survival."

While native people wish to preserve custom adoption, the 1990s have seen calls for reform. "There should be more screening," Martha Flaherty, president of Pauktuutit, an organization representing Inuit women, says

when asked for her views on custom adoption. There has been concern that children are sometimes adopted into high-risk homes or by adopters too old to meet the needs of a young child. Demand for monitoring mounted on Baffin Island in 1993 after a Cape Dorset woman with a well-documented history of psychiatric problems was convicted of manslaughter in the killing of her adopted infant daughter. More safeguards have been provided for under the new Aboriginal Custom Adoption Act, passed by the NWT Legislative Assembly in 1994.

R. v. Sikyea
Sam Anavilok, 1936–82
Kugluktuk (Coppermine), NWT
Stone, wood, sinew
26 × 17 × 15 cm

1962

Regina v. Sikyea

It has been called "the billion-dollar duck case" because that has been its worth to native northerners. The duck in question, which Mr Justice Sissons had stuffed, a little dusty now but cleared by Supreme Court of Canada decree of the judicial suspicion of being a tame duck rather than a wild mallard, sits in the glass display case beside the sculptures that illustrate the important cases of the Sissons and Morrow era. For the viewing public it may not hold the same interest as the little Inuit carvings, many of them illustrating riveting stories of murder and mayhem, but that duck changed the political face of Canada.

The case began when Michael Sikyea, a treaty Indian of the Yellowknife area, was found with a dead duck in hand that had just been shot. He was charged in JP court with shooting a female mallard duck out of season, a contravention of an international treaty, the Migratory Birds Convention Act. He pleaded guilty and was fined $10.

Elizabeth Hagel Bolton was in on the *Sikyea* case from the beginning. Sissons was away when the case came up in JP court but on his return he heard the details from an Indian agent and asked her to file for appeal, which she did. "It was a foregone conclusion," she says. "I knew he would not uphold the Crown."

For despite the guilty plea Michael Sikyea had ample cause to believe there was no closed season for Indians who hunted birds for food. He had been the interpreter for Chief Joe Susie Drygeese at Fort Resolution in 1923, when the northern Indians agreed to a treaty with the government of Canada. The Indians had signed only after receiving specific verbal assurances that their hunting rights would never be taken away or curtailed in any way. At one point as *R. v. Sikyea* wound its way through the courts, Sikyea was interviewed on the radio. "All the people understand that [hunting rights remain]," said Sikyea. "What they sign ... that's the laws made. That's why

they say as long as the river is running and the sun is rising that's the law. Never break."[1] But the treaty, it seems, was not nearly so ironclad. The problem may have arisen because the Migratory Birds Convention Act, an international treaty between Canada, Mexico, and the United States, was signed in 1916, late in the era of British Imperial rule, when Britain signed such international agreements on behalf of Canada. Thus, while Canada signed the treaty with the Indians, Britain signed the Migratory Birds Convention. Nevertheless, the Indians were not hampered or curtailed in freely shooting ducks for food until, thirty five years later, section 87 of the Indian Act (1951) was legislated, stipulating that all Indians were bound by "all laws of general application from time to time in force in any province." Despite their treaty, Indians in the NWT were now prohibited from shooting ducks during closed seasons (and in many places birds do not show up in northern Canada until after the closed season starts). Although the sun was still rising and setting and the river still running, Michael Sikyea found himself in court because he had shot a duck for supper.

When the appeal was heard, Mark de Weerdt made the case for the Crown. Sissons was known for demanding that the Crown prove to the hilt every fact of its case, and de Weerdt had taken appropriate steps to see that it did so. The prosecution brought in an expert from Edmonton to testify that the duck was in fact a wild duck. "When we got him on the stand, he couldn't tell by looking at it if it was wild or not, which wasn't too helpful," de Weerdt recalls. He then tried to get this same information from the RCMP officer who had arrested Sikyea. "I did the very thing that lawyers are warned not to do, I asked him a question I really didn't know the answer to – I just thought I knew the answer. I said to Corporal Robin, 'Can you tell the court of any domestic ducks in the NWT? You've been living here for some time.' Well, he blushed as red as his jacket and looked down at his boots and said, 'Yes, I have two of my own at home.'"[2] De Weerdt had the duck x-rayed to show the court it had been shot in

flight, but the question of whether the duck was domestic or wild was not to go away.

Sissons found Sikyea not guilty. "Judge Sissons dismissed the charge for a variety of reasons, one being that we couldn't prove the duck was a wild one," says de Weerdt. The judge could have dismissed the case on that ground alone – a ground of fact and as such unappealable. The case would have gone no further. But Sissons apparently wanted to declare the law. His reasoning was much the same as in *R. v. Kogogolak.* He held that the Indians still had their ancient hunting rights guaranteed under the Royal Proclamation of 1763, that there would have to be express words in the Migratory Birds Convention to abrogate, abridge, or infringe on the hunting rights of Indians. Sissons later wrote, "I did not find these words, and so held that the Act had no application to Indians hunting for food and did not curtail their hunting rights."[3] He believed that the solemn proceedings of the treaty between Canada and the Indians made only a few years after the signing of the Migratory Birds Convention would be a sham if the act were to prevail.

There was support for his verdict. In a similar case judges in Ontario followed suit, and in Alaska, where aboriginal people were also chafing under the international treaty, the *Tundra Times* gave a high profile to Sissons' handling of the case, noting how three years earlier 138 Alaskans had presented themselves to two game wardens, all 138 with eider ducks in hand.

But the Crown moved to appeal Sissons' verdict to the NWT Court of Appeal. Elizabeth Hagel Bolton says, "I could see then the case was going to the Supreme Court of Canada, and I felt I needed some expert help. I knew Bill Morrow and I got in touch with him and explained what was going on and asked if he would give me a hand. And he was delighted."

Morrow took the appeal, but the NWT Appeal Court ruled that Parliament could abrogate the hunting rights of Indians and that it had done so

through the Migratory Birds Convention Act. But in handing down the verdict Mr Justice H.C. Johnson asked a disturbing question:

How are we to explain this apparent breach of faith on the part of the Government, for I cannot think it can be described in any other terms?

This cannot be described as a minor or insignificant curtailment of these treaty rights, for game birds have always been a most plentiful and readily obtainable food in large areas of Canada.

I cannot believe that the Government of Canada realized that in implementing the Convention they were at the same time breaching the treaties they had made with the Indians. It is much more likely that these obligations under the Treaties were overlooked – a case of the left hand having forgotten what the right hand had done.

Elizabeth Hagel Bolton says, "Well, after that the case went to the Supreme Court of Canada." The duck went, too. PLEASE FORWARD TRIAL FILE MICHEL SIKYEA AND DUCK EXHIBIT TO REGISTRAR, OTTAWA IMMEDIATELY, wired the Supreme Court registrar, W.A. Short, to Yellowknife. The return telegram read, DO YOU WISH CARCASS OF DUCK SHIPPED. STOP. DUCK PRESENTLY IN FROZEN STATE.

Next Yellowknife informed Ottawa that Morrow would be bringing the duck to Ottawa personally. "Arrangements have been made locally to ship the carcass in a frozen state to Mr. W.G. Morrow, solicitor for Sikyea at Edmonton, Alta. Mr. Morrow will pick up the parcel from the plane at Edmonton Airport and keep the Duck in a frozen state until he himself flies to Ottawa for the Appeal. He will bring the carcass with him. In this way the carcass should remain in good condition." In fact, Morrow undertook some preliminary stuffing, perhaps on advice from Sissons. A photograph exists showing the duck, not in its final form, but partly stuffed, with little button eyes, lying beside Morrow's books on the council table of the Supreme Court of Canada.

Elizabeth Hagel Bolton attended. "I was there. Bill did all the speaking. He was a QC. I sat behind him because I was a plain barrister. He was the spokesman and I handed him the books. His case was that the Migratory Birds Act abrogated native rights. But we couldn't even get to that. The court was disinclined to deal with the question of native rights. This was quite evident. Right from the beginning they seemed to be looking for some out – so they could decide the case on other grounds. And they did find a way to do it.

"First of all the NWT Appeal Court had found we had been focusing on the wrong treaty. [Lawyers for Sikyea had originally thought he was present at the signing of Treaty No. 11 in 1922, but in fact Sikyea was a translator when a treaty was signed at Fort Resolution in 1923, probably an adhesion to Treaty No. 8.] And next, it had never been proved that the duck was wild. It never occurred to us this was important. They just didn't want at that time to deal with native rights; they weren't ready to think about it. I think we were in the court about an hour and a half at the most. The court wouldn't allow us to get to the meat of the case. We couldn't get past that sticky point about whether or not the duck was a wild duck. It was very disheartening to have this marvellous case go off on a silly thing like that. I can remember at the Supreme Court when we had a recess … we raced into the library and went through all the books we could find about wild animals. How to prove a wild animal is wild. Of course, given the small amount of time, we simply couldn't put our fingers on anything and I don't really think there is anything. Well, I was terribly disappointed. I couldn't believe such a small point could ruin the rest of it because to me it was such an important case. They wouldn't look at it because we couldn't get past the fact it was not a wild duck. We said it was a wild duck but it hadn't been proved."

Talking to Sikyea afterwards was not easy. "Nobody could explain it to Sikyea. I tried to tell him but he didn't believe what had happened. You can

appreciate it would be hard for him to understand. There's nothing but wild ducks up there."

In fact, the Supreme Court did accept that the mallard was wild. They did better than that. The story goes that Mr Justice Abbott, an avid duck hunter, saw the mallard sitting on the council table and took his colleagues aside. "Look, guys," it is said that he said, "if we don't find this duck is wild duck we'll be the laughing-stock of all the duck hunters in Canada." Their judgment upheld the NWT Court of Appeal, which had reversed Mr Justice Sissons' decision, but it ruled that unless a mallard duck is proved to be domesticated, the court must presume it is wild.

There was some consolation for Sikyea: after the conclusion of his case authorities stopped prosecuting natives if they hunted for food, Morrow thought because of bad publicity. And shortly after the judgment was handed down, Morrow filed a petition in the Exchequer Court of Canada. It prayed for compensation for the Indians and was signed by Michael Sikyea and representative chiefs. "The petitioners asked for the return of the lands their people had surrendered … or, alternatively, damages because the treaty had been broken," Morrow recalled in his memoirs.[4]

"That was the first lands claims case," says Elizabeth Hagel Bolton.

In fact, the petition was a non-starter. Morrow made a deal with government lawyers that the claim should be part of a proposed new Indian claims bill but the bill never passed first reading. Morrow became a judge before anything else could be done in the action.[5]

But many more claims were to follow, and eventually comprehensive claims by aboriginal people would cover half the territory of Canada.[6] The billion-dollar duck case was indeed worth a billion dollars. "That case raised the public consciousness," wrote Mr Justice Mark de Weerdt, "and for the first time questions were asked as to what the Indian treaty rights were worth if they could be taken away unilaterally by Parliament. It was plain that there was a need for recognition of what are now

enshrined in the Constitution Act, 1982, as aboriginal rights. The settlement of native land claims based on that recognition will be a most important outcome of this and other such cases in the 1990s, as it has been in the 1980s."[7]

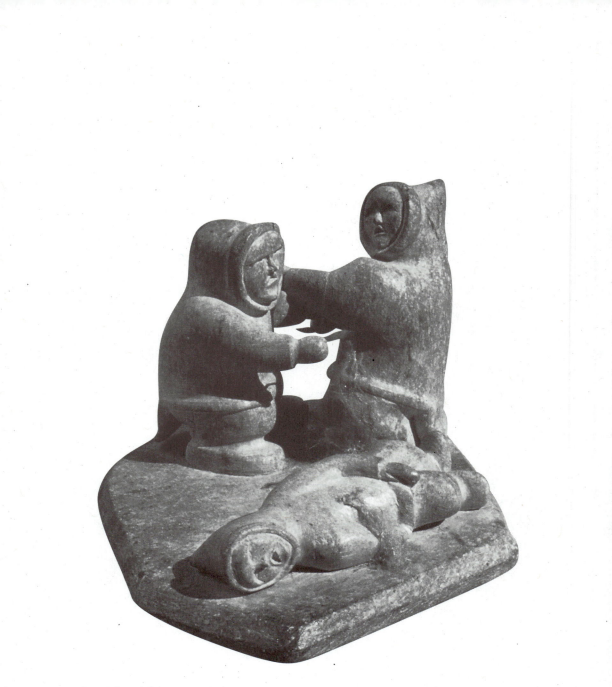

R. v. Mingeriak
Attributed to Bob Ekalopialok, c. 1910–70s
Kugluktuk (Coppermine), NWT
Stone, copper, knitting wool
21 × 13.5 × 11 cm

Regina v. Mingeriak

The little sculpture that illustrates *R. v. Mingeriak* depicts with dreadful effectiveness a particularly heinous crime. Though only a few inches tall, it seems monumental and indeed seems to tower in height in Richard Harrington's photograph, once on the cover of *Natural History* magazine. The accused is shown attacking a woman while his first victim lies at their feet. Both victims are covered in blood – in fact, "fuzzed" red knitting wool (according to Sam Tablo of Coppermine, the son of the probable creator, Bob Ekalopialok) – that streams realistically from the bodies. This is a sculpture that must have confirmed Frances Sissons' decision that the right place for the carvings was out of the house – in her husband's office. "Mother hated them," her daughter Fran Hoye once remarked.

The case came before Mr Justice Sissons in 1963 in what was then Frobisher Bay and is now Iqaluit. Mingeriak had killed a young boy and wounded the boy's mother and was charged with capital murder. The trial has been described as depicting the new face of crime in the North – a criminal act arising out of the circumstances of the new lifestyle Inuit were beginning to lead. Change had come to most Inuit after the Second World War, a result of the southern invasion that accompanied the building of the DEW Line, but in Iqaluit change had had a head start, for during the war the Americans had picked the head of Frobisher Bay as the site for an air force base.

The *Mingeriak* case was notable for having Arthur Maloney, one of Canada's greatest criminal lawyers, lead the defence. "The same as with *Kikkik*," says Everett Tingley, "the case was brought to the attention of the justice department, and instead of leaving it in the hands of northern people, they send in experts. Maloney arrived with a couple of top-notch psychiatrists, and he was armed for bear. He knew what he was doing. Because they were still hanging people in those days and that man faced the gallows."

Maloney, an active political figure as well as a criminal lawyer, was a leader in the fight against the death penalty. (He would be serving as an MP

in 1967 when Parliament abolished capital punishment except in the case of the murder of police officers or prison guards. The last hanging in Canada actually took place in 1962, one year before *R. v. Mingeriak* came to trial.) Bryan C. Bynoe of Toronto, once a student of Maloney's, worked with him on the *Mingeriak* case. He says, "Maloney was always involved in work for the underprivileged. He got a call from the justice department and was retained for the case – kind of a precursor to legal aid. He went up and took the preliminary inquiry."

Tingley remembers he considered himself complimented when Maloney remarked on the manner in which he reported court proceedings. "He said, 'You don't have any trouble in keeping up with what I'm saying – in Toronto they often do.'"

The facts were clearly established at the preliminary hearing before Magistrate Peter Parker. Constable Theodore Martin Doyle testified that on 5 February 1963 he received a call from an Inuk in Apex Hill, the Inuit village a mile or two away from Iqaluit, to the effect that there was a fight in progress at a house known as Matchbox No. 2. (These tiny "matchboxes," aptly described by their name, were some of the first houses put up for Inuit.) "Lying on the floor of the house I saw an Eskimo woman bleeding quite excessively. She was lying in the doorway to a bedroom … in the bedroom was a boy of approximately four to six years of age on the bed. The boy appeared to be dead."

The woman was Martha Semmee and the boy was her son, Salamonee Onalik. In court Martha Semmee testified that the accused had come to her door and "appeared to be angry, not as he usually is …" He stood just inside her door for some time. "He was standing there without saying anything. This made me frightened." Then Mingeriak came towards her and stabbed her. She heard her son say, "'I will like you if you don't hurt my mother,' [then] he called loudly for his father and then there wasn't much noise from Salamonee."

Mingeriak did not deny his guilt. The RCMP took confessions from him, one of which said in part, "The things that I have to say, I really want the Police to hear …" He had gone to a tavern, he declared, and had had several beers. "I don't know how many beers I had but I did spend four dollars." He had then gone home but when he found there was no one there, he had gone to the IODE Hall, where he had sat with his children. "I felt very light in my head and my whole body felt very light." Feeling this way, he had returned home for a short while and then had gone to Semmee's house. "I went inside and said to Semmee, 'Is your husband not home yet?' Semmee said yes and I left. I don't remember clearly whether I went to my own house but I do remember returning to Semmee's house." He told her he wanted sex. "I don't remember whether she said yes or no. I felt very light and started to fight her. I stabbed her with a knife. I don't remember where I stabbed her. It was as if I were dreaming. The boy was crying. He was saying something but I don't remember what he was saying."

After the preliminary inquiry to ascertain the nature of the case, Maloney retained the service of Dr Peter G. Edgell, a Montreal psychiatrist. "They flew Mingeriak down for tests between the preliminary hearing and the trial," Bryan Bynoe says. "The doctor had a suspicion that his trouble was a form of epilepsy, but he didn't have enough evidence with respect to his background. I went up for the trial and the pre-trial work."

In Iqaluit Bynoe and Edgell began to investigate Mingeriak's background to see if the evidence would support the diagnosis that he was subject to epileptic fugues – post-epileptic dream-like states in which the victim loses awareness of who he or she usually is.

Bynoe says, "The Crown wanted to know how we'd plead. Every Crown prosecutor wants to know that. Mark de Weerdt was acting for the Crown. We were unable to tell him, of course, until we had completed our investigation to see what the evidence would support. The doctor and I went out together and we interviewed a large number of people. There was one taxi

and we went around in that. There were dog-teams tied up outside the Inuit shacks – there was a lot of hunting and they hadn't all got snowmobiles at that time."

Iqaluit then was a far cry from the sprawling Baffin Island centre – soon to be capital – it has now become, with large schools, hotels of various calibre, arenas, highrises, malls, and ever-expanding residential areas. Life then revolved around the Federal Building, bought for a dollar from the Americans when the air force base became redundant. Here southern personnel ate and slept and went to the movies. There was also left-over military housing ("We stayed in a 'beach house,'" Bynoe recalls), a school, and a few other facilities, while over the hill was the Inuit community of Apex. And there were places to get a drink. "We did hear that they were having more problems with alcohol," Bynoe remembers.

The court would later hear that alcohol had caused deterioration in Mingeriak's condition. "He certainly had medical problems and was caught up in the white man's ways. But I'm not sure how sympathetic the general population was," Bynoe acknowledges. The crime had been, as Bynoe puts it, "awful": "There was a good deal of hostility. I'm not sure people always wanted to speak to us. It was hard to say because we were listening to them talk in Eskimo and left judging the body language."

Everett Tingley says, "Maloney did plea bargaining over the weekend; a local lawyer couldn't have done that. Mingeriak was charged with capital murder, and Arthur Maloney and Mark de Weerdt got together and when it came to Monday morning, Mingeriak pleaded guilty to non-capital murder. They had him sign a statement saying he realized he would be sentenced to life."

Plea bargaining? "In those days those were dirty words," says Bynoe. "But we told them what the defence was, helped outline the evidence – how it was established. The Crown was able to speak to our witnesses and the Crown – Mark de Weerdt – was satisfied. He could in good conscience accept it."

At the start of the trial the defence entered Mingeriak's syllabic statement which translated read, "I Mingeriak wish to plead guilty to non-capital murder. My lawyers, Mr. Maloney and Mr. Bynoe, have explained to me all my rights and I know that the result of pleading guilty means a sentence of life imprisonment …"

The reduced charge of non-capital murder allowed Mingeriak to escape the hangman. "Sissons was a great guy," Bynoe says, "with a deep compassion for the Inuit, and he was probably predisposed to hear such evidence as we presented."

Mingeriak went to jail and a year later wrote the judge a letter that said the following (in translation): "A long time ago I used to live as a hunter. I was well and happy then. I have unforgivable sins now … I am still trying to understand why I killed an infant. I can only conclude that I had lost my mind because I was drunk. Before that I was very fond of children, even when they were not my own … Now I know I will suffer as long as I live."[1]

Mingeriak died in jail, a suicide, some seventeen years after his conviction.

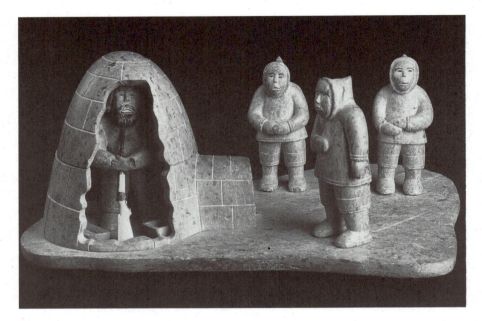

R. v. Amak, Avinga, and Nangmalik
Sam Anavilok, 1936–82
Kugluktuk (Coppermine), NWT
Stone, wood
35 × 24 × 15.5 cm

1963

Regina v. Amak, Avinga, and Nangmalik

In the summer of 1988 a group of twenty-six young Inuit gathered in Yellowknife to attend a demanding course designed to turn them into the Territories' first fully trained legal interpreters in the Inuktitut language. Most of them took time out to examine the sculpture display in the Yellowknife Courthouse. Timothy Sangoya inspected the pieces in the collection with particular interest. "I thought they were really neat. One of them showed my great-great-grandfather."

I first met Timothy Sangoya in 1989. At that time he was one of the valuable Inuit paralegals working in Iqaluit for Maliiganik Tukisiiniakvik (we would meet again later when he assisted the defence in *R. v. Niviaqsi Laisa*), where he regularly met community residents, many of them young people, in trouble with the law. The course he took in Yellowknife (only fifteen passed) taught him "legal terminology, where the law comes from, and how it is constructed in Canada." His duties to his clients were "to make sure they understand the charge, to look up the criminal code and translate the offence, and to represent them in court if necessary." But Sangoya never met offenders charged with a crime like the one that involved his great-great-grandfather – he was unlikely to do so, even though, ironically, assisted suicide has lately been much debated in the south.

In *R. v. Amak, Avinga, and Nangmalik* the accused were charged with aiding the suicide of Arrak Qulitalik (in the transcript Aleak Kolitalik), Sangoya's great-great-grandfather and the leader of a hunting camp about a hundred miles from the remote eastern Arctic settlement of Igloolik on the Melville Peninsula. "From what I've heard, he was tired of living. In our culture the elders have the right to be obeyed. My great-great-grandfather was respected, so the accused would have done what he asked," Sangoya declares.

The case came before Sissons in Igloolik in April 1963. Qulitalik, the old chief whose camp was said to be the best organized of the camps trading

into Igloolik, had been ill with measles, dangerous for Inuit, as they had little immunity. He was suffering after-effects, felt himself to be deteriorating, and may have thought he could lose his mind.[1]

Remembering the case, court reporter Everett Tingley says, "There was no policeman in Igloolik, and Bob Pilot – he was a famous policeman who became NWT deputy commissioner [in 1974] – came with us from Pond Inlet. He wasn't at all enthusiastic about prosecution. Qulitalik had wanted to die and the boys brought him a gun and the ammunition and he shot himself, but he should have known better – he missed the brain and hurt himself terribly. He didn't die and the boys stayed with him through the night. He told the boys that he wanted to see the sun come up one more time. So he lived until the sun came up and then he died."

Bob Pilot had met Qulitalik the year before his death, not at his camp but in the remote community of Arctic Bay at the top of Baffin Island. Pilot had gone there on a patrol by dog-team. He arrived at night after about four hours on the trail to find the tiny settlement surprisingly quiet. "The schoolteacher was showing a movie. I hadn't seen a movie in a couple of years, so I tethered the dogs and went over to the school. They were showing one of the NFB films on the North. I slipped in in the dark and sat beside a figure I thought was the Catholic priest. He had long white shoulder-length hair. 'Good evening, father,' I said. When the lights went on, I found my neighbour was Qulitalik. He was in his seventies or eighties and told me he was there visiting because he had wanted to come to Arctic Bay one more time; it was here in Arctic Bay as a young man that he first saw white people. With other Inuit he had come over the mountains and found Bernier and the crew of the government steamship *Arctic* in harbour there." (Joseph Elzear Bernier commanded Canadian government expeditions to the Arctic from 1904 to 1911 and explored the northern archipelago; in 1909 he unveiled a plaque on Melville Island that officially claimed the Arctic islands for Canada.)

The following year Pilot was flown by the police plane into Qulitalik's remote camp to investigate his death. "From the beginning Amak, Avinga, and Nangmalik were very open. They admitted their acts and were concerned about them. The people there were Anglican and there was an Anglican mission in Igloolik but the lay catechist there, a fine man, was related to Qulitalik, so the boys didn't go there; they wrote to the Catholic father and said, 'We did this.' They felt it was wrong.

"We flew in and the camp leader – perhaps he was the eldest among the boys – told me where they had buried the body – on the top of a hill – and I told them we'd have to dig it up."

Qulitalik had said he wanted to die and had told the boys he wanted their help. "At first they refused. But Qulitalik had a power over them. He told them that after his death his spirit would come back and there'd be no more seals or caribou unless they did what he asked. All three played a part. He told one to get the rifle, one to put in the bullet, one to cock it.

"The entire camp waited outside. Then they heard a shot. They waited a few minutes and then went in. Qulitalik was still sitting there. In the end he tried four times. After the first three attempts he was still sitting up. After the fourth attempt he was lying on the ground but living. He told the boys they would have to finish him off. They refused. He fell asleep for about twelve hours and then woke again. He died about four hours later from shock and subcutaneous bleeding. None of the bullets had been fatal."

After the investigation Pilot went down to Iqaluit to report. In his years in the North this was the only case of assisted suicide that he was called upon to investigate. "When I was asked, what I said originally was that I didn't see any purpose in proceeding. Then the word came down from on high; the advice that came back was that there's a time for evolution. This might be a good case to bring to court, with which to bring the law into the community, to show that the police are not just givers of welfare. The case was to be an adult education class but a bit tougher."

At the trial the three accused pleaded guilty. As the investigating officer, Pilot had to give evidence, and as one of the few white Inuit speakers available, he also had to translate for both the accused and the court.

Amak, Avinga, and Nangmalik were the first persons to be tried under the Canadian law prohibiting assisted suicide. While the suicide rate among young persons in the North has reached a disturbing level, mobilizing communities to provide crisis centres and support groups, suicide today among elderly Inuit has become rare; changing lifestyles and old age pensions have removed the imperative. When Inuit lived "the old way," such deaths were a part of life. A camp boss well understood the toll his incapacity, illness, or madness could take on his camp. In an interview conducted in 1983 the late Joe Curley, father of Inuit leader Tagak Curley, discussed the death of another great leader, his own uncle and adopting father, Angutimmarik. In the late nineteenth and early twentieth centuries, Angutimmarik had been a famous whaling boss and a shaman noted for his sophisticated understanding of illness. He lived to a great age, into the 1940s, and then determined to die. "You have probably heard that he committed suicide," Joe Curley said. "We tried to talk him out of it but we could not do it."

Sissons found Amak, Avinga, and Nangmalik guilty, but he suspended their sentences. "He called me in and discussed the sentence," Pilot remembers. "It used to be that if someone had been troublesome he'd be sent to one of the RCMP posts for a few months where he'd be under the eye of the police. He said he planned to send them to Pond Inlet. I said don't do that. They were all married with children. So he suspended the sentences and had them report to the HBC in Igloolik." Moving them away, Sissons agreed, would break up "the best camp in the north."[2]

After the trial Pilot returned to the area from time to time, "to inoculate the dogs, to take the census." He felt well received but he often wondered how the people had fared after the trauma of the trial – "for it did change the fabric of their society, I think. All of a sudden the twentieth century was plopped right down in the middle of their lives."

Some years later, at the time of his appointment as NWT deputy commissioner, Pilot received a letter from Qulitalik's granddaughter Rhoda Inukshuk, a well-known and respected Inuit leader as her grandfather had been. "It was a very kind letter," Pilot remembers. "It said that my involvement in the trial had helped make the proceedings at the time easier and more acceptable for the people."

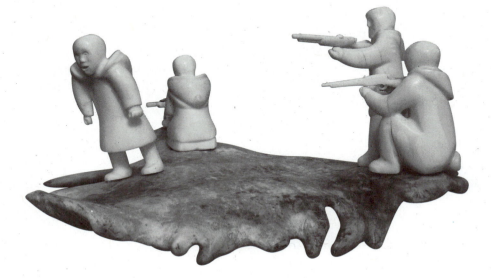

R. v. Shooyook and Aiyoot
Bernard Ekutartuq, c. 1918–87
Pelly Bay, NWT
Ivory, antler, stone
26 × 28.5 × 12.5 cm

1966

Regina v. Shooyook and Aiyoot

In photographs from the time of their trial, Isaccie Shooyook and Inuk Aiyoot seem barely into adolescence. They appear serious, responsible, and you think, "Boys from good homes." That home was six days by dog-team from Spence Bay (now Taloyoak), where *R. v. Shooyook and Aiyoot* was to take place, at Fort Ross in Levesque Harbour on the Boothia Peninsula. Here Aiyoot's father, Napatchee-Kadluk (the "short" Napatchee), was the headman, and three families – about twenty people – lived under his leadership in what was even in 1965 an unusually remote camp.

In 1994, remembering back as we sit in his house with its fine view over Taloyoak bay, Inuk Aiyoot tells me without irony that the old life was a better life than the one Inuit live today. "No skidoos, only dogs; food from the animals, just flour and ammunition from the company [the HBC]. Not too many people and everybody busy. Such a good, calm life."

In the summer of 1965 that good calm life at Levesque Harbour was destroyed in a manner that presented Mr Justice Sissons with his last case – certainly one of the most dramatic and thought provoking to come before his court. "If you're going to hold people accountable, you must provide protection," says Red Pedersen, a former Speaker of the NWT Legislative Assembly, commenting on the case. "That's what the system had not done. There was no protection; the community had to set up its own."

Until 1947, for a ten-year period, Fort Ross had been the site of a Hudson's Bay Company fur-trading post. But ice conditions in the area were always difficult, and for two years running, in 1945 and 1946, the HBC supply vessel *Nascopie* could not reach the settlement to deliver supplies, take out the bales of fur, or pick up or drop off personnel. (An Inuit elder remembered watching the young wife of one of the southern traders as she stood on the beach, eyes on the horizon where the ship for the second year was blocked by ice – "She wept.") The following year, in 1947, the company

relocated the post two hundred miles south to the more accessible Spence Bay, but a significant number of the Inuit hunters and trappers remained behind.

The Inuit who had traded into Fort Ross had been both local Netsiling-miut and Cape Dorset people. The latter were experienced trappers who in 1934 had come from the Hudson Strait on the *Nascopie* with their sleds and all their dogs to trap for the HBC as it pushed ever further into the Far North. They had arrived at Fort Ross after several sojourns at other remote northern locations, and when the company relocated to Spence Bay, most Cape Dorset people at first remained behind. After a few years, however, only Napatchee-Kadluk's camp was still in the area. Although by 1965 short-take-off planes were already opening up the North in a way unthinkable a short time earlier, Napatchee-Kadluk's camp was profoundly isolated.

R. v. Shooyook and Aiyoot, the first jury trial in Spence Bay, opened 15 April 1966, with David Searle as prosecuting attorney, Howard Irving acting for Aiyoot, and W.G. Morrow, in one of his last appearances as a trial lawyer (he would shortly replace Sissons on the bench of the Supreme Court of the Northwest Territories), appearing for Shooyook. The Crown charged that the accused jointly in "July A.D. 1965, at or near Levesque Harbour, Northwest Territories, did unlawfully commit the capital murder of Soosee (E5–20), contrary to Section 206 (1) of the Criminal Code." In the initial accounts of the case that filtered down to the south, the crime appeared especially shocking because the victim, Soosee, was the wife of Napatchee-Kadluk and the mother of Aiyoot.

Right from the beginning the Crown acknowledged that *R. v. Shooyook and Aiyoot* was a difficult case. David Searle admitted this in his opening address to the jury – a panel of six, all required in the NWT at the time (this jury included the first woman juror in the NWT, Dolores Koening, a Pelly

Bay schoolteacher). He said that the witnesses they would hear would tell them about the extreme pain and hardship Soosee had caused her camp because of her illness (later identified as schizophrenia). He described the conditions at Levesque Harbour: "There is no RCMP detachment there, no Northern Affairs Officer, no nursing station, and no Hudson's Bay Company post. In summer these people live in tents, in the winter they live in snow houses." He concluded, "Our sympathy must be with these people who found themselves in this impossible situation. Your job is to hear the evidence, to take instruction on the law from His Lordship, to consider the facts, and to determine whether the two accused be guilty or not guilty. I do not envy you your task."

Soosee had been hospitalized twice for her erratic behaviour, once having to be evacuated to Edmonton in a strait-jacket; then, back in remote Fort Ross, she had again become deranged, terrifying her campmates with increasingly bizarre conduct. In her madness Soosee threatened to kill and blew her breath on people, making them fear she was infecting them with her disease. Indeed, Soosee was dangerous, as three medical authorities appearing for the defence, two of whom had treated Soosee in 1959 and 1964, testified. Their evidence was that in her schizophrenic state Soosee would use 100 per cent of her strength, that the voices in her head would dominate her behaviour, and that she would be a menace to the lives of those in the camp.

Many years later William G. Morrow's widow, Genevieve, recalled her husband's stories of the case: "Soosee was a huge woman. She had gone berserk, so the people of the camp fled to a nearby island where they could observe Soosee's actions from across the water. She began chopping up their canoes, destroying the boats on which they depended for their livelihood. They finally decided on a plan of action and two of them went across and shot her down. They kept a record that recounted the whole story, and gave this to the RCMP. Otherwise nobody would ever have known."

The first witness, called by the Crown, was Kadlu, the father of the accused Shooyook. "We knew the police would not like this, but she would have killed a lot of people. That's the reason why we killed her," he told the court. He was asked if it would have been possible to take Soosee to Spence Bay. "If it had been in winter instead of in the spring we could have done this," he answered, but then he added, "When the rivers break out, when it thaws you cannot cross … We could not do it, we as Eskimos … We knew we could not go by dog team, and there was too much ice to go by boat."

Kadlu read to the court the notes he had made day by day in July as he and his fellow campers watched Soosee's actions become more and more threatening. His notes told how for self-preservation they had decided to leave their camp, how they had taken refuge on a nearby island from which they could watch Soosee through a telescope, and how the four boys of the camp were eventually dispatched back to the island to take necessary action.

Kadlu read his notes slowly, sentence by sentence, so that the interpreter could interpret into English:

Today is the 9th; she's throwing things out of the tent, and she hasn't been sleeping for a while. She's keeping wandering around and not doing any sleeping. She's throwing rocks, and pulling her hair out. It looks as if she's going to kill her husband, and she's throwing rocks at us all, and blowing her breath. We love her but we have to tie her up.

We have tied her up, as we could not do anything else. She's trying to get after us. She is throwing sticks at the people while we are having service. She gets out of the ropes that she's tied up with. The ropes she was tied up with are all laying outside, and we tied her up again. She said she is going to kill us, and we love our children. We are afraid she is going to kill us all.

It was at this moment, when Soosee had completely terrorized the camp, that the headman Napatchee-Kadluk took the decision that all should

move to a small adjacent island. From there they could observe Soosee's actions. At first Napatchee planned to stay behind with his wife, but Kadlu said he must come with them. Kadlu's notes convey the fear the campers felt:

We are running away, and have only taken two tents. We are getting ready in a hurry to go to the island. We are sleeping on the island today, today is the 13th.

In the morning we saw her outside. We are scared to go to her. She is knocking down the tents, and knocking down the aerial masts. She's knocking down both of the aerial masts. She is wandering all over the place, we are watching her from the island. Now it is evening, she is throwing things out of the tent.

We are watching her in the morning ripping up the tent. We are scared to go to her, because she was wanting to kill the people. We don't want anyone to go to where she is, because we do not want her to kill the children that are now alive. We are going hungry, as we are unable to go hunt meat. Sometimes we manage to get one seal to eat during the day. All this time she is pulling her hair, and she is shaking out clothing and the bedding. She also walks in the creek without any boots on. She slaps the ground all around her.

She has been wandering all over the place, but this evening she has gone back to the tent. She has her parka on now. Now she is throwing things in the water while we are watching her, and she looks as if she is washing clothes, but there are no clothes there. She is now wandering around without her parka. She has the tent torn to shreds. Now she is throwing other things around besides the tent. She is turning all around and doing things and shaking out everything she picks out. She is throwing all sorts of things around really bad, and she's throwing rocks at the gear.

During today she has knocked over all the tents. She's breaking up all the gear. We are watching her doing this. We are scared to go where she is … We don't want our people or our gear to get lost … We had to leave our gear, and now she is breaking it all up. She wants to kill us, but we don't want to die now. The devil is

making her do these things, and she's doing it. Why she is doing this we don't know, but she is made to do these things by the devil.

Why she is doing this we don't know but we are sorry about it. God in Heaven is the only one that we can ask to help us. We are praying to God all the time to help us, as God in Heaven can help us.

On July 15 the elders of the camp made their desperate decision. Remembering the difficult days, Aiyoot tells me that his father, Napatchee-Kadluk, Kadlu, and his aunt talked together. "My mother was no longer human." They had bound her tightly with ropes before fleeing to the island, and there through his telescope Napatchee-Kadluk had watched Soosee break free with superhuman force. In her wild wanderings she had tried to open the chest in which the guns and knives were kept. "We are certain that the devil is making her do these things," read Kadlu from his notes. "The only thing to do now is for someone to go after her. If she runs away she will not be hurt, and they will not do anything to her. If she comes after them she will be shot, because we are really afraid of her, because she has been saying that she is going to kill everyone, everybody."

The young men – Aiyoot, Shooyook and his brother Naketakvek, and a fourth youth, Sheemeegak – left the island for the camp. "I told Shooyook," Napatchee-Kadluk testified, "that when they went after her, and if she ran away crying, and ran away from him not to do anything to her, but if she came towards them, even though she was crying, and started after them, they were to shoot her because she would kill them instead."

Naketakvek told the court what happened: "When they reached the beach, Aiyoot shouted to Soosee with a loud yell. When Soosee saw them she started to come towards them. A number of shots were fired to warn her away but she kept coming towards them. Her face looked different and she was acting crazy or funny. When the bullets were flying around her she just kept on coming towards them. She was blowing in their faces."

Shooyook and Aiyoot fired warning shots. Then, when Soosee continued her advance, impervious, Shooyook shot to kill. When he ran out of ammunition, he took Aiyoot's gun and fired the fatal shots.

Kadlu described the end. "She did not die for a long while. She only died after she was shot three times."

After it was over, the whole camp prayed together. They had been scared for a long time, Kadlu said, and they thanked God because he had helped them win. Napatchee-Kadluk and other camp members went over to the camp and buried Soosee. "She was dead and I did not want her lying around," he said.

In he fall the awaited aircraft arrived to take the children of the camp to Aklavik for school. Kadlu's carefully written notes with the record of Soosee's final days were sent out with the plane to the RCMP.

In his final address to the jury Morrow made an eloquent plea:

Unless a police plane or another plane came in, they were stuck. They lived in small tents, and you have heard how dangerous and how terrifying it would be to expect these people to carry on their normal lives with Soosee as she was at this particular time … We have got to take that situation as it was. Not as we would have liked it to have been … The symptoms that were there in July, 1965, indicate that she could quite easily have on a mere whim – call it what you will, she may have thought it a spirit calling to her or the devil, that doesn't matter – the fact is she could at any given moment have killed … You could have had the same situation anywhere else in North America, but you had it here in Fort Ross. You had it under the circumstances where you had no remedy, no way to clear it up, and what happened was the justifiable result …

It is my submission, Lady and Gentlemen of the jury, that on the evidence that is before you, and on the evidence particularly of the Doctors, … that you cannot, I submit, or should not, reach any verdict except not guilty.

Sissons gave a charge to the jury similar in many parts to his charge in *R. v. Kikkik*, but the jury did not find its task easy. As a result, primarily, of

the student activism of the late 1960s, it has been illegal in Canada since June 1972 for a juror to disclose the deliberations of a jury. There is, however, no retroactivity. Dolores Koening recalls that jury members found it no simple matter to resolve their conflicts – in this 1996 trial. Sissons had succeeded in obtaining a jury that was drawn largely from the region and that included Inuit representation. As usual, this had been a demanding exercise. The clerk had sent out telegrams to the settlements – HAVE TOMMY STAND BY – but weather conditions had made it impossible for the court plane to fly into Cape Dorset and other settlements to pick up some of the bilingual Inuit who might have served.

Dolores Koening recollects how it happened that she became the first woman to serve on an NWT jury. "It was Easter time and a pilot came flying in to Pelly Bay where I was teaching. He said he was going to Yellowknife and I said take me along, and when I got down there of course I thought, how am I going to get back? But I knew this trial was coming up and I knew Judge Sissons. I'd known him as a friend when I'd lived in Yellowknife earlier. So I phoned him and said, 'Can I hitch a ride back on your plane?' He said, 'Mmm. Probably you could, but how about letting your name stand for jury duty?' They were trying to fly people in from Frobisher and various places but the weather was down and they couldn't fly all these people they wanted in. So I was there and sort of a likely candidate so I got selected." A second teacher and two Inuit were also on the jury.

When the jury began its deliberations, it became apparent that Inuit jurors and *qallunaat* jurors would have difficulty agreeing. "They [the Inuit] felt very differently from the way the legal people felt," says Dolores Koenig. "They said, 'They killed a woman and therefore they are guilty.' But then when we said according to Canadian law if you are guilty of first degree murder you should be hung – we still had capital punishment – they said, 'Well, no, they shouldn't be hung. They killed her but they shouldn't be hung.' So that was what the debate was about. I didn't think they should

be charged with anything at all – because they had had to do it for the survival of the group. But they said, 'Well, they did it; therefore they are guilty.' It was a classic case of our system going wrong."

Sissons had always been reluctant to accept guilty pleas from Inuit accused of a crime. In the usual translations employed in court at the time, guilty and not guilty seem to have come across as "Did he do it?" and "Did he not do it?" The concepts of legal and moral guilt were lost. Sissons had frequently commented on the problem. Now, in his last case, there was building in the jury room what he might have considered a classic example of this kind of confusion.

The court had combed the North for bilingual Inuit to serve on this jury (most of the Spence Bay bilingual Inuit were already employed for the duration as interpreters for the court), but the two Inuit jurors selected, Dolores Koening recalls, understood little of the English language. "They spoke almost *no* English," she says with emphasis. "Primarily they spoke no English."

During the jury's deliberations, the foreman asked for an interpreter. "I have never had such a request before," commented Mr Justice Sissons. "I don't know."

Crown counsel David Searle said, "It is a requirement that all jurymen speak and understand the English language ... but an Eskimo could [speak and understand English] and still need an interpreter for the very complicated phrases."

"I don't think it should be allowed," said Morrow. "I think it might be considered a mistrial."

"Well, we certainly don't want that you know," said Sissons. The request was refused.

There were additional difficulties. The jury returned for further instruction. "One thing that has cropped up in our talks," said the jury foreman, "is how should we find the defendants if we feel that they in fact carried out

the execution of Soosee, and under duress, or under the orders of some other parties, in such a way that they actually had very little choice in the matter? They were told to do something and they in fact went ahead and did it."

Jurors familiar with Inuit traditions would have seen the action of Shooyook and Aiyoot in just such a light. In acting as they did, the camp members appear to have followed traditional practice. Oral histories collected from elders in recent years carry many accounts of how a man or woman, judged by fellow campers to have become a danger to the community, was eliminated through group action.[1] Indeed, Napatchee-Kadluk must have known of this practice from his Cape Dorset boyhood.

The RCMP annual report for 1929 recounts the patrol taken by Sergeant James Wight and Constable Paul Deresch from the Lake Harbour detachment on south Baffin Island to Cape Dorset to investigate "the now familiar story of an outbreak of homicidal insanity, and the consequent protective measures of a tiny community – which occurred in 1925 and 1926." In the autumn of 1925 at a camp about 250 miles inland from the Cape Dorset trading post, "a young man named Makogliak went insane, apparently from religious mania; he was noticed behaving strangely, and he told one at least of the party that he had heard a voice from the clouds telling him to kill all the people of the camps." Three days later he shot and killed his father, Kovianaktoliak; his mother, Klowa; and Kimipikalook, an elderly widow who had been one of the wives of Inukjuarjuk, the great south Baffin leader, father to Pootoogook, the so-called Eskimo King; the photographer and historian Peter Pitseolak; and a host of other Inuit notables.

Makogliak was disarmed and kept under close watch, but it was impossible at that season to take him to a trading post. In his account of the murders, quoted in the annual report, Sergeant Wight noted, "The camp life and hunting was disorganized on account of the watch that was being kept on him, and after about three months every one was quite worn out

and nervous, and, on a second threatened outbreak by him in the spring of 1926, the camp decided to destroy him, which they did by pushing him under the ice in a river."

The report then related that "no attempt was made by these people to evade the police; they sent word that when they were wanted they would come in voluntarily, but they were obliged to keep on hunting to support their families."

No prosecution was instituted "partly because of the great difficulty of arranging transport ... and partly because of the extreme hardship of the position in which the Eskimos found themselves." Sergeant Wight was optimistic that communal killings on Baffin Island were about finished, "as the police are able to cover the country summer and winter where all native settlements are." But despite the fame of the force for its long patrols, up to the last days of traditional camp life such a task in the vast Arctic remained formidable, indeed impossible.

From his evidence it was clear that Napatchee-Kadluk had talked to Shooyook about a course of action. The court record suggests that both the Crown and the defence reacted warily to the jury foreman's request for information on "how we should find the defendants if we feel that they in fact carried out the execution of Soosee, and under duress." The jury was sent out while the lawyers discussed the matter.

"I think they will have to be told," said Morrow, "in my opinion, that if they feel these people were ordered to do this, much as a commanding officer would order a soldier to do this, that that would constitute murder under our code." In other words, to carry out an illegal action because ordered to do so is no defence.

"My Lord," said defence counsel Irving, "the jury chose what I regard as a very unfortunate word when they used the word execution, and Your Lordship no doubt notices that Mr. Searle [for the prosecution] didn't use a word so strong as that. I find it difficult My Lord to think that there is

adequate evidence before the jury in which they could find these men came over in duress to carry out an order of this sort ...

"I think as far as the witness Napatchee-Kadluk went," Crown counsel Searle declared, "was to say after much beating around the bush ... was he had spoken to Shooyook about going out to attempt to scare her away, and if she wouldn't scare, he should shoot her. I think this is about as far as it goes, but I don't think it can be said that is necessarily duress."

"Well the only duress in the submission of the defence counsel would be overall duress," said Morrow. "The fear that was injected by all the circumstances. It wasn't fear of the headman, no duress from the headman."

The jury was called back and asked to indicate what evidence it found for duress. "My Lord," said the foreman, "what we had in mind principally is the patriarchal system, where members of that group of people were under the direction of a leader, or leaders in the group, and they are given directions to do something, or perhaps to perform one of several alternatives, but they themselves perhaps have very little voice in the matter."

"Yes, I get you," responded Mr Justice Sissons. "But the problem that poses itself from that is, there is no direct evidence that there is any such system as far as this case is concerned. There is nothing before the Court on that is there? I can't recall any evidence given in Court."

In reply, the foreman said that the statement of the headman Napatchee-Kadluk might have left that impression. The evidence of Napatchee-Kadluk was read back, after which Sissons said that the statement did not clarify the situation completely: "It simply comes back to the question of self-defence, doesn't it, rather than duress or any orders of anyone." The jury is master of the facts, the judge master of the law, and Sissons continued, "I don't know what direction I can give you in the matter, because I am afraid I will be dealing with a question of fact, rather than a question of law."

The jury retired to deliberate. "We had a hard time coming to a decision," remembers Dolores Koening. "Finally we compromised and acquitted

Aiyoot and brought in a verdict of manslaughter for Shooyook with a strong recommendation for clemency."

Mr Justice Sissons handed down a two-year suspended sentence to Shooyook. While the verdict recognized that shooting Soosee was a crime, the sentencing recognized the extenuating circumstances. In Sissons' last case, a trial by jury and discretion in sentencing had again served him well.

A few weeks after the trial *Maclean's* magazine published an article by Farley Mowat written in what a nervous civil servant once referred to as his "polemic style" and provocatively titled "Who Were the Executioners?" Perhaps there was the feeling in certain quarters that murder charges against Shooyook and Aiyoot had been unjustified. But Morrow called the jury's judgment "a great social verdict"[2] and the case "the high water mark of the culture clash of our northern native in conflict with Canadian law."[3] He believed that the verdict was "a complete vindication of the jury system. A judge trying the case alone would have had to find both men guilty in law, and what a travesty that would have been. But the jury saved the day. In its absolute power it could ignore the law, as it did, and bring in a socially acceptable verdict, or solution, as I choose to call it."[4] According to Dolores Koening, it had been a close thing.

The end of the hunting camps – by 1970 there were few remaining – meant that circumstances like those that brought Shooyook and Aiyoot to court were unlikely to arise again; and the passing of the old way, together with the availability of old age pensions and family welfare, put an end to such practices as assisted suicide and infanticide, which southern society had considered criminal. Criminal cases in the Northwest Territories would now increasingly involve liquor – and later, drugs.

Genevieve Morrow recalls that her husband felt sympathy for Shooyook. "His rifle, which had been confiscated, was rusty and old, and Bill took his fee and bought him a new one." Mr Justice Morrow was to see that gun

again. On his last circuit in 1976 he had to waive jurisdiction in a case in which Shooyook was charged with abandoning a polar bear carcass after shooting it in self-defence.

In the years since *R. v. Shooyook and Aiyoot,* Inuk Aiyoot says, his life has been "pretty good," though like every life marked by ups and downs. His father, Napatchee-Kadluk, suffered a stroke and lived on in *qallunaat* hospitals for five or more years in a state "almost like dying." Aiyoot himself lost his "cross" arm in a bizarre accident – the sleeve of his parka got caught in the equipment on a contractor's truck and his arm was twisted off. Though it could sometimes take a week to get a plane into Taloyoak, miraculously one was on the runway on that particular day. The nurses packed the arm in ice and "put it in a box" and the aircraft immediately flew Aiyoot to the south. But even so "it was too long – more than eight hours," and the doctors could not reattach the arm. Back home Aiyoot retooled his skidoo so that he could easily drive it with only one arm. He put his life back together as he had done after the trial.

A year after *R. v. Shooyook and Aiyoot,* Aiyoot married Mary Annauyak. He and his young wife briefly lived out on the land, at Thom Bay, before moving permanently to settlement life in Taloyoak. In 1970 Aiyoot was hired to work for the Co-op, and he is still there today. He and his wife have had three sons, and "because we didn't have any girls we adopted two girls." He hunts whenever he can and has a cabin out on the land. He has no hard feelings about the trial. The court treated him "really well. My father, too, he felt okay about the court." In fact, he does not remember the court case as having been traumatic. But he cannot say the same of the events at Levesque Harbour. "I think of them but I do not think about them every day – I don't want to do that." He and Shooyook, "who shot my mom," are still in touch. Shooyook lives in an outpost camp around Arctic Bay, and Aiyoot sometimes visits him. The two talk to each other on the ham radio.

Looking back at the tragic events that occasioned *R. v. Shooyook and Aiyoot*, Aiyoot says, "The hard times were in June, July, August, I think until October. We couldn't travel and we had no radio. That was our real problem … we had no radio."

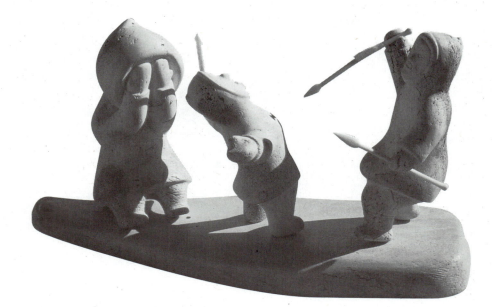

R. v. Jeffrey
Abraham Kingmeatook, 1933–93
Taloyoak (Spence Bay), NWT
Whalebone and bone
35 × 13.5 × 20.5 cm

Regina v. Jeffrey

"In the time of the old Inuit people, sometimes there were not enough women for all the men, so two or three men used to fight over one woman. That's what they had to do – in their own culture. People would fight or have a tribal war, because there were not enough women." Lena Kingmeatook is explaining the carving her late husband, Abraham Kingmeatook, made that illustrates *R. v. Jeffrey*, a case William G. Morrow, sworn in as Mr Justice Morrow on 12 September 1966, heard on appeal on 6 April 1967 in Iqaluit. This was one of two small whalebone carvings by Kingmeatook that Morrow collected and donated to the Yellowknife Courthouse Collection of Inuit Sculpture.

The ancestors of both Lena and her husband had lived on the Arctic coast, and Lena says, "He was thinking of the people in the past – our grandparents, great-grandparents and the people before them. Then the Inuit didn't have steel for their snow knives, they didn't have rifles – nothing that travelled as fast as a bullet. But they wrestled by hand, wounded each other, killed each other, wounded each other fatally."

A domestic drama, not so different from those Lena describes, lay at the heart of *R. v. Jeffrey*. The incident, which looked at one point as if it might escalate into a fight to the death, started because Jeffrey, part Nascopie Indian, part Inuit, had lost in a finger-wrestling competition. Mark de Weerdt, the Crown prosecutor at the appeal, says, "They were playing some game of finger pulling and the woman was to go to whoever won, but the wrong man won. The husband wouldn't go along with the gag." Alcohol fuelled the fracas. The case was a minor one but representative of the alcohol-related crimes that were now ever before the court.

During his years in the North, Mr Justice Sissons had had ample opportunity to become saddened by the effects of home brew, alcohol, and solvents. His family reports that he kept many articles about alcohol abuse and poor living conditions.[1] When Morrow made his first tour in 1960 as defence

counsel with the Sissons court, only one case did not involve liquor. In 1964 RCMP chief superintendent MacDonnell told the Territorial Council that alcohol was a factor in 99 per cent of crimes of violence or theft.[2]

In the appeal of Matthew Thomas Jeffrey against the three-month sentence imposed by a justice of the peace, Mr Justice Morrow heard that on 12 December 1966 Jeffrey, his wife, Tukanie, and his friend Erkidjuk had drunk steadily, first at the Frobisher Bay Recreation Association lounge, then at the Royal Canadian Legion, where they played cards, and then, after 10:30 p.m., at Jeffrey's house, where he and Erkidjuk competed in the ancient Inuit contest of finger wrestling. In this sport the participants sit on the ground with their legs straight out in front of them, feet touching. They link their little fingers, and then each man tries to pull the other over to his side. In camp days the game was played on the floor of the igloo or outside, and it was always part of the competitions that traditionally took place in the giant igloos or *kagees* built at festival times. Jeffrey and Erkidjuk had decided on this method of competing for Tukanie's favours, but when Jeffrey lost he became angry. He got his gun and asked his wife to bring him three bullets. He loaded the weapon and, according to the court record, said to Erkidjuk that he was "going to scare him good." He fired on either side of Erkidjuk, who was standing near the wall. Next he said he would shoot him in the ear, but he changed his mind and said he would shoot him in the stomach. Erkidjuk said to hurry up and get it over. At this point Jeffrey handed the weapon to Erkidjuk, who ejected the remaining bullet and handed the gun to Tukanie. Erkidjuk then punched Jeffrey twice and left the house.

Perhaps neighbours heard the shooting; Jeffrey was shortly arrested and charged with pointing a firearm. When his case came up in JP court, Jeffrey said in his defence that he had acted to protect his home and family. Erkidjuk had beaten him and threatened his wife. He had had no intention of hitting Erkidjuk but he had no phone and could not call for help.

JP Mills found Jeffrey guilty, sentenced him to three months, and declared that alcohol had played a significant role. He noted that while it was not

illegal for Jeffrey to consume alcohol on a regular basis, it was not an excuse for taking the law into his own hands.

After hearing the appeal, Morrow gave Jeffrey a suspended sentence.

Morrow heard this minor case shortly before his famous decision on 6 June 1967 in *R. v. Drybones*, sometimes called "the decision of the century." His ruling in *Drybones* would be upheld by the Supreme Court of Canada, which rendered inoperative a provision of the Indian Act that penalized Indians found drunk off a reservation. The court found that this provision contravened the Canadian Bill of Rights in that it provided different penalties for offenders on the basis of race.[3]

About this time Morrow also found himself heading a royal commission. He received a surprise call from the minister of justice, Pierre Trudeau, who asked him (as Morrow related in his memoirs) "to investigate and report on the administration of justice in Hay River." For a couple of years there had been rumours of problems in the Great Slave Lake community, and while the royal commission was set up to investigate these, by the time it got under way its scope had become more far reaching. Passing through Ottawa on a holiday, Morrow met Trudeau. "He suggested that, although the inquiry was directed at Hay River problems, he would be pleased to have me broaden its mandate so as to cover the administration of justice in general terms. I was determined to take full advantage of this invitation."[4]

Morrow did just that. When Sissons retired, there was a sense that the administration of justice in the North would enter a new era. Court reporter Everett Tingley notes that Sissons did not believe in being too diplomatic. "He used to say, 'Any people who don't behave around here, I have a simple treatment: they get their asses kicked until their noses bleed.'" Tingley does not believe that Morrow would have expressed himself that way but Sissons had been the man for the day. "That expression came up – that very expression," Tingley remembers. "And Judge Morrow gave his opinion. He said Sissons was the man to be the first judge. I think what he meant was that

he was the man to go as far as he did; he had broken the ice and got things going."

Morrow wrote his report in two parts. The first addressed the problems relating to Hay River. "Perhaps the worst single situation that came to light during this inquiry," he wrote, "was the terrible effect liquor was having on the community, especially the Indian population. At this time, intoxication was treated as an offence and the result was that a great number of native people spent time in jail. With so many Indians incarcerated, it was easy to understand their view that the police were 'picking' on them." Morrow recommended that drunkenness no longer be treated as a crime *per se*.

But Morrow's report also contained what he called a "blueprint for change." He made seventy-four recommendations for change, most of which were eventually adopted.

One of my recommendations addressed the problem posed by the frequent holding of the JP's court in the police detachment: this practice had given rise to the suggestion that the police actually ran the court. As a result of my report, the government made it a policy to provide the court with premises separate and distinct from the police station in each of the settlements. Magistrate Parker, who worked hard to improve the image and the expertise of the JP's court, began to set up yearly conferences under his supervision; there, the justices of the peace, being lay people, were given instruction to help them more fully understand the law.

What was to become an annual practice, and a most worthwhile one, arose from my recommendation that a representative from the attorney general's department in Ottawa should come to Yellowknife and review the problems and needs of the justice system in the Territories. As a result, when first the Honourable John Turner and later the Honourable Ron Basford assumed the mantle of minister of justice and attorney general of the Territories, they made many trips to the north to study its unique conditions. Each man, accompanied by his department heads, acually travelled on circuits with my court to see conditions for himself. Sol Samuels was

designated assistant-deputy attorney general of both the Yukon and the Northwest Territories and played a most valuable and beneficial role.

A significant change occurred when the Government finally decided to pay the justices of the peace on an honorarium basis. In my report I had criticized the barbaric system, then in force, whereby JPs were paid by the conviction – a system that could only lead to suspicion in the minds of the public.

But undoubtedly the most important request, as Morrow himself suspected, was his recommendation for a comprehensive system of legal aid. He pointed out that "the vast majority of northerners appearing in court were indigents unable to afford counsel. This resulted in John Turner's introduction of a full-scale legal aid scheme in the Northwest Territories that became the prototype for similar systems in the rest of Canada." The legal aid scheme, in turn, led to the growth of the northern bar. "Young lawyers, for the first time, realized that they could earn a decent living while engaged in defending the liberty of their frontier clients."[5]

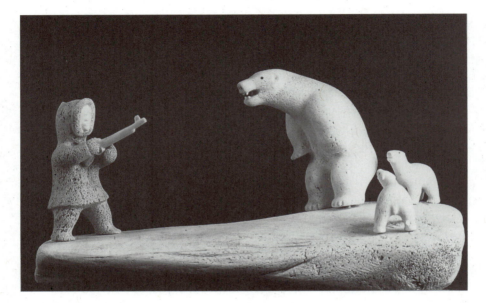

R. v. Tootalik
Abraham Kingmeatook, 1933–93
Taloyoak (Spence Bay), NWT
Whalebone and bone
37 × 22 × 20 cm

Regina v. Tootalik

"I have to tell you," says Jimmy Totalik ("Tootalik" in trial transcripts; "Totalik," as he prefers it, in the phone book), "that I like to catch polar bears. Before we had the game laws one year I caught five." In King-meatook's carving, Jimmy Totalik seems a small man positioned as he is below the great height of the bear, but Totalik is a match for bears. He has hunted the polar bear with a spear. "I learned from my dad how to hunt them with guns or spears, but I was brought up when there were already white people, so I always had a rifle. Once when I was out of bullets I caught a polar bear with a spear." His son Kovalaq, who is interpreting, says, "He was not afraid at all. He picked up a spear from under the polar bear, from under a live polar bear. You have to have dogs – it's the only way to catch polar bears with spears."

By the window waiting is Molly, Totalik's wife. As soon as we've finished the interview, they will leave for camp. Totalik tells me that before they had children (they have nine, four of their own and five adopted) when they lived up north around Fort Ross, Molly used to help with the polar bear hunt. "She stayed with the dogs when they had to keep still. She was scared of the polar bears, so she didn't catch them. We had no snow machines then. Before we had the game laws we used to hunt with dogs. We were living where it freezes all year long; we'd let the dogs loose and that way you could catch polar bears easily. If you didn't let the dogs loose they weren't easy to catch. Nowadays they sell the skins to the white man but we used to use them for the bed or for clothes; we didn't throw anything away." And polar bears are good eating "when they've got a lot of fat," though not, Totalik tells me, when they've been tagged. "With the ear tag the taste seems different for some reason."

Totalik says that when NWT game laws were first imposed, they were hard to accept: "Now we have to go by the game laws, but in early times when we were getting the laws, I didn't like it at all. But now they don't worry me much; I've got used to them. But it used to be that hunting was the only

way to feed the family; it was all animals then. That was the only food we had."

In 1969 Totalik's polar bear hunting expertise made him the protagonist in a law case that turned out to have international implications and occasioned the headline TAKE LAW BOOKS WITH YOU over his picture in *News of the North* for 29 January 1970.

R. v. Tootalik first came before Mr Justice Morrow sitting in JP court in . what was then Spence Bay. It would be the most discussed case of Morrow's court. "Morrow was a very, very energetic man, very keen on doing his job," says Mr Justice Ted Richard, NWT Supreme Court senior justice. Mr Justice Mark de Weerdt relates, "He had flown into Spence Bay without any lawyers along, met the corporal, and probably said, 'Is there anything I can do for you, Corporal?' The corporal would have said, 'I'm not sure, sir. There's a case here I should talk to the Crown about.' And Morrow would have said, 'Oh, don't worry about that; just bring it on.'" On their circuits Sissons and Morrow were prepared to act as justices of the peace, magistrates, or superior court judges. Sissons believed that "no court should be too superior" to hear any case.

On 14 April 1969 Totalik, then thirty-nine, and three companions were travelling by dog-team several miles off the coast of the Boothia Peninsula on the sea ice near Paisley Bay. They were looking for polar bears to shoot for their hides. They sighted three bears together, two smaller bears and a larger one. Totalik and one of the other men, Argvik Agvil, waited for the other two of their party, Mathias Munga and his deaf mute son, Oomeemungnak (a man who does not talk), to catch up. The plan was that Oomeemungnak should take the first shot and if he was successful sell the skins to the HBC. They let the dogs loose and Oomeemungnak got the larger bear and one small bear with a single shot. The third bear ran away but the dogs worried it back into the area and Totalik shot this one. In due course, back in Spence Bay, Totalik was charged with hunting a female polar bear

with young, contrary to the NWT game ordinances. Totalik, as head of the hunt, accepted full responsibility.

Sitting as justice of the peace, Morrow heard the evidence in August and adjourned the case to Yellowknife. De Weerdt, then a member of the bar, surmises that Morrow said to Totalik "something like 'Don't say anything; I will get you a lawyer and we will make sure you are defended and your rights protected.' He dashed off to Yellowknife in his plane and said to me, 'I am appointing you to defend Totalik.'"

The case occurred at a time when there was international interest in the extent of Canadian sovereignty in the Arctic because of the passage of the ss *Manhattan* through the Northwest Passage (which Canada claims as Canadian waters). In November, appearing before Mr Justice Morrow, de Weerdt mounted a novel defence. "Defense Counsel Mark de Weerdt dropped a bombshell when he charged that the Court did not have justification and Territorial Ordinances could not be applied because the offence had occurred on the sea ice outside the three mile limit and Canada had not claimed sovereignty over Arctic waters," wrote the reporter for *News of the North*.[1]

Mark de Weerdt explains his defence strategy, "I got a transcript of what evidence had been heard and it looked like an open and shut case. The only thing that hadn't been proved was where the bears were shot. So I went and I read up on bears and talked to a local wildlife expert, and it turned out that bears swim around a lot and they can be found thirty or forty miles out at sea. In those days we had a rule of thumb that said Canada extended for three miles from its coasts, so I thought maybe Totalik has an out here. They haven't proven where the bears were shot; it could have been on the sea ice miles from shore. I raised the argument but it didn't wash. Morrow wrote a very interesting judgment saying that these waters were all Canada, part of the Northwest Territories."

Morrow quoted Prime Minister Lester Pearson, who in 1946, while Canadian ambassador to the United States, had said, "A large part of the world's

total Arctic area is Canadian. One should know exactly what this part comprises. It includes not only Canada's northern mainland, but the islands and the frozen sea north of the mainland between the meridians of its east and west boundaries, extended to the pole."

He quoted Prime Minister Louis St Laurent, who in 1953 in the House of Commons had stated, "We must leave no doubt about our active occupation and exercise our sovereignty in these lands right up to the pole."

He pointed out that the Sissons and Morrow courts had done their part. "It has been notorious that this court has administered the laws of Canada in all parts of the territory, including such of the Arctic Islands as have inhabitants in the various places visited. It is to be observed that on at least one occasion court was actually held in a ski-equipped Otter sitting on the sea-ice off Tuktoyaktuk."[2]

Because of the recent presence of the *Manhattan* in Lancaster Sound, Morrow's judgment excited wide interest. The Canadian government had never made an outright declaration of sovereignty over the Arctic waters, intent apparently on avoiding an international court challenge from the United States, which believed the Northwest Passage, an integral part of the waters, to be international. With Morrow's ruling, for the first time a clear decision on Canada's sovereignty over Arctic waters was established in a Canadian court.

Morrow found Totalik guilty as charged, but ended his judgment as behooves a fighter for native hunting rights: "I regret having to find an Eskimo guilty of a game offense such as this. Apparently the game department, through no negligence on their part, have found it difficult, if not almost impossible, to give adequate education and instruction to the native people in such remote areas as Spence Bay. To me, game enforcement of this kind is a matter of education rather than policing. We all know the polar bear should be protected but the Eskimo, living in the limited horizon of his harsh world, knows only that the polar bear is to be hunted for food and for the money the hide will produce."

Morrow postponed sentencing until he was next in Spence Bay. Sitting again as a magistrate, he heard the lawyers speak to sentencing. The maximum penalty was a $1,000 fine, a year in jail, or both, Crown prosecutor Orval Troy told the court. But Troy said he supported the defence counsel's request for a nominal fine.

"I don't enjoy finding you guilty. I know that you are a hunter and that your people have always been hunters," Morrow told Totalik. "I have found you guilty and must fine you something." Then he said, "The Crown says, 'Don't be mean,'" and fined Totalik $5.

But Totalik never paid that fine. Mr Justice Morrow's ruling on Canadian boundaries still stands, but Mark de Weerdt succeeded in overturning Totalik's conviction. He remembers, "We went up to Spence Bay so the appeal could be held where Totalik lived, before another judge, and there I saw the skins. The skins of the supposedly little cubs were – within an inch or two – nearly as large as the mother's." In the appeal de Weerdt did not argue the aspects of the case that touched on Canada's international boundary. "I've never seen such a relieved judge as Justice [H.C.B.] Maddison [of the Yukon] when I arose and said, 'My Lord, we will not be arguing the international law.'" Instead he reminded the court of the earlier evidence of a wildlife expert that "bears usually stay with the mother for two years and then they go their separate ways, and if they hadn't found a mate in the third year, they may all stay together for another year. That is pretty clearly what happened – and on that basis the charge of shooting a mother polar bear with young was dismissed."

Totalik got his skins back, and with the help of de Weerdt and Morrow, he sold them to Eric Hardy, a Calgary millionaire, for $1,000 apiece – in those days, de Weerdt notes, a good price.

De Weerdt believes that although Morrow was the trial judge for the ground-breaking *R. v. Drybones*, "he came to recognize that *R. v. Tootalik* was his most important case." Genevieve Morrow sometimes heard her husband speak of it as "a real sleeper which someday could be very important

to Canadian sovereignty in the Arctic." And some years later, after Morrow's death in 1980, when amidst public indignation in Canada another US government vessel was about to venture into Canadian Arctic waters, Genevieve Morrow wrote to Prime Minister Joe Clark to alert him of the judgment. Clark wrote back that his government was aware of the decision.

Mr Justice Morrow's judgment in respect to Canadian Arctic boundaries has not been challenged.

It is July 1994, and this year for the first time that he can remember, Totalik has yet to catch a polar bear. He says he's an old man now, and he spends most of his time fishing close by Taloyoak. "You need a skidoo to go polar bear hunting today and skidoos are expensive." But he adds, "I'm still catching them. I caught my last bear last year."

CURRENT TIMES

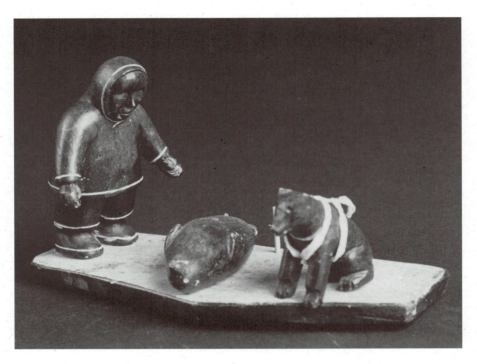

Though included in the Yellowknife Courthouse Collection of Inuit Sculpture, this carving does not appear to represent a case.
Mary Evekhoak Akana, 1936–
Cambridge Bay, formerly of Kugluktuk (Coppermine), NWT
Stone, hide, wood, sinew
16.8 × 8.8 × 10 cm

1991

Interpreting the Law
Regina v. Niviaqsi Laisa

"Juror, look at the accused; accused, look at the juror," intones Anne Mould, deputy clerk of the Supreme Court of the Northwest Territories now on circuit to Cape Dorset, Baffin Island. Immediately, Akalayok Qavavau interprets the words in Inuktitut – "*Naalakti iqqarturaksaq takunnaruk; iqqarturaksaaq naalakti takunnaruk.*"

Akalayok is one of a small handful of linguistic geniuses on whom the court relies now that an amendment to the NWT Jury Act has made it possible for unilingual native people to serve as jurors, *naarlaktiit* (the ones who sit and listen). She and a second interpreter, Atsainak Akeeshoo, will spell each other every fifteen minutes, and every word uttered in court, or *apiqsuivik* (the place where questioning takes place), will be consecutively interpreted.

The case in question is a double murder trial – *R. v. Niviaqsi Laisa* – with NWT supreme court justice Mr Justice Ted Richard on the bench. It is one of the first cases for which a jury having unilingual Inuktitut speakers is to be empanelled, necessitating a completely bilingual trial, and it is a challenge for interpreters and for the court. But the justice system in the Northwest Territories is no stranger to challenge. Since the now historic days of Mr Justice Sissons, it has been recognized that to serve justice in the North, the laws and the courts must adapt.

Jurors who speak a native tongue and no other may be only the first of a number of changes as the years of transition for Canada's northern aboriginal people come to a close and they take increasing control. The NWT Department of Justice plans to put in place a number of Community Justice Initiatives. It is to observe one new initiative – and catch the drift of change that I am here in this court this day in May 1991 for *R. v. Niviaqsi Laisa*, a case that has sent shock waves through the Territories and seems likely to prove that crimes in the modern era are different, too.

As is routine, the court – the judge, two lawyers for the Crown, two lawyers for the defence, sheriff, clerk, recorder, two Inuit paralegals who work with the defence, one Inuit interpreter (the second conveniently lives in Cape Dorset) – and also the accused and the witnesses flew in yesterday. Proceedings are now in progress in Cape Dorset's recently built community centre, the courthouse for the session.

At the entrance today is a device to detect weapons, and the officers of the Royal Canadian Mounted Police carry arms. "Emotion runs high," says court clerk Anne Mould. "Two children are dead."

The community centre is packed this morning with observers and those called for jury duty. Most weeks it is the scene of bingo, movies, and dances. Several times a year there are community feasts; on big tarps, hunters cut up the caribou or seals they have brought back on their cargo sleds from trips out on the land and to the floe edge. For the duration of the Supreme Court sessions, however, the community centre is seemly and dignified.

The Maple Leaf and the NWT flag are tacked to the wall. Those RCMP members who will testify wear their red coats, and Mr Justice Richard, in black robes with red tabs, sits behind a large table at the head of the room. At tables to the left are the court clerk and the sheriff; at the right are blue plastic chairs for the jurors; and in front, at tables, are the lawyers and the accused.

As usual in the North, it is a young court. The judge is in his forties. Crown counsel Louise Charbonneau is twenty-six. This is her first murder case. "A jury trial throws a lot of good sense back into the community," she says. She is my room-mate in the Kingait Inn, where most of the court is billeted. It is squeezed to capacity. Only the judge has a room to himself. Also in residence are a journalist from the British magazine *Vogue*, a journalist and a photographer from the German magazine *Der Stern*, and an Arts and Culture of the North tour run by New Yorker Sandra Barz. None of these people are here for the trial (though many are regular in their attendance in court); rather they have been drawn to Cape Dorset because of its renown

as a centre for northern art. Sometimes known as the Athens of the Arctic, it is the most acclaimed of the Inuit communities that for more than forty years have sent carvings and prints to art markets down south.

Some of the people in court today are artists with names well known to southern collectors. Seated beside me is Pitaloosie Saila, a noted printmaker. She is an aunt of one of the victims, Putalik Pudlat. "My brother never talks. Only tears," she says. "It would be better if he talked."

The sheriff has polled 140 persons for jury duty. This amounts to a considerable proportion of the adult population of this community of about 1,000, many of them children (the Northwest Territories has one of the highest birth rates in the world). Among the throng is an occasional young woman wearing the beautiful traditional *amautik*, a triumph of design and usefulness with its pouch for carrying a baby, but most in the crowd wear polyester windbreakers and pants. The windbreakers glow: they are purple and pink, turquoise and blue and rose. They are made in China.

It is afternoon before the jury selection is complete. Mr Justice Richard then tells the jurors that they are judges of the Supreme Court for the case, that the partnership between judge and jury is an ancient one. The community of Cape Dorset "is looking to us – to you and to me – to make sure this is a fair trial and an unbiased trial." He explains that the presentation of evidence is based on the adversarial system. "You and I as impartial judges sit and listen to what the witnesses and lawyers have to say … We rely on the lawyers to bring out the relative facts by asking questions of the witnesses."

Interpreter Atsainak Akeeshoo keeps her pencil at the ready and jots down key words in the manner approved by the NWT legal interpreter training program. Every word uttered by the judge – the *iqqaqtuiji* (the one who causes someone to recollect) – is interpreted with a rapid-fire precision.

Since the time of the explorers, aboriginal interpreters have acted as guides and helpers for every category of southerner in the North. Their skills are legendary. Without their interventions much of the accumulated knowledge of the Arctic regions would not exist. NWT courts have always

relied on interpreters, many of whom learned fluent English in church-run residential schools or sometimes during hospitalization in the south.

But until recently an interpreter's knowledge of court procedure was picked up on the job. Accidents could happen. A court official recalls an instance when a juror interrupted the interpretation of a witness's testimony and told the court, "Excuse me, that's not what the witness said." The Crown prosecutor rose immediately to ask for a mistrial.

Since 1988 the NWT government in Yellowknife has offered legal interpreter training in four two-week modules, each dealing with various aspects of the law. Module number one covers origins of the law, the structure of the courts, and criminal procedures, while module number two deals with specific offences, specific defences, and young offenders. "The training gives a lot of confidence," says Atsainak Akeeshoo.

"Before you were just thrown to the lions," says interpreter Suzie Napayok of the Yellowknife Language Bureau, which supplies interpreters for the courts and the NWT Legislative Assembly. Even now, she says, trainees sometimes delay taking module number three (jury trials, expert witnesses, coroners' inquests) because "it's too technical, too difficult, there's too much pressure – a person has to be very strong to deal with it all."

The NWT minister of justice, Michael Ballantyne, says that in 1989 his department pressed ahead with its decision to let unilingual native speakers serve on juries despite "a lot of opposition" from elements in both the territorial and federal governments. Such juries necessitate totally bilingual trials; they increase costs and the likelihood of appeals. (The test case is considered to have been *R. v. Ulayuk*, also a murder trial before Mr Justice Richard, held in Igloolik in 1990. Lawyers for the accused ran a defence of insanity, requiring many expert witnesses and three interpreters. The case went to appeal but *not*, court officials say with satisfaction, because of any problem with interpretations.) Suzie Napayok believes the efforts are worthwhile: "The system has definitely been improved because now unilingual people can participate – previously they'd be excluded."

As Mr Justice Richard concludes his opening remarks to the jury, he warns that the jurors must expel from their minds all that they have heard about the case. This will not be easy for the jurors to do. The tragedy of the deaths of two young children, for which the accused, Niviaqsi Laisa, now stands trial on two counts of non-capital murder, has haunted the people of Cape Dorset for a year. One of those polled was excused from jury duty because he is related to both the accused and the victims.

The charges are read. The accused rises; he pleads not guilty to two charges of second-degree murder and then, the first surprise, perhaps, to observers of this trial, guilty to manslaughter. We begin to see that essentially this case will be about the difference between murder and manslaughter. It will turn on whether the Crown can prove murder or whether the accused is guilty of the lesser charge. Shortly, it will transpire that the case will hang on whether the jury will accept the "defence of intoxication."

Alcohol, drugs, substance abuse – all are associated with family violence and rising crime rates. Apart from unemployment, there is no greater problem than addiction facing the Territories. There are alcohol and drug dependency programs in all communities (many have voted themselves dry), but the battle against addiction must be fought every day. Iqaluit RCMP officers considered they were breaking new ground when they acquired Police Dog Argus, trained to sniff out drugs. Taken to the airport to check out a plane on his first patrol, he proved his worth by zeroing in on individuals in the disembarking Blue Rodeo rock group. When charges were laid, the case went to appeal. It has yet to be determined whether Police Dog Argus attentions are legal. This has exasperated many northerners maddened by the influx of drugs into their communities. "The dog would definitely help us," an RCMP officer tells me. "People involved in drugs up here are very well insulated."

The Crown begins to build its case. Crown prosecutor Pierre Rousseau tells the court that on the evening of 14 May 1990 Niviaqsi Laisa was at House 58 in Cape Dorset, where he lived with his parents; he was upset

about something that had happened earlier that day and was sniffing propane. "We expect the evidence to show you that the accused then strangled two children and put their bodies in a bag," Rousseau says.

The accused is twenty-five years old, stocky, with a shock of black hair and a chalky white face. "Is he crazy?" people ask, but the court will hear no evidence to indicate psychosis. Like many of the generation whose parents left their camps in the 1960s for settlement life, Niviaqsi Laisa has little education. He dropped out of school at grade five when he was about twelve. He began to drink alcohol at age eleven. Illegal drugs and other substances followed. He has virtually no employment record because for much of his adult life he has been in jail.

At first Niviaqsi Laisa's crimes were minor thefts, break and enters committed perhaps with the aim of obtaining something to drink. But lately the community has observed that his crimes have become more violent: he has strangled puppies and been convicted of assault. In fact, at the time of the deaths of the children, he was again in trouble with the police, awaiting trial for beating up his girlfriend, Malaya Pootoogook, by whom he has had a child. While he waited for his case to come up, the court had ordered him to keep away from Malaya.

The Crown calls its witnesses, and as each fills in part of the story, a picture emerges. We learn how the deaths of Putalik Pudlat, four, and Louisa Ohotok, five, which the accused has admitted he caused, came about.

The parents of the accused take the stand. From his father, Laisa Qudjuarjuk, we learn that on the day of the children's deaths (14 May 1990), Niviaqsi told his parents that he wanted to see his son. They agreed to take their skidoo and go to the house where Malaya Pootoogook lived with her parents and ask for the child. Niviaqsi's mother went inside but Malaya's family didn't let her take the child.

Qudjuarjuk tells the court how Niviaqsi reacted to the news on their return: "He said he could kill everybody in that house. He got very mad. He threw the phone at his mother. He went straight to the bedroom. My wife

and I left the house." Qudjuarjuk took his wife to join some women who had got together to sew. Sometime later he returned home because, he explains, he wanted to make sure Niviaqsi was alright. He stayed about ten minutes. Niviaqsi was watching television. Qudjuarjuk says, "I noticed he was no longer mad and so I was thankful for that."

Perhaps, it is suggested in court, Niviaqsi had begun to sniff.

Over the next hours Qudjuarjuk returned to the house several times. He and his wife also visited friends. He says, "Sometime during the evening we heard that two children were lost and we decided to assist." At about one in the morning he went back to the house and found Niviaqsi again watching TV. "I told him that they were searching for the two children and they hadn't found them yet. He said 'Yes.'" The next day Qudjuarjuk returned home to find Niviaqsi sleeping. He woke up when his father entered. Qudjuarjuk says, "I told him they still hadn't found the children. He just said 'Yes.'"

On his next visit Qudjuarjuk found the house empty. Organized searches for the children were now in progress, and Qudjuarjuk opened all the bedrooms and searched in all the closets. "I was quite upset," he admitted, "because maybe they could have been there." Niviaqsi's parents were well aware that their son's behaviour had become antisocial.

Each time the court recesses, observers flock into the foyer to drink free coffee, supplied by Palaya Qiatsuq, the community centre manager. Here I talk to paralegal Timothy Sangoya. Paralegals are now trained in four centres across the Territories.

One of Sangoya's duties for the defence has been to investigate the background of the accused. "It may be worthwhile for you to know," says Sangoya to me, "that the friends of that individual were warned a year ago by local elders: 'If you don't do something about him, he's going to end up killing somebody.' And about a year after, he did it." Sangoya is one of those who believe the Inuit should have their own justice system, which, while continuing many existing structures and practices, would depend also on

the greater involvement of Inuit elders. But who is an elder? "All the legends have gone," I hear a member of the court remark.

Sangoya defines an elder as "a mature adult who handles himself and his family and extended family in a responsible manner." Elders would counsel, watch, and warn, perhaps giving young offenders extra chances within the community rather than isolating them by jail sentences. "It's crime prevention," Sangoya says. Yellowknife legal interpreter Suzie Napayok says, "The southern justice system is a very high horse kind of business. It's very intimidating. I think Inuit people are more likely to say, 'Maybe if we show [an offender] the right way to do things, he'll adjust and be a contributing member of our society.'"

The next witnesses tell how the community searched for its missing children. Around 1 a.m. on 15 May 1990 RCMP constable Lance Martel received a call saying two children had not returned home. He got out the truck and drove around town. Some forty people were already searching. All through the day the searches continued. During a court recess, Charlie Manning, the Inuk who was mayor at the time of the tragedy, tells me, "We set up teams – team one, team two, team three. The area for searching was laid out on a map." All houses were searched, except for those that were locked. House 58, where Niviaqsi Laisa lived with his parents, was one of these. Late in the day a hamlet meeting was held and a decision taken to ask for help from the Baffin Emergency Response in Iqaluit. At about two in the morning of 16 May emergency forces arrived. The searches continued, now under the direction of RCMP corporal Gary Asels, by air as well as on land, but to no avail.

Then the RCMP approached Mayor Manning and asked for certain information. Were there persons in the hamlet who might hurt small children? During a recess, Martel explains, "As the searches continued and provided no results, we said, 'Let's not rule out foul play.' It was decided to check out certain houses again."

Manning supplied the name of Niviaqsi Laisa. "The house was locked and also it had been noticed that Niviaqsi looked nervous," he tells me. Constables

Mark Belliveau and John LaSeur took Jamesie Pitseolak, a young bilingual Inuk, as interpreter and went to ask Laisa Qudjuarjuk for the key to House 58. "The RCMP wanted the key so I gave it to them," Qudjuarjuk testifies. They asked him if he wanted to accompany them but he said no. The police went to House 58, unlocked the door, and began to search each room, opening closets and cupboards. Jamesie Pitseolak also searched. As he looked about Niviaqsi's bedroom, he spotted a First Air hockey bag on the floor under a jacket and some blankets. "I touched the bag and right away I knew it was them. I said, 'Oh no, oh no,' and John came over and opened the bag."

After this we learn that late in the day the RCMP found Niviaqsi with the searchers on the outskirts of town. "We saw Niviaqsi Laisa walking and Belliveau went to one side and I went to the other and we put him down on the ground," Constable Martel tells the court. "I told him he was under arrest for the murders of Putalik Pudlat and Louisa Ohotok." Back at the hamlet Niviaqsi Laisa made two statements to the police. One statement is recorded on video at the scene of the crimes. Though frequently offered the opportunity, the accused did not call legal aid, as was his right, but he tried to call his mother.

The testimony now becomes highly technical as lab reports are offered in evidence, but neither clinical terms nor the frequently Elizabethan parlance of the court appear to pose problems for the two interpreters. "Believe it or not, these words are easy to translate," says Timothy Sangoya. "People often say there are not enough words in Inuktitut, but this is not really true for those of us who still have our language. Maybe in the western Arctic [where many aboriginal languages are disappearing] this is so but not on the Baffin." One of Sangoya's jobs for the defence is to listen to the interpreters and check accuracy; their interpretation is also recorded.

Trainees usually bring strong natural aptitude and drive to their work (top interpreter Mikle Langenham, who works for the Legislative Assembly, says, "From childhood I wanted to be an interpreter"). But there are pitfalls, as Betty Harnum, coordinator of legal interpreter training at the time of *R. v.*

Niviaqsi Laisa, points out. (Harnum, who speaks all dialects of Inuktitut, is literate in the Dene languages and has basic conversational skills in Slavey, would shortly be appointed NWT commissioner of official languages.) "The real problem for interpreters," she says, "is that they feel responsible for making sure every word and aspect of court procedure is understood, although actually in court there are many things that the average English-speaking person probably does not perfectly understand." The problem is compounded because "it is difficult to find equivalent translations in the native languages that have the same legal meaning as the English term, because the same legal system has not existed historically in native cultures as in our Indo-European societies. Any specific word carries with it a host of connotations, associations, and a cultural frame of reference. It is derived from a specific historical background."

Regular brainstorming sessions are an important feature of the training program. Trainees gather together to work out translations for expressions and terminology they are likely to encounter. These are entered into a computer. Trainees also help clean up inexact translations that have come into general use since the early days of the circuit courts. In one part of the Territories, for instance, the Inuktitut translation for "the accused" has often been *pirayaktuq* (the one who did it). Now a new term, *pasijaksaiyug* (the one who is possibly to blame), has been entered into the computer. "Sometimes it is really hard to find the right word or term … to make sure that the translation to be used doesn't include too much or leave something out," Harnum explains. "For example, the word 'evidence' can mean both spoken testimony and exhibits. In Inuktitut this used to be translated by 'what the people say,' but this is too much because it includes also what the lawyers say and excludes documents and material objects like guns." The approved translation for "evidence" is a phrase that means "the words of the people who are asked to come and tell their stories and the things that are shown and are supposed to be thought of." Clearly, it is a problem, Harnum admits, that many concepts cannot be translated by a single word. "We go over and over terminology. Interpreters say, 'Not again!'"

Sometimes a less than satisfactory expression remains in use because it has gained too much currency to change. Not all judges like the word for judge – *iqqaqtuiji* (the one who causes someone to recollect). They point out that lawyers perform that function. (The word for Department of Justice is *iqqaqtuijikut* [judges and company].) And the word for interpreter – *tusaaji* (one who hears) – is not entirely satisfactory. "There's been some suggestion about changing it," says Harnum, "since interpreters obviously do more than listen, but the word has taken on a broader connotative meaning. It will probably not change just because it is so widely used and understood."

In the final days of the trial a television camera is set up in court and we witness a shocking document – Niviaqsi Laisa's confession videotaped in House 58. As Constable Martel asks questions, the camera follows Niviaqsi Laisa through the house into his bedroom. The Union Jack and heavy-metal rock flags hang on the walls. I am told there is also graffiti, but I do not see it. We watch and hear Niviaqsi Laisa say, "I was going crazy. I couldn't even see my son so I really got mad."

"What happened next?" Constable Martel asks.

"Those two kids walked near my place," Niviaqsi Laisa says. "They went into my place around nine … I was sniffing propane torch, that is why I was really mad … I asked them to get out but they wouldn't get out so I sniffed some more of that propane torch."

"And then?"

"I went into my room to sniff some more. Those kids came in. I was kind of passed out – that's how it happened."

Martel probes again.

"I started choking them," Niviaqsi says.

"I was kind of passed out too."

"Who was first?" Martel asks.

"Louisa." And after a minute, "I really can't remember. I was high on that propane torch. When I started to remember I was choking Putalik … Then I realized that I killed two little kids … When I finally realized what I was doing the little kid was already dead."

And in this tragic video Niviaqsi also tells Martel, "I didn't really try to hide them [the bodies]. I could of hid them but I didn't."

Why did he participate in the search? "I just wanted to let someone find them at my place. I didn't want to tell my parents."

After the Crown rests its case, the defence produces only one witness, Dr Alan Long, a clinical psychologist attached to the Donwood Foundation, a Toronto public hospital licensed for the treatment of addiction to alcohol and other drugs. He tells us what propane is and what it does. Propane is a solvent belonging to the family of petroleum products that includes naptha, nail polish remover, and commercial cleaners. It is packaged in cylinders or tanks with a valve that must be opened to let the gas out. Substance abusers put a pin in their mouth and press it on the valve. With a few sniffs most people become confused, sleepy, and have a false sense of well-being. But propane is a toxic substance with a poisonous effect on the brain function. As the gas is sniffed into the lungs, the blood picks it up and carries it throughout the body. It is stored in the cells of the brain, and if a person continues to sniff, it becomes a disabling drug. "Propane pulls a blanket on consciousness," says Long. As a result of the absorption of poison and the displacement of oxygen, "the cells in the brain become dim – like lights when the electricity is withdrawn." Long continues, "A person affected in this way acts in a very animal-like way." He becomes restless and can become irritable. As he becomes more and more intoxicated, he becomes dangerous; there is no indication of conscious concern for the effect of his actions on himself or other people. Afterwards, there is dim memory of acts committed: "maybe a little bit – a snapshot." Perhaps there are "fits of recall that may make it appear that he was aware of what he was doing. But he is like a sleepwalker." Use of propane, Long tells the court, "induces dissociation."

In the foyer Timothy Sangoya tells me that dissociation translates as *pilarik* (not being in touch with reality). Sangoya has no compunction about indicating the fate in the old camp days of truly antisocial individuals, those who hazarded the safety of society: they were executed following the

decision of senior members of the community. The old life allowed no room for sentimentality. Until recent days there were men living in Cape Dorset who had participated in such executions.

With Long's testimony, the case approaches its close. In cross-examination Crown attorney Pierre Rousseau draws from Long the admission that few scientific studies specific to propane sniffing have yet been undertaken. Nevertheless, Long has helped the case for diminished responsibility. The closing arguments to the jury follow. Defence lawyer Neil Sharkey emphasizes points from Long's testimony. (The word in Inuktitut for defence lawyer is *sapujjiji* [the protector].) Sharkey reminds the jury that Niviaqsi Laisa has confessed his crimes to the police. "We as Niviaqsi's lawyers suggest to you that Niviaqsi is guilty but we say the proper verdict is that he is guilty of manslaughter ... he had lost almost all his mental faculties and his lights [were] just about right out."

Mr Justice Richard now charges the jury: "You are the judges of the facts of the case and I am the judge of the law. For example, I will tell you what a murder is in law and you will decide if there was a murder in this case." He reminds the jury of the presumption of innocence – "The burden of proof never leaves the Crown." He explains the difference between murder and manslaughter: to justify a verdict of murder, the Crown must prove that the accused had the intention to cause the crime; in manslaughter, intent is not a factor. And Mr Justice Richard spends considerable time on "the defence of intoxication." Sometimes an accused becomes so intoxicated that he commits a crime without intending to commit it. When this happens, the defence of intoxication may apply because he did not have the intent to commit the offence.

There is evidence, he says, that the accused was sniffing propane prior to the deaths of the children, but the mere fact that he had propane in his body does not assist him if he had the intent. "Ask yourself if at the time of the deaths he had the necessary intent ... Ask yourself at the time of the deaths did he have the capacity to form the intent ... And secondly, did he in fact

form that intent?" He tells the jury that the Crown must prove beyond a reasonable doubt that the defence of intoxication is not available. "If you are left with reasonable doubt you must find him not guilty."

"Beyond a reasonable doubt" – no words used in court have caused more debate during the legal interpreters' brainstorming sessions. Partly, the problem is that the concept is imprecise. Course director Betty Harnum illustrates this point: "We have even resorted to drawing a line marked out from 1 to 100 and asking trainees to indicate the point at which they would feel satisfied 'beyond a reasonable doubt.' Some people draw the line at around 70 while others only at 99, leaving a minuscule latitude for human error."

But for interpreters translating into Inuktitut there are additional difficulties: there are no exact translations for "reasonable" and "doubt" – only approximations. The sense of the word "reasonable," the interpreters have decided, is best suggested by the phrase "someone who is thinking well." The construction now in the computer for "beyond a reasonable doubt" is *nalunaluarunniqtuq* (it no longer causes one to be too much perplexed). Sometimes, for extra emphasis, this is expanded to *nalunaluarunniqtuq isumatsiaqtumut* (it is no longer too perplexing to someone who is thinking well), that is, to a reasonable person it is beyond doubt. Betty Harnum likes a simile one trainee came up with to help clarify the concept: being sure beyond a reasonable doubt is "like a chair you feel safe sitting in."

Shortly before lunch the jurors retire to deliberate.

As I walk away from court, I meet Charlie Manning's sister, Annie, driving with her young son on her all-terrain vehicle. Her duties as a schoolteacher now keep her too busy but she was one of the first Inuit women in the Territories to serve as justice of the peace. As we talk, she remarks on the concern felt in the community that the accused might receive a light sentence. "They say he could be out in five years." The sentence for manslaughter, as for murder, is life, but there is wide latitude with regard to eligibility for parole. "What he did was so cruel – he murdered two children." She feels that police have not worked hard enough to eradicate the

drug pushers from the fragile communities of the new North. "They haven't really tried," she says. "Maybe they're scared." Later I hear a court official discuss the pushers. "We haven't strung them up," he says. (Only in 1996 will the RCMP, in response to the concern of Baffin Island residents, set up the Nunavut Drug Enforcement Unit and, with a warrant from a Yellow-knife judge, again employ the services of a sniffer dog.)

After lunch, back at the community centre, the court fills up. In the foyer we mill around waiting for the jury to return with its verdict. I talk to Charlie Manning. "There's been a lot of emotion over the case," he says. "Still is. I told the RCMP it could errupt. They should watch it or the same thing could happen that happened in Pangnirtung." An accused in that central Baffin community, Charlie explains, had given some home brew he'd made to a woman and she had died after drinking it. "They started trampling the prisoner. The police did nothing – because they were overpowered."

Then suddenly we are back in court. But not for the verdict. A note has been sent to the judge from the jury, but it does not ask for instruction or clarification on a point of law. It is a note from a single juror and says in part, "Since he [Niviaqsi Laisa] was growing up he has been in great pain and he could never take that pressure out of his heart. He took the first thing that could help him open up – propane torch. That thing caused him to kill even when he didn't want to kill. It wasn't done on purpose. I sympathize with you, Judge."

The note is read into the court record and the jury admonished that it must only consider the evidence before it and the submissions the lawyers have made, and not the early life of Niviaqsi Laisa. The jurors return to the jury room, but in minutes they are back and deliver their verdict. They have found Niviaqsi Laisa guilty on two counts of second-degree murder.

Mr Justice Richard thanks the jury: "I appreciate that you have been through a great deal in arriving at a unanimous verdict." He says that the law requires that he ask for the jury's recommendation, although they are not obliged to give it, on the number of years Niviaqsi Laisa must serve

before he is eligible for parole (not less than ten, not more than twenty-five). If they have a recommendation he will consider it. The members of the jury retire but quickly return; they have decided to leave sentencing entirely to the trial judge.

The jurors now are free to go. But I notice that many return and sit in the audience section of the court. Interpreters Atsainak Akeeshoo and Aka-layok Qavavau switch from consecutive to simultaneous interpretation. All through this case, which has so epitomized the dark aspects of life in the North today, their skills have shone. Now they take turns sitting in the front of the court, talking in very low voices into a microphone with a sensitive head. As older and unilingual Inuit enter the court, they pick up sets of headphones. Through these they hear a simultaneous interpretation of all proceedings.

The lawyers make submissions with regard to sentencing. The Crown asks for a sentence "in the upper region." Crown attorney Pierre Rousseau says that there are no mitigating circumstances and that "the jury decided he knew what he was doing." From defence lawyer Valdis Foldats, we learn that Niviaqsi Laisa has been described by psychiatrists who have seen him recently as being in a state "of absolute despair"; that he has said his father and mother were good parents; and that while awaiting trial he has attempted suicide twice.

When the lawyers finish their submissions, Mr Justice Richard retires and again we wait in the foyer, drinking coffee. Then the judge returns and the moment of sentencing is at hand. Mr Justice Richard describes Niviaqsi Laisa's crimes. A substance abuser for most of his life, for no apparent reason he has taken the lives of two very young children, "the worst possible crime against his family and the community of Cape Dorset." Then he declares, "I am satisfied that it is fit and proper in this case to increase the period of parole ineligibility ... Justice requires this in my view. It is difficult for me and it saddens me to send a young man to prison for a long time. It

is what justice and my conscience require me to do in this case." Niviaqsi Laisa must serve twenty years in prison before possibility of parole.

The case of *R. v. Niviaqsi Laisa* is over and now perhaps the wounds can begin to heal. The crowd leaves quietly. The sentence is severe. Perhaps the defence will appeal in hopes of earlier parole. "The jury was split, we know – because of the note," says Sharkey. "Gives us a loophole and we'll take it," says Foldats.

In fact, the defence has already conceded that their client will spend many years in jail. "Citizens of the North," Valdis Foldats has declared in his final remarks to the court, "are particularly aware of what alcohol abuse does, of what drug abuse does, and of what substance abuse does. This case brings home that message in the most tragic manner imaginable.

"If you drink enough alcohol, if you take enough drugs, if you sniff enough propane, you lose your humanity. You become an animal. Everyone in this community and indeed everyone in the North should learn from this case. Drugs, alcohol, solvents – all of these things destroy lives."

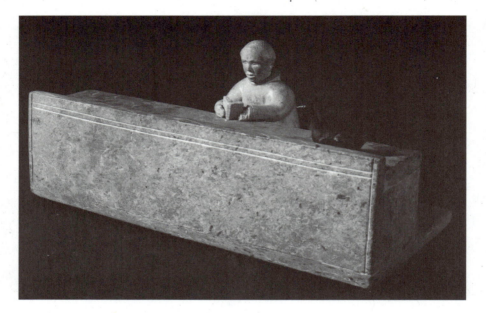

Sissons on the bench (front view)
Artist unknown
Kugluktuk (Coppermine), NWT
Stone
31.75 cm (length) × 17.8 cm (height)
Collection of John Webster, Calgary

In Nunavut: Okalik for the Defence

On the first day of April 1999 the new territory of Nunavut will come into being, and all things being equal, Paul Okalik, thirty-two, from Pangnirtung, will practise at its bar.

In 1989 during an interview in Iqaluit with territorial judge Orval Troy, I listened as the judge talked to Mr Justice Mark de Weerdt on the telephone. De Weerdt had that day in Yellowknife sworn in a new member of the NWT bar. How long before there would be an Inuit lawyer? Ten years, the judges decided. Paul Okalik, if all goes according to schedule, will finish articling one year ahead of time and become the first lawyer born and bred on Baffin Island, where until the 1970s there was not a single native high school graduate.

I meet Paul Okalik in November 1996 in an Ottawa coffee-shop where the menu is bagels and cream cheese. He is five months away from graduation. Okalik was about two years old when Mr Justice Sissons left the North, but I discover he is an admirer of the judge. "I read his memoirs. I felt a great respect for him because he stood up to the establishment and tried to ensure that the values of the Inuit were taken into account. That got him into trouble in some cases. He was trying and nobody was at the time."

In Nunavut Sissonian flexibility will be a necessity, he believes. "We have to introduce something that will have a more positive impact on our communities."

Okalik is well acquainted with the Nunavut Act. It was as part of the negotiation team that he first came to Ottawa. Nunavut will have its own supreme court and its own court system. The Charter of Rights and Freedoms and the Canadian criminal code will be the law as everywhere in Canada. But like the other territories, Nunavut will be empowered to enact wide-ranging legislation, although the prosecutorial function will remain in Ottawa. "The criminal justice system is under federal jurisdiction, so we have to work with what's there now," Okalik says. "I don't always agree with

the law, but there's only one way you do anything about it, that's to learn about it and try to use it."

Okalik chose his career in boyhood after observing the court in action. "My teachers told me I could be anything I wanted and I thought – uhhh, I want to be a lawyer." Elaborating, he says, "From the time I was in elementary school, I saw a lot of activity in the legal field with family members which wasn't always positive. I felt from then on that I wanted to practise law."

He watched as friends and relatives came up before the court. Okalik understands the problems ("I went through those problems") and feels that sentencing practices have failed his contemporaries. "Personally, I lost a brother. My brother had some problems with the law that drove him to the point where he ended up committing suicide. He was sent to jail and as part of the sentence he had to pay back; he couldn't afford to pay back, so he would have gone back to jail and he wasn't looking forward to that." Okalik is not aware of all the factors in his brother's case; he has never seen the file, but he says, "It's still on my mind."

Okalik comes from a historic Cumberland Sound family. His great-grandfather was Angmarlik, one of the last of the great Inuit whaling bosses who helped operate the whaling stations established by Scots and Americans in the nineteenth century. In 1946 Angmarlik took the last bowhead hunted in the Sound, an event commemorated by photographs in the Hudson's Bay Company Archives.

Okalik himself never lived on the land. His family left camp for settlement life a few years before his birth. He credits his mother, Annie (who died in 1989), with instilling in him the desire for an education. "She wanted her children to have some security – and some income. From time to time you do hear some commentary to the effect that when you go to school you're just indoctrinated into the non-Inuit society. I beg to differ. I haven't changed my views. If anything, my education has encouraged my ambitions

because I've had time to research my values, to learn how I can apply them in dealings with government and non-Inuit entities. When I go up North, I go to the high schools to talk about the importance of getting an education. I've never had to look for work."

Because there was no high school in Pangnirtung in Okalik's youth, he left home to attend school in Iqaluit, but quit before finishing. He started working with the Nunavut negotiators in 1985 ("I developed confidence from that"), the same year that he received his high school diploma through adult education correspondence courses. In 1988 he moved to Ottawa. "Negotiations were getting pretty heavy and we were spending most of our time down here dealing with the government." He took a year off in 1991, when, he says, he found he was drinking too much, and went back home "to straighten out my life." Over these years he had taken a few university courses, and when he returned to Ottawa he began full-time studies. "From there on everything just picked up." He earned a degree in political science and Canadian studies and then entered law at the University of Ottawa. "Initially I had some difficulty. I didn't know how to write properly. Since that period I've learned what professors need."

But aspiring Inuit lawyers need commitment. To begin with, there is a protracted, sometimes lonely sojourn in the south. Okalik acknowledges this: "I still go through it. When I go home I look at everybody and smile. My teeth get tired from smiling when I first go up." But he adds, "For myself it was relatively easy. I knew I wanted to study law, so anything that stood in the way I just put it aside." He met what looked like a serious roadblock in 1996, his final year, when the NWT government cut off his education grants. "The NWT changed its funding policy. They said I'd been down south too long. I got this letter in the middle of my exams. No warning. I was very offended by that practice. To get my education, I have to stay down south." He "phoned around" and was told to contact Indian and Northern Affairs, which picked up the tab. But money is always tight. "I've had the

benefit of working on the Nunavut Agreement. There's still work and that enables me to get by." He supports two children, drives them to school each morning, and thinks his car may just hang in till spring.

Is there an area of law that attracts him particularly, I ask. He says, "In my legal studies I'm taking as broad a field of law as I can. When I do practise, there'll be a lot of issues that have to be addressed and I will be part of that."

Right now, he tells me, he's writing a paper on the tort law of passing off and breaching trademarks, which has relevance for the marketing of Inuit art. He explains that there have been a number of instances of intentional attempts to mislead the public. "Some of the techniques of these people are very deceptive. They claim it's original when it's not; it's done by a certain artist when it's not; it's made of stone when it's not. There was one case in the 1980s where Mrs Alma Houston went to a high school in the Ottawa area to speak to high school art teachers. The high school teachers were all eager to show off their carvings but unfortunately most of the carvings were imitations. So if high school teachers can be fooled, so can the general public. The essential part of passing off is if you are going to market your wares as somebody else's, then you are liable for all your actions. There's a law called the Trade Marks Act which protects the consumer. I'm trying to look at methods to apply the law to prevent abuses."

Does he think his law degree will take him into politics? "Perhaps," he says, but he does not pursue the question. "We have to apply the law and I would like to have a role in that. A lot of Inuit don't know the law or that they can use it to their advantage. They have to become aware; then they have the option of exercising their rights."

What does he think of Shakespeare's advice, "First, kill all the lawyers"? He smiles, "In some of my classes I feel that way."

Certificate programs in legal studies at Nunavut's Arctic College may eventually ease the Inuit graduates' way into law schools in the south, but when Paul Okalik gets his call to the bar, he will represent the major component

of the Nunavut Inuit professional class (an Inuit doctor from the western Arctic practises in the south).[1] How does he feel about the pressures that are likely to come from all sides? The demands on Nunavut's first native lawyer will be immense. But Paul Okalik savours the day. "The least I can do is try and contribute with my education," he says. "I knew when I went to law school that there won't be a lot of Inuit lawyers. So I've known what I'm getting into. I look forward – very much – to helping my fellow Inuit use and take advantage of the laws in place."

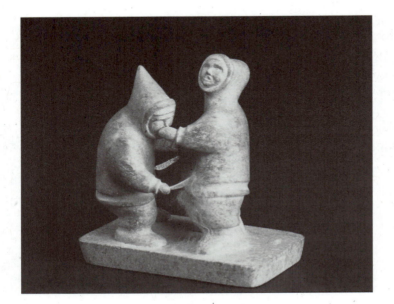

Case unknown (possible alternative for *R. v. Mingeriak*)
Attributed to Bob Ekalopialok, c. 1910–70s
Kugluktuk (Coppermine), NWT
Stone, copper, knitting wool
11.5 × 7 × 13 cm

The Yellowknife Courthouse Collection of Inuit Sculpture

It is a bright arctic July in 1994 when I reach Kugluktuk and check into the Coppermine Inn, the hotel that diamonds built. Kugluktuk, at the mouth of the Coppermine River, from which it once took its name, is close to the diamond strikes of the Lac de Gras area and is witness to the birth of a new Canadian industry. In the summer heat it is a dusty patch of grid housing on the shore of the gleaming Coronation Gulf, part of the Beaufort Sea. For me this Arctic coast community is a long-anticipated port of call: it was here in the fifties and sixties, when the settlement huddled around the church and the HBC post, and the Inuit lived in snow houses, shacks, and "the matchboxes," that the artists who are likely to continue to be described as the "Coppermine carvers" created the nucleus of the Yellowknife Courthouse Collection of Inuit Sculpture.

There are twenty-five sculptures and one stuffed duck (a mounted musk-ox skull has been removed) in the glass display cases in the Yellowknife Courthouse. All were acquired by Mr Justice Sissons with the exception of three that were donated by Mr Justice Morrow.[1] Of the twenty-five carvings on display, eighteen are specifically identified with cases that came before the Sissons and Morrow courts and are discussed in this book, while one depicts the Mafa story, a scandal that Kugluktuk people still talk about. The collection includes two works by a Taloyoak artist, one by a Pelly Bay artist, one by a Cambridge Bay artist, and one by a Holman Island artist. Apart from these five works, the sculptures in the collection – including those as yet unidentified as to case or carver – are all believed to be by Coppermine artists or by those associated with the community for significant periods. None of the carvings are from the eastern Arctic. Even though some of the sculptures portray cases that occurred on Baffin Island, the little figures in the carvings always wear western Arctic clothing.

In her article "An Introduction to the Arts of the Western Arctic," Janet Catherine Berlo contended that the arts of the western Arctic communities have not received the kind of attention accorded the arts of the central and eastern Arctic. The Yellowknife Courthouse Collection of Inuit Sculpture, created by western and Arctic Coast artists, is an exception. Since the early 1960s numerous articles on the collection have appeared in Canada and the United States. The articles, however, have tended to focus on how the carvings relate to the cases they illustrate. As I went about writing this book, I realized I wanted to know more about the way Sissons and Morrow put the collection together and also more about the talented artists represented. As a result, I developed the habit of asking a few questions of those I interviewed to see if they had any knowledge of the carvings or carvers that might fill out the picture.[2]

Of the artists themselves, only one is known to be alive today. He is Holman Island sculptor and printmaker Alec Banksland, also known as Peter Aliknak, born about 1928 into a family constellation of artists (his sister is graphic artist Agnes Nanogak) and whose work is represented in the collection of the National Gallery of Canada. When I talk to him about the sculpture he made that depicts *Re Katie's Adoption*, I am surprised to learn that he is unaware that his carving is part of the Yellowknife Courthouse Collection and that he is uncertain how this came about. The same is true for Lena Kingmeatook, who sanded and polished the carving that illustrates *R. v. Tootalik* made by her late husband, Abraham Kingmeatook (1933–93). "She doesn't have any idea at all how it got to the courthouse," says our interpreter Tommy Nalongiak Anguttitauruq. Lena recalls that her husband made the carving around the time he had ordered an outboard motor, a tent, and fish nets and didn't have food for the children. "He collected those small little pieces of whalebone from the ground around the old Co-op store. He took them home and started carving them." Lena also remembers her husband making the carving that illustrates *R. v. Jeffrey* but again has no idea who the purchaser was.[3]

Valuable information about the manner in which Mr Justice Sissons went about assembling his collection came from photographer and writer Richard Harrington, who in 1962 in Yellowknife made the first complete photographic record of the Inuit carvings representing Sisson's trials. In an interview he tells me, "As I recall, he was never involved directly in negotiations for carvings. Publicly, he was above and beyond that." Requests for carvings reached the artists through an intermediary; this person would also receive the finished carvings and see that they reached the judge "via the underground," as Harrington puts it. "As I remember, the request went sort of underground to an RCMP policeman who went to the village and said, 'Oh well, you carve this thing,' and later it went via the underground way to his collection. That's how it was done." Information I received during other interviews appears to confirm that this was Sissons' method. Evidence suggests that while he loved the Inuit carvings and bought many at Inuit co-ops while on circuit, he himself did not directly ask for the carvings that illustrate the cases that came before him. Sissons asked schoolteacher Dolores Koening to commission a carving for him in Pelly Bay, famous for its ivory carvings, to depict *R. v. Shooyook and Aiyoot*. She approached Bernard Ekutartuq (1918–87), and as a result Sissons added the only ivory work to his collection. He asked Bob Pilot, the investigating RCMP officer in *R. v. Amak, Avinga, and Nangmalik*, to help him acquire a carving for that case. Pilot recalls that he did not do this, but he did get Pond Inlet carvers to make Sissons a bone cane, for which, Pilot says, "he paid handsomely."

Still puzzling me was how Sissons came to buy so many carvings made by Coppermine artists. In a letter to me, Sissons' daughter, the late Fran Hoye, wrote, "Dad's letters indicated that he purchased quite a number of soapstone carvings in Coppermine in August of 1956 … but he made no reference to particular carvers."[4] Sissons noted in his book that he first visited Coppermine in April 1956.[5] It is very possible that he saw Inuit carvings at a display in the school and perhaps met some of the artists. But in fact he visited the settlement rarely. The Right Reverend John R. Sperry,

third Bishop of the Arctic, now retired, who lived in Coppermine from 1950 to 1969 and knew all the artists (and sometimes the accused), notes that during these years the court rarely visited the community. "We went for an eleven-year period without a single court appearance," he says, adding that problems that came up were handled in JP court; only in his last years there – he now lives in Yellowknife – did the court come in on circuit more frequently. While he agrees that western carvers never attained the fame that eastern carvers did, he says, "It had to be that at the time Coppermine had a superior name in the western Arctic for carving – one or two of the carvers were exceptionally good – and therefore they were commissioned to do certain carvings on behalf of the judge. I have no knowledge of commissioning of that nature, but it is quite likely that the RCMP were involved. I would think that relations between the judge and the police were fairly close, although I am sure there were times when the police were not happy about his judgments."

Many other people I talked to suggested that members of the RCMP might have acted for the judge. The officers knew all the members of a community and were frequently keen collectors themselves. But although I contacted a number of officers who served in the settlement (and elsewhere) during Sissons' time on the bench, I was unable to find anyone who could confirm RCMP involvement. Constable Lou Laliberté, who got to know Sissons in Rankin Inlet during *R. v. Kikkik*, says, "Just because Sissons was the sort of man he was, people would have been anxious to help him." But he concedes that Sissons would have been unlikely to approach carvers with suggestions that they carve him a "crime"; on reflection he adds that as an officer of the law he might have had some misgiving himself.

One person who certainly did send carvings from Coppermine to the "outside" was Father Lapointe OMI. In 1966 A.R.C. Jones, a professor of woodlot management at Macdonald College, Ste-Anne-de-Bellevue, Quebec, visited Coppermine and made an arrangement with the priest to have several small shipments forwarded to him. Among the pieces he received

was a small shamanist figure that had the body of a fox and the head of a woman with flowing braids, similar in style, size, and theme to a carving in the collection of the National Gallery of Canada by Peggy Ekagina (1919–93). The series of three carvings illustrating *R. v. Kikkik* is attributed to this artist.[6]

Other possible candidates to act for the judge might include the Coppermine Co-op personnel and the early welfare teachers, as well as northern service officers. (HBC personnel might be considered as well, but Red Pedersen, HBC post manager for many years and later Speaker of the NWT Legislative Assembly, disclaimed any knowledge.)

The "welfare teachers" (as teachers sent north through the Department of Indian and Northern Affairs to work at the federal day schools in the 1950s were called) must have been remarkable people; their duties included teaching, health and welfare administration, and also the development of arts and crafts. From 1951 on, three consecutive welfare teachers – Douglas Lord, James Angus, and, after 1954, David Wilson – actively worked to develop carving talent in the community, and by the time of Sissons' visit a carving and handicraft program was well in place. (Local Inuit say carving started for them in 1950 when a man from the community went to Camsell Hospital in Edmonton for TB treatment and came back with the idea of making carvings for sale.) Most of the marketing was done through Mrs J.R. Woolgar of the Canadian Handicraft Guild in Yellowknife, who arranged to sell carvings on consignment through the guild and other outlets. Pioneer pilot Ernie Boffa flew the carvings to Yellowknife monthly, free of charge, on his return trips to Yellowknife after delivering the mail in Coppermine. During his term as welfare principal, Wilson arranged for Mrs Woolgar to send him registered packages of one-dollar bills to pay carvers for their work. At that time most Inuit never handled money, and as a lesson in economics Wilson counted out payment for carvings dollar by dollar. He also arranged to have quantities of stone quarried at Tree River and brought into the community for sale to the artists in the winter months at eight cents

a pound, "not at all too high, since it was found through the winter that a lot of the stone was of a poor grade … and much that was sold had to be taken back and better stone given in exchange."[7]

Poor stone was always a problem for Coppermine artists – usual sources were Rae River, Richardson River, and Tree River – and perhaps this is part of the reason they never attained the fame of eastern Arctic artists. "They didn't have the kind of stone to create large figures. The carvings were always six or eight inches high," Bishop Sperry explains. Working in small scale, Coppermine carvers made a specialty of composite carvings – several small figures, objects, or animals attached to a base. That they became masters of this type of composition and that the approach adapted well to storytelling is amply demonstrated in the pieces created for the courthouse collection.

The artists and handicrafters formed the Coppermine Eskimo Co-operative in 1960, and when Duane Halliday, now of Dawson Creek, BC, became Co-op development officer in 1968, the Co-op directors included Marion Hayohok, the only member to speak English, Peggy Ekagina, Walter Etoktoo, and Nellie Kanovak. One of their duties was to set prices for carvings. "Any three members could act as carving price setters," Halliday says.[8] Coppermine artists were developing their market through their Co-op during Sissons' later years in the North, but Halliday knew of no special orders for the judge.

Among northern service officers, a possible accomplice during certain years might have been David O'Brien, a keen collector of Inuit art, who died in 1976. O'Brien was area administrator in Coppermine from 1961 until 1963, when he moved to Cambridge Bay, where he briefly held the same position. From 1964 to 1967 he was a tourist development officer and travelled widely. After his death his Inuit art collection was acquired by the Prince of Wales Northern Heritage Centre in Yellowknife. Among the carvings is one described by the centre's appraisers in 1984 as "illustrative sculpture of one of Judge Sissons' cases." The carving shows two men, one on his back, the

other cutting his victim's throat with a copper knife. Blood (perhaps, the appraisers thought, fur died red or red duffel fibres) flows from a wound, as in the carving for *R. v. Mingeriak.*[9] When I telephone O'Brien's widow, Mrs Elaine Narraway of Ottawa, she tells me that although she had little specific information, the family is under the impression that her late husband "won the carving" from Mr Justice Sissons, whether on a bet or in a game of chance she does not know. Interestingly, Alec Banksland recognized O'Brien's name and remembered him as one of the white people who used to visit Holman Island and liked to buy carvings.

It is to ask more questions that I have come to Kugluktuk, and with the help of community officials, I have a productive meeting with a group of Inuit elders at one of their regular weekly get-togethers. Some of them are, or have been, carvers. The elders help me identify the work of certain artists and pass on useful information (much of which appears in the captions for the illustrations in this book), but I do not discover the identity of the judge's accomplice (or accomplices). Jack Alonak recalls seeing his mother-in-law, Agnes Topiak (1905–79), one of the most skilled of the Coppermine artists, at work depicting the stabbing scene in *R. v. Angulalik*. (This artist made at least two of Sissons' carvings.) He remembers that "someone asked her to do that story," but he does not know who that person was. "My mother-in-law used to get a lot of her ideas from stories her husband told," he says. Bishop Sperry never collected Inuit art himself, but carvings were sometimes presented to him. He prizes two carvings by Agnes Topiak, of a man and woman, both in Copper Inuit clothing. "She was a superior artist," he says. "She was one of the original artists and she had the artistic temperament; she was always carving. She had talent far beyond what you might have expected." This artist's work is usually signed AGNAS TOPIAK.

The elders readily confirm that Peggy Ekagina was the artist who made the three small sculptures illustrating *R. v. Kikkik*. Ekagina, with her simplified line, has one of the most distinctive Coppermine styles, but when I talk

later to her sons Moses Elatiak and David Tiktalik, they tell me they do not think their mother would ever have carved such desperate acts as those portrayed in the sculptures. I am assured by elders at the meeting, however, that artists as expert as Agnes Topiak and Peggy Ekagina could and would carve any subject they were asked to do.

Looking through the pack of photographs I carry with me, Martina Klengenberg Anavilok, well known herself for small igloos with removable tops, picks out a picture of a carving she believes to be by her husband, Sam Anavilok (1936–82). It shows a hunter with bow and arrow aiming at birds in flight and represents *R. v. Sikyea*. "He used to do carvings like that," she says. Later examination of the piece reveals the name Sam Anavilok written on the side. Anavilok also carved the sculpture representing *R. v. Amak, Avinga, and Nangmalik,* and there is both stylistic and circumstantial evidence to allow confident attribution to Anavilok of the carving representing *R. v. Ayalik.* Anavilok lived in Cambridge Bay at the time the crime occurred, only moving to Coppermine in 1961. Martina remembers attending the trial: "Nobody was allowed to speak or move." Sissons tried the case and in his memoirs indicated that no Inuit would wish to make a carving representing a case where the crime had been the killing of an RCMP officer. The carving was collected by Mr Justice Morrow, who had been defence lawyer.

Another safe attribution for a carving came from Sam Tablo, son of Bob Ekalopialok (born in 1910, date of death unknown). Sam Tablo remembers his father carving the sculpture representing *R. v. Kogogolak*. He debates whether his father might have made the carving for *R. v. Pitseolak*: "My father did do carving of two men pulling a woman but I haven't seen tents before." A typed label identifies Bob Ekalopialok as the carver of another sculpture, one that depicts a man knifing a shorter figure who is down on his knees. This has been thought to represent the stabbing in *R. v. Angulalik*, but it has also been suggested that it illustrates the death of the child in *R. v. Mingeriak*. In all probability Bob Ekalopialok also made the better-known

carving for *R. v. Mingeriak,* a particularly dramatic little sculpture, as well as what could be another depiction of this case. This latter initially appeared to be by Sam Tablo himself. Sometime after my talk with him, when I was back in the south, Joanne M. Bird of the Prince of Wales Northern Heritage Centre measured the sculptures in the courthouse collection for me and found his name scratched into the stone, but Sam Tablo denied that the work was his. However, he "kind of recognized" both carvings, he told Jimmy Miyok, executive officer with the territorial government in Copper-mine, who kindly conducted a follow-up interview. Tablo had "said most probably they were done by his father." Such mix-ups in the early carving days were not unknown.[10] Sam Tablo had noted that on occasion both he and his father used red knitting wool – "fuzzed" – to represent blood, a dramatic feature in the *R. v. Mingeriak* carving.

Ekalopialok died in an accident in freezing weather out on the trail. He had shot a polar bear and was found with his head pinned down by his sled, which was loaded with seven hundred pounds of polar bear meat. It is said that some people thought he was killed by the polar bear's spirit.

Bishop Sperry says that although the courthouse carvings are true depic-tions, "because the commissions came via another person, a lot was left to the imagination. Some of the carvings are not exactly accurate. For instance, Angulalik used a penknife, not a large snow knife, to attack his assailant. And in the mallard case (*R. v. Sikyea*), the Indian shot the duck with a rifle, not a bow and arrow. This doesn't spoil them."

Of the seven other sculptures not known to specifically relate to Sissons and Morrow cases some may represent unidentified Sissons cases. One or two I thought might be alternative renderings of the well-known cases pre-sented in this book. There is also a particularly powerful piece showing a woman garrotting a man. This turned out to represent the "Mafa" case, which came to trial before Sissons' appointment. Peter Kamingoak of Kugluktuk told me of the events: "This woman [in the carving] shot her husband but when he came to life again she garrotted him. Some months

later her lover shot his wife and they moved in together. The Anglican clergyman alerted the RCMP and they dug up the graves." The man in question shot himself but due process caught up with Mafa. She stood trial and was acquitted. According to Bishop Sperry, who heard the story from others, "She had a little baby and the jury was made up of armed service people from Cambridge Bay. Her lawyers told her to keep holding and suckling the baby. Then the question confronting the jury presumably was, 'Are you going to separate this mother from her child?'" Sissons' daughter Fran Hoye believed that this "carving of Mafa murdering her husband was done by Evaloglak."[11] Sperry says that he knows of only one person this could be, an Alice Evaloglak, "a woman about the same age as Mafa. She did some carving but not very much." However, her husband, George, also made carvings occasionally. The family now spells the name "Evaglok."

Finally, among this miscellaneous group there is a charming small carving that does not appear to relate to a case. It shows a successful hunter, his dog, and a seal. Martina Anavilok thought the carving might be by her sister Mary Evekhoak Akana who now lives in Cambridge Bay. I wrote to Mary to ask and sent a photograph of the carving. "Hello white person," Mary Akana replied in a letter translated by John Komak of Cambridge Bay. "The carving that had a person, a seal and also a dog, that's the carving I made."

One may hope that more information will come to light to identify artists and clear up some mysteries still associated with the collection.

Only one of the illustrations in these pages shows a carving that is not part of the Yellowknife Courthouse Collection. This carving is the retirement gift presented to Mr Justice Sissons by the courthouse staff, and it is currently in a private collection. In *Judge of the Far North* Sissons described the work as "a very fine Eskimo stone carving, showing me on my Bench with a familiar duck."[12]

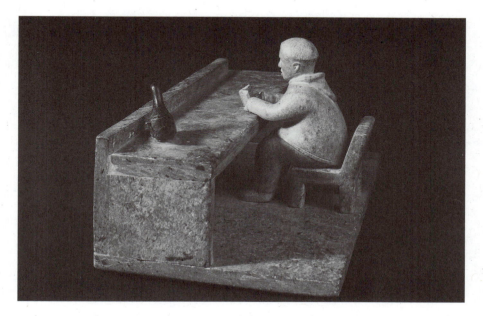

Sissons on the bench (side view)
Artist unknown
Kugluktuk (Coppermine), NWT
Stone
31.75 cm (length) × 17.8 cm (height)
Collection of John Webster, Calgary

NOTES

PROLOGUE

1 For stories of the early explorers related by Lena Kingmeatook and Tommy Nalongiak Anguttitauruq, see Eber, "Rumours of Franklin." Tommy had heard that his mother was shown to explorer Knud Rasmussen as a baby and it may be from the group of Inuit to which Tommy's relatives belonged – hunters on King William Island – that Rasmussen gained the belief he is known to have held that the east side of King William Island would yield the answer to part at least of the Franklin mystery. Tommy heard from his relatives that while one of two vessels beset in the ice northwest of King William Island went down in the ice, the other sailed northeast to the other side of the island.

THE NWT SUPREME COURT AND ITS HISTORY

1 National Archives of Canada (NA), Department of Northern Affairs and National Resources, General Responsibility for the Administration of Justice, RG 22, box 855, file 40-2-9c.

2 Sissons, *Judge of the Far North*, 39–40.

3 Ibid., 14.

4 Ibid., 15.

5 Ibid.

6 Ibid., 63.

7 Ibid., 14.

8 Ibid., 59.

9 Rowe, "Assimilation through Accommodation," 43.

10 Hallendy, "The last known traditional Inuit trial on southwest Baffin Island in the Canadian Arctic," Paper for World Archaeological Congress III.

11 According to *The Canadian Encyclopedia* (978), Inuit called Superintendent Henry Larsen "Hanorie Umiarjuaq" (Henry with the big ship). He skippered the RCMP vessel *St Roch*, which between 1940 and 1944 became the first ship to traverse the Northwest Passage in both directions.

12 In Rowe, "Assimilation through Accommodation," 62–4 (Sissons to Lesage, 8 March 1956, PAC, RG 85, box 540–1, p. 2; Lesage to Garson, 20 March 1965, PAC, RG 85, box 540–1, p. 1).

13 Ibid., 64.

14 *Up Here*, January/February 1989.

15 *Yellowknifer*, 16 May 1989.

16 In court file for preliminary inquiry, *R. v. Ayalik*.

17 Morrow, "Justice in the Canadian Arctic."

18 *Time*, 20 December 1963.

19 De Weerdt, "John Howard Sissons (1892–1968)."

20 Smith and Kelly, "William G. Morrow."

21 Morrow, "Mr. Justice John Howard Sissons."

22 *Nunatsiaq News*, 22 September 1995.

23 Ibid.

24 Sissons, *Judge of the Far North*, 115.

REGINA V. KAOTAK, 1956

1 Sissons, *Judge of the Far North*, 63.

2 Diubaldo, *The Government of Canada and the Inuit, 1900–1967*, 17–18.

3 Sissons, *Judge of the Far North*, 68–9.

REGINA V. ANGULALIK, 1957

1 Sissons, *Judge of the Far North*, 86–92.

2 For much of the information in this chapter I am indebted to Dr Robin McGrath, St John's, Newfoundland, who in addition to supplying firsthand information in interviews, kindly gave me permission to quote from *Stephen Angulalik: Perry River Trader*, in the Northern Biography series, and also from unpublished draft manuscripts.

3 *Telegram* (Toronto), 12 March 1957.

4 Sissons, *Judge of the Far North*, 88.

REGINA V. KIKKIK, 1958

Author's Note: Some of the excerpts from court transcripts have been lightly edited with respect to paragraphing and punctuation.

1 The term "Ennadai Lake Inuit" is explicit and was used in most official documents of the period. Anthropologists consider the more correct term to be "Ahiarmiut."
2 In Tester and Kulchyski, *Tammarniit (Mistakes)*, 214.
3 Eber, *When the Whalers Were Up North*, 164.
4 Tester and Kulchyski, *Tammarniit (Mistakes)*, 205–37. As the writers point out, by the mid-1950s the state had an elaborate infrastructure in place, involving several departments of government, "to address the crises that seemed to plague the Inuit and the northern economy" (205).
5 Ibid., 228.
6 Sissons, *Judge of the Far North*, 108.
7 Ibid, 109.

REGINA V. PITSEOLAK, 1959

1 Pitseolak and Eber, *People from Our Side*, 39.
2 Ibid., 145.
3 Ibid., 143–8.

REGINA V. KOGOGOLAK, 1959

1 James Kavana suggested that a better spelling would be "Kogliac."
2 Rowe, "Assimilation through Accommodation," 233.
3 Sissons, *Judge of the Far North*, 119.
4 Statement of Jimmy Kogogolak to the RCMP, 12 March 1959.
5 Sissons, *Judge of the Far North*, 119.
6 The Supreme Court of Canada ruled in 1939 that Eskimos are "Indians" within the contemplation of the British North America Act, 1867.

7 In Sissons, *Judge of the Far North*, 159.

8 *Time*, 20 December 1963.

9 Ibid.

10 Batten, *Lawyers*, 134–5.

11 Sissons, *Judge of the Far North*, 178.

REGINA V. AYALIK, 1960

1 Morrow, ed., *Northern Justice*, 56.

2 Sissons, *Judge of the Far North*, 130.

3 Ibid.

4 Ibid., 131.

RE NOAH'S ESTATE, 1961

1 Sissons, *Judge of the Far North*, 134.

2 Ibid., 134–6.

3 Ibid., 136.

4 In his book *Bare Poles*, Harold Strub wrote, "The matter of residential schools points up the fact that, like other societies, native societies do not respond to situations and ideas monolithically and reflexively. While for some the history of the residential schools and the family disintegration they caused are too painful to contemplate, others believe that the aptitude for study fostered by a strict school regimen helps to build the kind of leadership resource that native society as a whole sorely needs for the challenging times ahead ... the latter want to open residential schools for students with leadership potential" (13).

5 Sissons, *Judge of the Far North*, 140.

6 Ibid., 138.

7 NA, Department of Northern Affairs and National Resources, General Responsibility for the Administration of Justice, RG 22, 60 x 855, file 40-2-96.

8 Sissons, *Judge of the Far North*, 140–1.

RE KATIE'S ADOPTION, 1961

1 Alec Banksland's stepbrother is the Holman artist Jimmy Memogana whose parents died in a bad flu epidemic.
2 Sissons, *Judge of the Far North*, 143.
3 Ibid., 142.
4 Ibid., 143.
5 NA, Department of Northern Affairs and National Resources, General Responsibility for the Administration of Justice, RG 22, box 855, file 40-2-9c.
6 Sissons, *Judge of the Far North*, 144.

REGINA V. SIKYEA, 1962

1 Sikyea on CFYK in Yellowknife, in Sissons, *Judge of the Far North*, 151.
2 Leonard, *Weekender*, 30 June 1988.
3 Sissons, *Judge of the Far North*, 152.
4 Morrow, ed., *Northern Justice*, 63–4.
5 In 1995 Canada opened formal negotiations with the United States in regard to the Migratory Birds Convention Act and aboriginal and treaty rights. Amendments require Cabinet approval in Canada and Senate ratification in the United States.
6 Keith Crowe, "Land Claims," *The Canadian Encyclopedia*, 971.
7 De Weerdt, "John Howard Sissons (1892–1969)," 404–5.

REGINA V. MINGERIAK, 1963

1 Sissons, *Judge of the Far North*, 165–6.

REGINA V. AMAK, AVINGA, AND NANGMALIK, 1963

1 Sissons, *Judge of the Far North*, 163.
2 Ibid., 164.

REGINA V. SHOOYOOK AND AIYOOT, 1966

1 Fear is suggested as the cause of a number of Inuit murders of whites as well. In *The Howling Arctic* (161–7), Ray Price described the circumstances that caused Inuit of the Pond Inlet area to execute Robert Janes, an isolated trader considered to have become a danger: "The execution had been carefully planned and it was regarded by the Eskimos as a just end for a dangerous man." The Inuk Nukallak, who fired the fatal shots, was rewarded by the community. In this 1923 case a jury selected from officers and crew of the *Arctic*, the ship that brought the court, found Nukallak guilty of manslaughter (with a recommendation for mercy because of extenuating circumstances). He and his associates had assisted the police in their investigation, and it was noted by observers at the trial that the Inuit did not recognize the seriousness of their position. Nukallak was sentenced to ten years in the Stoney Mountain Penitentiary. Among those familiar with the North, there was considerable sympathy for him. His friend, the well-known Scottish whaling master John Murray, travelled to visit him in prison. He was paroled and died in Pond Inlet of TB, probably contracted while in jail.

2 In Morrow, ed., *Northern Justice* (70), Mr Justice Morrow declares, "In reality, of course, the proper legal remedy should have been a charge of conspiracy to carry out an execution laid against the entire group, but the crown would have had no witnesses to call upon if this route had been followed." Mr Justice de Weerdt once suggested a coroner's inquest would have served.

3 Morrow, "Riding Circuit in the Arctic."

4 Morrow, ed., *Northern Justice*, 70.

REGINA V. JEFFREY, 1967

1 Letter from Fran Hoye to D. Eber, 12 February 1993.

2 Rowe, "Assimilation through Accommodation," 196–7.

3 *The Canadian Encyclopedia*, 519–20.

4 Morrow, ed., *Northern Justice*, 87–8.
5 Ibid., 91–3.

REGINA V. TOOTALIK, 1969–70

1 *News of the North*, 29 January 1970.
2 *Edmonton Journal*, 21 November 1969.

IN NUNAVUT: OKALIK FOR THE DEFENCE

1 In 1997 there were three Canadian law graduates of Inuit or part Inuit descent: Violet Ford, a native of Labrador, in Ottawa; David Ward, born around Baker Lake, raised in the south, and practising in Edmonton; and the Honourable James J. Igloliorte, of Corner Brook, Newfoundland, who studied law following his appointment as magistrate.

EPILOGUE: THE YELLOWKNIFE COURTHOUSE COLLECTION OF INUIT SCULPTURE

1 After Mr Justice J.H. Sissons' death in 1969, his collection of sculpture was given to the people of the North. Mr Justice William Morrow contributed three additional works to the collection, which is now known as the Yellowknife Courthouse Collection of Inuit Sculpture. The trustee of the collection is always the senior justice of the NWT Supreme Court, in 1997 Mr Justice Ted Richard.
2 In the period during which Sissons and Morrow assembled the collection, many artists did not sign their works. As a result, some pieces are unidentified. Other carvings appear to have a signature (in syllabics or roman); some have names scratched on the surface, although these are not necessarily the signatures of the artists; and typed labels have been stuck to the underside of the base of others. In *Judge of the Far North* Sissons mentions by name only

the artists Allan Kaotak, Agnes Topiak, and Sam Anavilok, although he appears to have tried to ascertain the names of others who made certain articles for him – for instance, he wrote to Bob Pilot, stationed with the RCMP in Pond Inlet, asking for the name of the maker of his bone cane. Some identifications over the years may have disappeared and further papers with useful information relating to the collection may exist, but they did not come to light during my investigations.

3 Among material relating to the collection is a photograph of Abraham Kingmeatook. On the reverse is a syllabic note by Kingmeatook, translated by Tommy and Lena as follows: "Here I am holding a carving much liked by white people. They love my carvings and I do my carvings. The people in Taloyoak I would like to thank them very much also. Here's one of the pictures." It is signed "Kimiaktook," followed by a disc number and dated simply 3 May, without the year. However, both Kingmeatook carvings in the collection are dated 1970 under the base with a felt-tip marker; his name is also written there, spelled Kimiaktook. According to Lena, Kingmeatook was "partly Japanese," the offspring of an Inuit woman and a member of a Japanese scientific party working in the NWT at the time of his conception.

4 Letter from Fran Hoye to D. Eber, 1 February 1993.

5 Sissons, *Judge of the Far North*, 70–5.

6 A.R.C. Jones later wrote an article about the carved caribou antlers that were a feature of Coppermine work at the time – see Jones, "The Caribou Carvers of Coppermine," *Canadian Geographical Journal* 77, no. 2 (1968): 58–63.

7 David Wilson, "Report on the Handcraft Program," written at the Federal Day School, Coppermine, NWT, 30 March 1956. Now in files of the Inuit Art Section, Department of Indian and Northern Affairs.

8 Letter from Duane Halliday to D. Eber, 20 December 1994.

9 Catalogue card of the collections of the Prince of Wales Northern Heritage Centre and correspondence with Joanne M. Bird, curator of collections, Culture and Heritage Division, Government of the Northwest Territories, 4 July 1994.

10 In regard to this sculpture, Joanne M. Bird wrote, "Perhaps he [Sam Tablo] took the sculpture to the middleman (i.e. the person who acquired it for Sissons) and then this person put the name on the bottom. When we did appraisals of the sculptures in the PWNHC collection Tom Webster & George Swinton [appraisers] noted 2 or 3 pieces which they thought were made by a husband but delivered to an Arts and Crafts Officer by the wife and then the wife's name (& disc number) were put on the bottom of the piece. So perhaps Sam Tablo's name was added at a later date." Fax from Joanne M. Bird to D. Eber, 1 March 1966.

11 Letter from Fran Hoye to D. Eber, 1 February 1993.

12 Sissons, *Judge of the Far North*, 189.

SOURCES

The text of this book draws upon two principal sources of material: the author's personal interviews and the transcripts of the fourteen cases that came before the Sissons and Morrow courts and are depicted by Inuit carvings in the Yellowknife Courthouse Collection of Inuit Sculpture. The author was privileged to read the transcripts of these various trials and preliminary inquiries (except for *R. v. Amak, Avinga, and Nangmalik*, which according to court personnel has unaccountably disappeared) in the Judges' Library in the Yellowknife Courthouse.

Interviews were conducted in the Northwest Territories, elsewhere in Canada, and on occasion over the telephone, from 1989 through early 1997. A few interviews took place at earlier dates while the author was working on other projects. These include interviews with James Houston in Iqaluit in 1973 and over the telephone to Connecticut on 9 March 1981; with Joe Curley in Arviat in 1983; with Joan Attuat in Rankin Inlet in 1983; and with Eleshushee Parr, Pitseolak Ashoona, and Ikayukta Tunillie in Cape Dorset at various times during the 1970s. Excerpts from these interviews appear here because of their specific bearing on particular topics. With the exception of short exchanges, all interviews were tape-recorded. The viewpoints of informants are their own, and differing versions of some of the incidents related here may exist.

In the days of the Sissons and Morrow courts, transcripts were taken down by shorthand and later transcribed. Sections of transcript used here have sometimes been edited for punctuation. The spelling of Inuit words in the Roman alphabet has been in flux for many years, and a consensus is only now emerging. In the 1950s and 1960s most Inuit had no English signatures or accepted English spellings for their names (and until the 1970s no surnames). The court reporter had to spell Inuit names the best he or she could, phonetically. As a result, native names in a transcript are sometimes found with varied spellings, and since spellings have evolved over the years, the spellings are frequently not those currently in use. Similarly, in its artists' biographies the Inuit Art Section of the Department of Indian and Northern Affairs lists multiple spellings for the names of all the artists represented in the Yellowknife Courthouse Collection. (One artist has two names – Alec Banksland and Peter Aliknik.) The spellings used here in the case of living persons are the

spellings in use today. For instance, while any of the seven variations (according to the Inuit Art Section's biographies) of the spelling of Abraham Kingmeatook's last name could have been used, the spelling used here is that employed by the artist's widow in the phone book. Along the same lines, while there was the temptation to follow the spelling used for the defendant's name in *R. v. Tootalik*, the evidence is there in the phone book that Jimmy Totalik and his relatives today spell their name with only one "o".

In recent years many northern communities have adopted the old Inuit place-names. To mention four instances, Frobisher Bay has become Iqaluit, Lake Harbour has become Kimmirut, Eskimo Point is now Arviat, and Coppermine has become Kugluktuk. Many more communities are expected to follow their lead. Since historic documents as well as many articles and books on the Inuit artists use the earlier names, both old and new community names appear here.

UNPUBLISHED SOURCES

Hallendy Papers. Published and unpublished papers prepared for and presented to scholarly conferences, including "The last known traditional Inuit trial on southwest Baffin Island in the Canadian Arctic." Paper prepared for the World Archaeological Congress III, 1994, by Norman Hallendy with Osuitok Ipeelee, Annie Manning, Pauta Saila, and Pitaloosie Saila, August 1991. In the possession of Norman Hallendy, Carp, Ontario.

McGrath Papers. Clippings and manuscripts (published and unpublished) on the life of Stephen Angulalik, by Robin McGrath. In the possession of Robin McGrath, Portugal Cove, Newfoundland.

Rowe, Andrea W. "Assimilation through Accommodation: Practice, Rhetoric and Decisions in the Territorial Court of the Northwest Territories 1955–1972." Master of laws thesis, University of Toronto, 1990.

Transcripts of trials and preliminary inquiries, Yellowknife Courthouse.

PUBLISHED SOURCES

Batten, Jack. *Lawyers*. Toronto: Macmillan of Canada, 1980.

Bellman, David, ed. *Peter Pitseolak (1902–1973): Inuit Historian of Seekooseelak*. Montreal: McCord Museum, 1980.

Berlo, Janet Catherine. "An Introduction to the Arts of the Western Arctic." *Inuit Art Quarterly* 10, no. 3 (fall 1995): 15–21.

Brice-Bennett, Desmond. "When the System Works." *Arctic Circle*, Fall/Winter 1993.

Bucknall, Brian O. "John Howard Sissons and the Development of Law in Northern Canada." *Osgoode Hall Law School Journal* 5 (1967).

Burns, Dean. "He Who Listens." *The Beaver*, February/March 1995.

Canadian Arctic Producers. *Coppermine*. Ottawa: Canadian Arctic Producers Cooperative Limited, 1981.

The Canadian Encyclopedia. Edmonton: Hurtig, 1985.

Condon, Richard G., with Julia Ogina and the Holman Elders. *The Northern Copper Inuit*. Norman and London: University of Oklahoma Press, 1996.

Department of Culture and Communications, Government of the Northwest Territories. *Sissons*. Yellowknife: produced for the Department of Justice. Multiple printings; no date.

de Weerdt, M.M. "John Howard Sissons (1892–1968)" *Arctic* 43, no 4 (December 1990).

Diubaldo, Richard. *The Government of Canada and the Inuit, 1900–1967*. Ottawa: Indian and Northern Affairs, 1985.

Eber, Dorothy Harley. *When the Whalers Were Up North: Inuit Memories from the Easten Arctic*. Montreal and Kingston: McGill-Queen's University Press, 1989.

– "Glimpses of Seekooseelak History." In *Cape Dorset*. Winnipeg: Winnipeg Art Gallery, 1980.

– "Images of Justice." *Natural History*, January 1990.

– "Rumours of Franklin." *The Beaver*, June/July 1996.

– "Interpreting the Law." *Arctic Circle*, Summer 1992.

Griffiths, C.T., E. Zellerer, D. Wood, and G. Saville. *Crime, Law, and Justice in the Baffin Region, N.W.T. Canada.* Burnaby, BC: Criminology Research Centre, Simon Frasor University, 1995.

Hallendy, Norman. "The Silent Messengers," *Equinox,* January/February 1996.

Halliday, D.S. *Tales, Trials and Tragedies of the Arctic.* Dawson Creek, BC: D.S. Halliday, 1990.

Jones, A.R.C. "The Caribou Carvers of Coppermine." *Canadian Geographical Journal* 77, no. 2 (1968).

Leonard, Doug. "Million dollar duck, milestone of justice." *Weekender,* 30 June 1988.

Lightstone, Susan. "The Many Faces of Justice." *Arctic Circle,* Fall/Winter 1993.

McGrath, Robin. *Stephen Angulalik: Perry River Trader.* Northern Biography series. Yellowknife: Department of Information, Government of the NWT, 1984.

Morrow, W.G. "Justice in the Canadian Arctic." *Queen's Quarterly* 72, no. 1 (1965).

– "Mr. Justice John Howard Sissons." *Alberta Law Review* 5 (1967).

– "Riding Circuit in the Arctic." *Judicature* 58, no. 5 (December 1974).

Morrow, W.H., ed. *Northern Justice: The Memoirs of Mr. Justice William G. Morrow.* Toronto, Buffalo, London: Osgoode Society for Canadian Legal History/Legal Archives Society of Alberta/University of Toronto Press, 1995.

Mowat, Farley. "The Two Ordeals of Kikik." *Maclean's,* 31 January 1959.

Nicklen, Louis Roy. "Language and the Law." *Up Here,* January/February 1989.

Pitseolak, Peter, and Dorothy Harley Eber. *People from Our Side: A Life Story with Photographs and Oral Biography.* Edmonton: Hurtig, 1975; Montreal and Kingston: McGill-Queen's University Press, 1993.

Price, Ray. *The Howling Arctic.* Toronto: Peter Martin Associates, 1970.

Sissons, J.H. *Judge of the Far North.* Toronto: McClelland and Stewart, 1968.

Smith, Jan Alexander, and Sherrilynn J. Kelly. "William G. Morrow: A Bench with a View." *Alberta Law Review* 28, no. 4 (1990).

Strub, Harold. *Bare Poles: Building Design for High Latitudes.* Ottawa: Carleton University Press, 1996.

Tester, Frank James, and Peter Kulchyski. *Tammarniit (Mistakes): Inuit Relocation in the Eastern Arctic, 1939–63.* Vancouver: University of British Columbia Press, 1994.

INDEX

MCGILL-QUEEN'S NATIVE AND NORTHERN SERIES
(In memory of Bruce G. Trigger)
Sarah Carter and Arthur J. Ray, Editors